BECKMANN Selz, Peter Howard
7|96 Max Beckmann

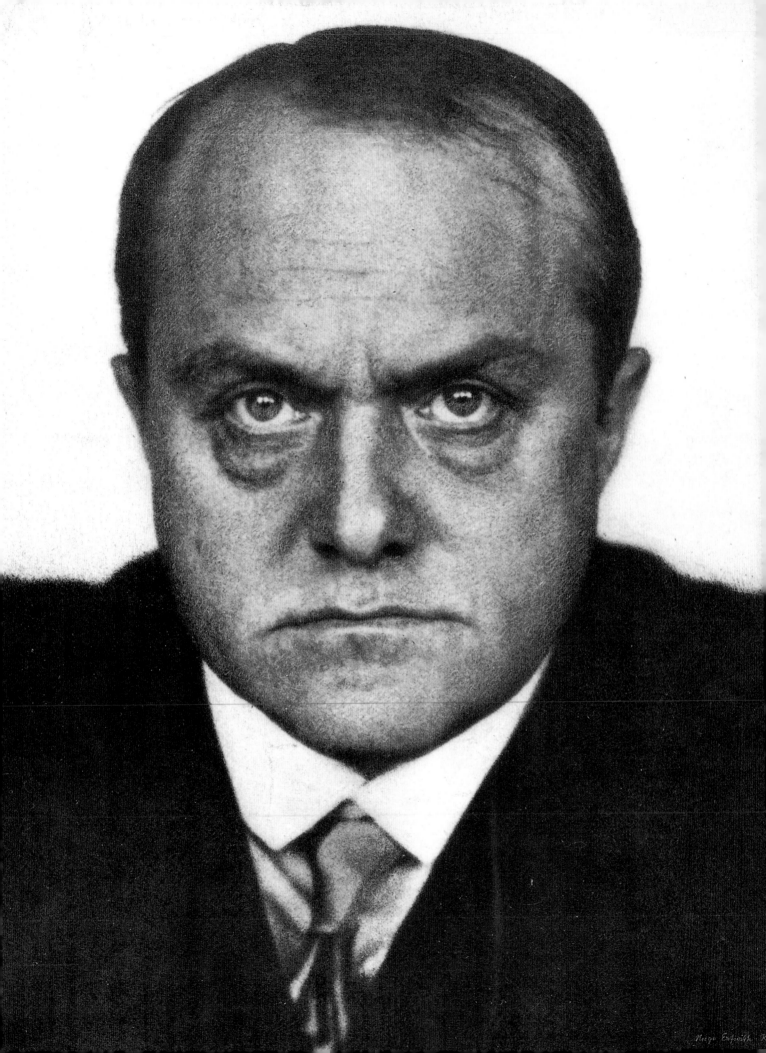

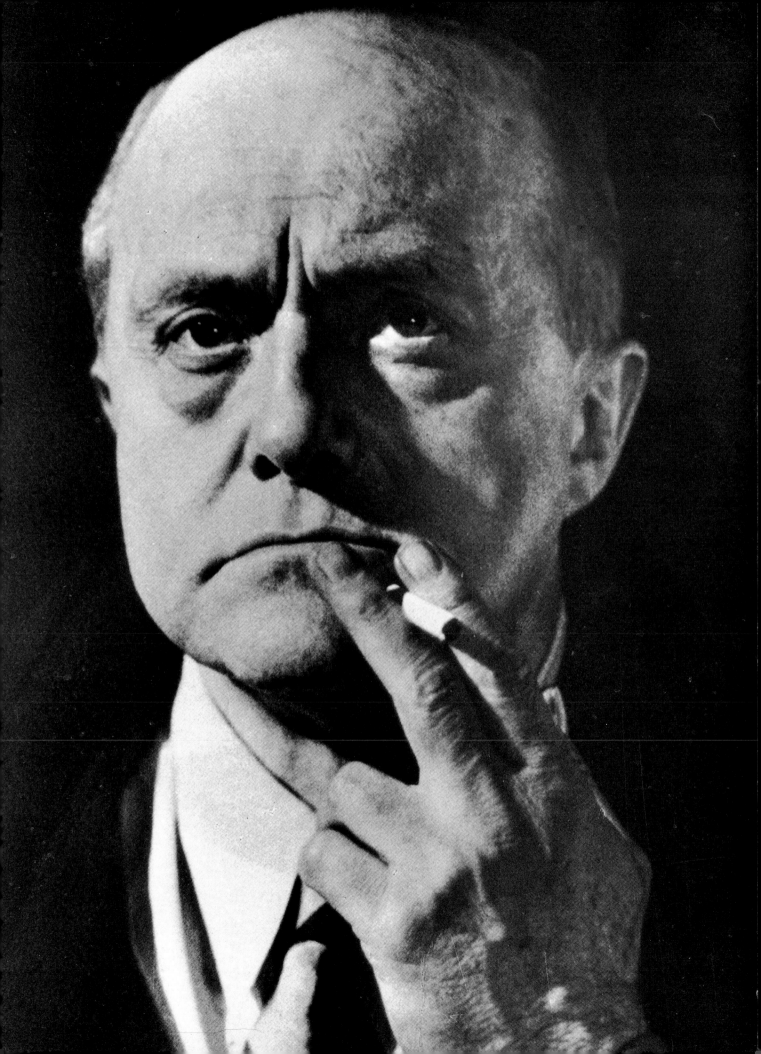

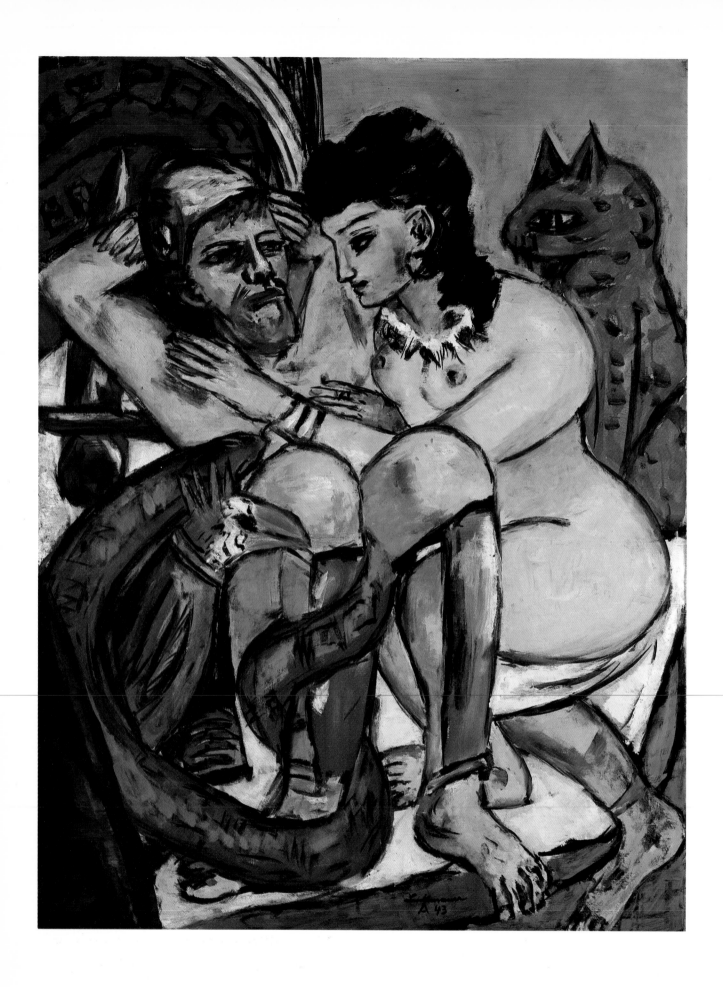

MODERN MASTERS

MAX BECKMANN

PETER SELZ

Abbeville Press Publishers
New York London Paris

Max Beckmann is volume 19 in the Modern Masters series.

To Carole

FRONT COVER: *Self-Portrait with Blue Gloves,* 1948. Oil on canvas, 36 x 31⅛ in.
(91.5 x 79 cm). Private collection; Courtesy of Thomas Ammann Fine Art, Zurich.
BACK COVER: *Falling Man,* 1950. Oil on canvas, 55½ x 35 in. (141 x 89 cm).
National Gallery of Art, Washington, D.C.; Gift of Mrs. Max Beckmann.
FRONT ENDPAPER, left: Max Beckmann, c. 1931–32. Photograph by Hans Erfurt.
FRONT ENDPAPER, right: Max Beckmann, Saint Louis, 1948.
BACK ENDPAPER, left: Max Beckmann painting on the Baltic Sea, 1907.
BACK ENDPAPER, right: Max Beckmann at the Brooklyn Museum of Art School, 1950.
FRONTISPIECE: *Odysseus and Calypso,* 1943. Oil on canvas, 59 x 45⅛ in. (150 x
115.5 cm). Hamburger Kunsthalle, Hamburg, Germany.

Series design by Howard Morris
Editor: Nancy Grubb
Designer: Steven Schoenfelder
Production Editor: Owen Dugan
Picture Editor: Paula Trotto
Production Manager: Lou Bilka

Marginal numbers in the text refer to works illustrated in this volume.

Library of Congress Cataloging-in-Publication Data
Selz, Peter Howard, 1919–
 Max Beckmann / Peter Selz.
 p. cm. — (Modern masters)
 Includes bibliographical references and index.
 ISBN 1-55859-889-8 (cloth)
 ISBN 0-7892-0119-4 (paper)
 1. Beckmann, Max, 1884–1950 —Criticism and interpretation. 2. New
objectivity (Art)—Germany. I. Title. II. Series: Modern masters series.
ND588.B37S4 1996
759.3—dc20 95-42055

First edition
15 14 13 12 11 10 9 8 7 6 5 4 3 2 1

Contents

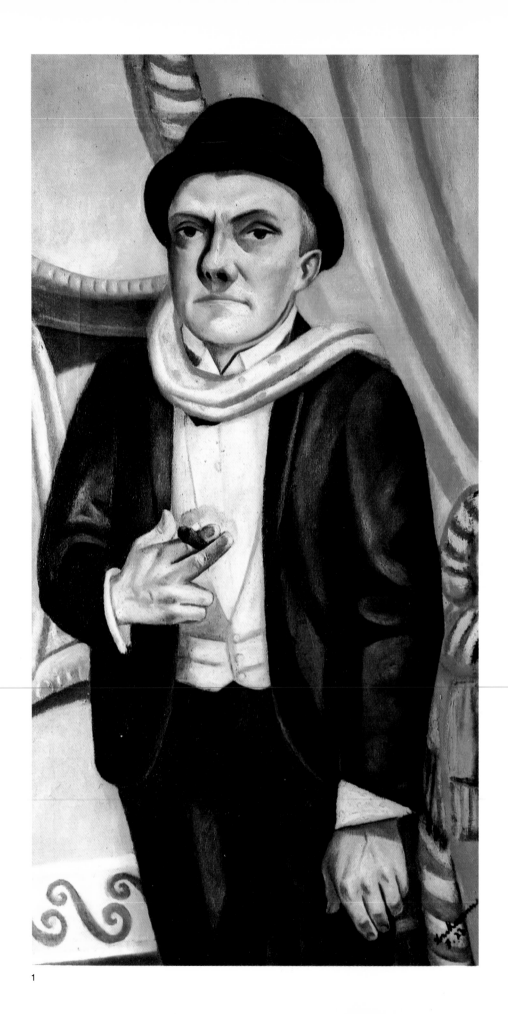

Introduction

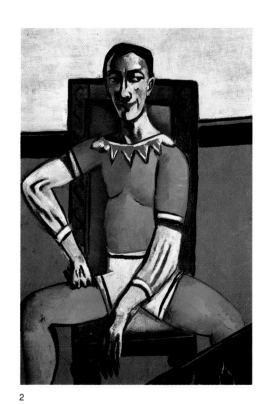

2

1. *Self-Portrait with Red Curtain,* 1923
Oil on canvas, 43⅜ x 23⅝ in. (110 x 59.4 cm)
Private collection

2. *Portrait of N. M. Zeretelli,* 1927
Oil on canvas, 55¼ x 37¾ in. (140 x 96 cm)
Fogg Art Museum, Harvard University Art
Museums, Cambridge, Massachusetts; Gift of
Mr. and Mrs. Joseph Pulitzer, Jr.

Recognized as Germany's foremost painter of the twentieth century, Max Beckmann was a major modernist who was by no means satisfied with the dogma that painting must restrict itself to lying flat on the picture plane. Throughout his life he espoused the figurative mode and endowed it with a narrative and often mythical imagery. His art can be difficult to understand because his iconography is so highly personal—a transcendental symbolism that defies verbal explication. Yet it is accessible to those who open themselves to experiencing the artist's creative imagination.

Beckmann cannot be pigeonholed into one particular ism. After his early work in a romantic-naturalistic style, he developed a manner of painting that was very much his own. Although he has often been labeled a "German Expressionist," especially by American commentators, he strongly objected to such categorization. To be sure, he shared many of the artistic and spiritual concerns of his Expressionist colleagues, but he was always careful to remain separate from groups and associations, feeling (as he asserted in his 1938 lecture in London) that "the greatest danger which threatens mankind is collectivization."

Beckmann had little use for what he considered the decorative, the primitivist, and the abstracting features of Expressionism. Only once, in the pivotal *Neue Sachlichkeit* (New Objectivity) exhibition of 1925, did Beckmann allow his work to be shown in the context of a specific group of artists. Like many other artists in the New Objectivity movement, he often found his subjects in political events. His paintings and prints shared with those by his colleagues of that period a certain stillness of the figures and objects, but he went far beyond the sober pictorial constructions of these new realists. For Beckmann realism was, as he himself repeatedly pronounced, a "realism of inner visions." He would have agreed with Johann Wolfgang von Goethe that the particular serves to represent the universal, and he paid a great deal of attention to individual details, but it was the universal quality of art and its ultimate values that Beckmann had most in mind.

In his paintings Beckmann explored the dichotomy between *bios*

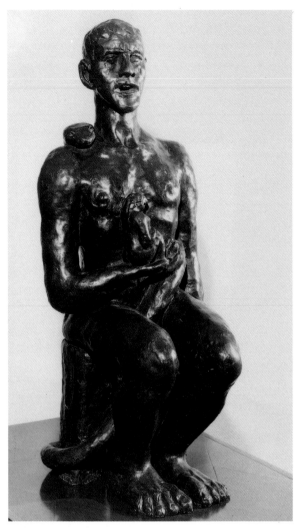

3

(matter) and *logos* (spirit), sensing that the artist's task was, above all, to penetrate bios to gain access to logos, in order to find a bridge from the here and now to the eternal. Beckmann was acutely aware of man's alienation in the world and of the anomie of modern life. A disciple of Friedrich Wilhelm Nietzsche from early youth, Beckmann turned to myth making in his later masterpieces. Like Nietzsche, he questioned the orthodox view of the divinity, writing in 1919: "In my paintings I accuse God of his errors. . . . My religion is hubris against God, defiance of God and anger that he created us that we cannot love one another."[1]

When the Nazis assumed power in Germany, Beckmann became a target for their vilification. Nearly six hundred of his works were confiscated from German museums, and when his paintings were defamed by being included in the infamous *Degenerate Art* exhibition of 1937, he left Berlin for Amsterdam, never to return to his native land. Beckmann was one of the rare twentieth-century artists whose creative energy did not decline in later years. Quite the contrary: he produced nine triptychs, the culmination of his life's work, during his final twenty years. Five of these were done in the Netherlands during a time of extreme deprivation—painted

3. *Adam and Eve,* 1936
Bronze, height: 33½ in. (85 cm)
Robert Gore Rifkind Foundation, Beverly Hills, California

4. *Minna Beckmann-Tube,* 1924
Oil on canvas, 36½ x 29 in. (92.8 x 73 cm)
Bayerische Staatsgemäldesammlungen, Munich

during bombardments and personal harassment, as he witnessed arrests and deportations. Unlike many of his contemporaries, Beckmann incorporated his own experiences into his paintings, though usually encoding them into mysterious forms. His art encompasses many aspects of his life: his knowledge of painting and its history, his far-flung reading in literature, philosophy, and theology. In most of his triptychs he used the tripartite format to express an interaction between the lateral wings and the central panel, often juxtaposing the negative and positive forces of life and dreams. Frequently he interpreted these forms as staged spectacles in which mysterious figures enact their dramatic parts with the artist himself as director.

Max Beckmann was one of the rare modern artists who was able to fuse the authoritative tradition of European painting with the essential features of modernism (including its subversive rebellion) into a unique personal statement of tragic dimension. At a time when deconstructionists dismiss as romantic fallacy the notion of the unique work of art, Beckmann stands out as an artist who had no doubt about the destructive potential of art as well as its life-enhancing power.

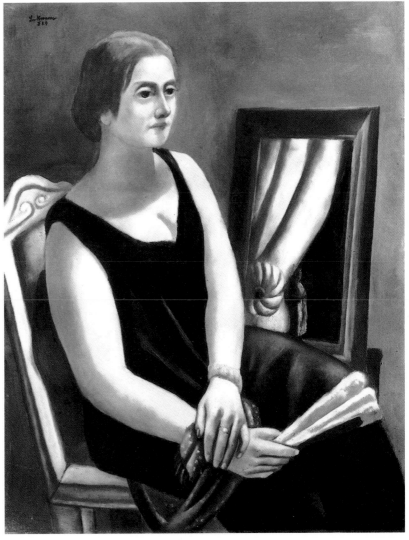

4

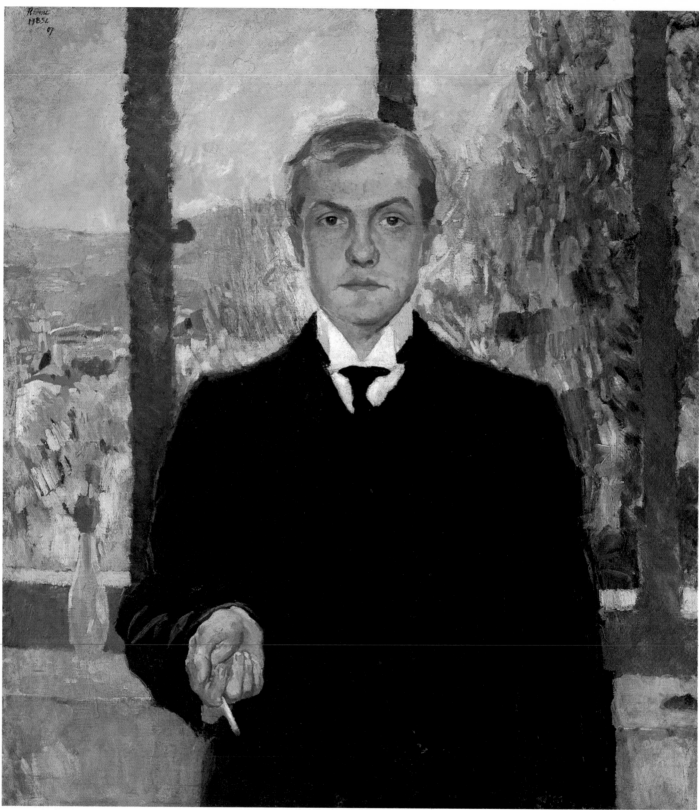

5

1 Early Work and World War I

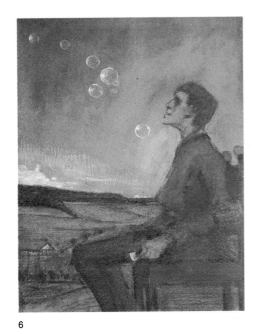

6

Max Beckmann had already achieved phenomenal success as an artist when, in the summer of 1914, at the age of thirty, he enlisted in the medical corps of the German army—an experience that was to change his art and his life. The previous year the dealer Paul Cassirer, arbiter of taste in the Berlin art world, had given him a successful one-man show. He also published a monograph on the young artist, which listed 125 paintings,[2] including a number of works with such oversize dimensions that neither Cassirer nor Beckmann himself could have expected them to sell. Beckmann's style changed radically during and after the war, but this fearless grandeur of scale remained a constant, indicating the extraordinary ambition of a painter who purposefully engaged himself in a dialogue not only with his nineteenth-century predecessors, especially Eugène Delacroix and Hans von Marées, but also with the Renaissance masters he studied and admired—Luca Signorelli, Piero della Francesca, and the painter of the Avignon Pietà (Musée du Louvre, Paris). Beckmann recognized as kindred spirits artists whose profound emotions were transmitted by the articulate composition of the human form in pictorial space.

Although it took years for Beckmann to attain a comparable authenticity, he had begun showing real talent at an early age. Born in 1884 in the industrial city of Leipzig, where his father ran a prosperous flour business, he was taken back to his parents' home-town of Braunschweig at age ten. There, in a medieval city, he grew up among soberly industrious millers and farmers. His first significant experiences with art came when he studied the magnificent collection of works by Rembrandt in the Herzog-Anton-Ulrich Museum. Entering his thoughts about Rembrandt in the little sketchbook he kept as a youth, Beckmann began his great dialogue with the art of the past, which stopped only with his death. He claimed as a spiritual ancestor that other miller's son, Rembrandt, who was being newly evaluated in the 1890s. Like the great Dutchman, Beckmann throughout his life depicted his own image in a vast number of self-portraits. When, finally, he moved to Amsterdam, where he lived for ten years not far from Rem-

5. *Self-Portrait, Florence,* 1907
Oil on canvas, 38⅛ x 34⅝ in. (98 x 90 cm)
Hamburger Kunsthalle, Hamburg, Germany

6. *Self-Portrait with Soap Bubbles,* c. 1900
Mixed media on cardboard, 12⅝ x 9⅞ in.
(32 x 25.5 cm)
Estate of Peter Beckmann, Berlin

brandt's Rosengracht, he referred to his idol as "the chief." Rembrandt, Hieronymus Bosch, and William Blake were the "old magicians," the "nice group of friends who can accompany you on your thorny way, the way of escape from human passion into the fantasy palace of art."[3]

In about 1900 the young Beckmann made an imaginative self-portrait. He is alone, sharply outlined in profile against a wide, lonely landscape, aimlessly blowing soap bubbles into the air and looking after them with a tense gaze. This picture, in the linear style of the turn of the century, shows the amusingly romantic fantasy of the young painter. It is nonetheless a surprisingly bold composition, in which half the area is given over to the sky. A few years later Beckmann created a technically brilliant etching of his face, mouth open in a stylized scream, a grimace that recalls the eighteenth-century bronze "character heads" of Franz Xaver Messerschmidt. This etching, the first of over three hundred prints by Beckmann, was done during his years at the Weimar Academy, where he went after being rejected by the Dresden Academy. While there, from 1900 until 1903, he received a very traditional training. He studied principally with the Norwegian painter Frithjof Smith, whose practice of drawing a charcoal sketch of the total composition on the primed canvas preliminary to painting was to stay with Beckmann for the rest of his life.

Like numerous artists of his generation, Beckmann felt the need to go to Paris, and he actually set up a temporary studio there in 1903. He probably encountered the Avignon Pietà, which made an indelible impression on the young artist, in the exhibition *Les Primitifs français* (1903). He was similarly impressed with Edouard Manet, Vincent van Gogh and, above all, Paul Cézanne. But he also kept his distance from the Ecole de Paris, saying: "What they do there, I already know,"[4] and in 1904 he left Paris to settle in Berlin.

Beckmann was a man most at home in metropolitan environments—much later, when settling in New York, he spoke of the "freedom of the large cities"[5]—and Berlin at the beginning of the century was just coming into its own as a European capital. It was a tough, nervous, and often brutal place—a relatively new city, mainly industrial and administrative, full of vitality, trying to control its undercurrents of violence with Prussian order. The city achieved national and international renown when the Berlin Secession was founded in 1892, partly in protest against the closing of a controversial Edvard Munch exhibition by the conservative academicians of the Verein Berliner Künstler (Berlin Artists' Association). The Secessionists stood firmly for modern art, especially Realist, Impressionist, and Post-Impressionist painting. Under the capable leadership of the painter Max Liebermann and the art dealers Bruno and Paul Cassirer, they exhibited works by artists ranging from Wilhelm Leibl to Cézanne. They also opened their doors to the younger generation in Germany, showing paintings by Emil Nolde and Wassily Kandinsky, as well as by Beckmann, in their large new building on the Kurfürstendamm. Although the Impressionist bias of the Berlin Secession was eventually to be rejected by a new generation of painters, the enterprising Seces-

7. *Large Gray Waves*, 1905
Oil on canvas, 37¾ x 43¼ in. (96 X 110 cm)
Mayen Beckmann; Archive of Dr. Beckmann, Murnau, Germany

8. *Young Men by the Sea*, 1905
Oil on canvas, 58¼ x 92½ in. (148 X 235 cm)
Kunstsammlungen, Schlossmuseum, Weimar, Germany

9. *Double Portrait: Max Beckmann and Minna Beckmann-Tube*, 1909
Oil on canvas, 56 x 43 in. (142 x 109 cm)
Staatliche Galerie Moritzburg, Halle, Germany

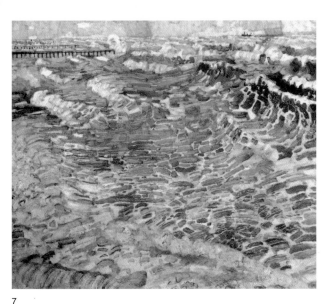

7

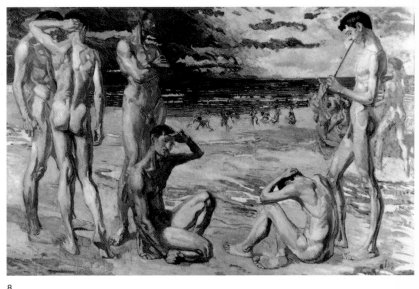

8

9

sionists—especially Liebermann, Lovis Corinth, and Max Slevogt—brought individuality, sensitivity, strength, and imagination to Parisian plein-air painting. The young Beckmann would have been well aware of them.

Beckmann made a number of beach scenes and seascapes around 1905, painted with a broad brush and a heavy, curving stroke. In a canvas like *Large Gray Waves* the stroke, an extension of the Neo-Impressionist *tache* (spot), resembles the rhythmic movement of the waves themselves. While the brushstroke shows the impact of van Gogh and the general grayness of the picture recalls Liebermann's seascapes, Art Nouveau seems to have influenced the way Beckmann filled the whole canvas with the decorative pattern of the sea, interrupting the waves only with the mere indication of a pier. Beckmann loved the sea and would visit it whenever possible throughout his life; at the same time its vast expanse filled him with awe and anxiety. Incredibly sensitive to space, he would become disquieted by the sea's "almost spaceless infinity," which would lead him to both "deep depressions and wild consciousness of the self."[6]

The sea is the background of his large and ambitious composition *Young Men by the Sea*. In this virtuoso piece Beckmann showed what he had learned. The six nude young men, each painted in a different position, provide proof of his anatomical knowledge and pay homage to the grand compositions of Signorelli and Cézanne. This canvas brought the artist to national attention. He submitted it to the annual exhibition of the Künstlerbund (German Artists League) in Weimar, where Count Harry Kessler, director of the Kunstgewerbemuseum, and the artist and architect Henry van de Velde awarded Beckmann the Villa Romana Prize for a six month's stay in Florence. The picture was acquired by Weimar's art museum in 1906.

In 1906, before setting off for Italy, Beckmann married Minna Tube, a fellow art student at the Weimar Academy whom he had met at a Mardi Gras costume ball in 1902. (All his life Beckmann, the conjurer, loved the costume party, the masked ball—those areas on the border of unreality where the essence of life often comes to

7

8

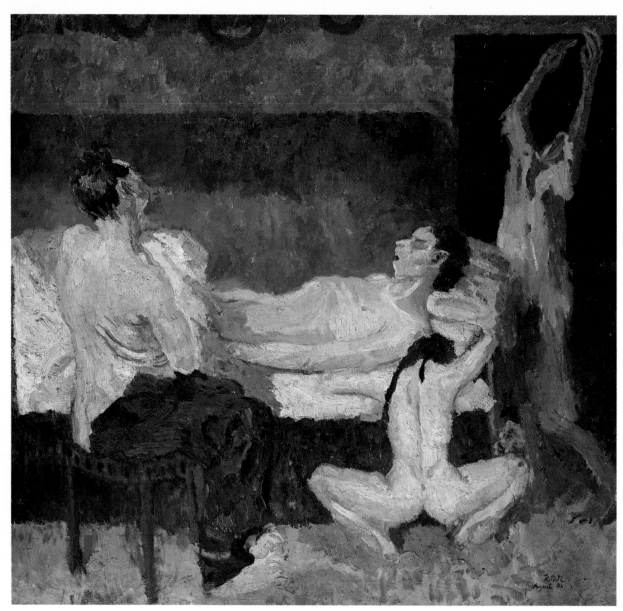

10

the surface.) Soon after their wedding he experienced the first real tragedy of his life: his mother, to whom he had been extremely close, died of cancer in the summer of 1906. The profound reflection caused by her death was expressed in *Large Death Scene*, painted in August 1906, a picture of agonized despondency in which three people embody different modes of despair. The woman sitting below the corpse, occupying the place of the sorrowing Virgin in Italian Early Renaissance depictions of the Deposition, is a particularly poignant image.

Although the violence of the figures' emotions seems grossly overstated, the artist superimposed a certain restraint by means of a composition carefully structured of horizontals and verticals. The wailing woman with arms upraised at the head of the bed is contained by a perpendicular window frame, while the window itself, black and shut, seals these mourning figures off from the outside world—an isolating device that would be used with even greater force in Beckmann's postwar period. The light color key—particu-

10. *Large Death Scene,* 1906
Oil on canvas, 50¾ x 54¾ in. (131 x 141 cm)
Staatsgalerie Moderner Kunst, Munich

11. *The Sinking of the Titanic,* 1912–13
Oil on canvas, 104¼ x 129¾ in. (265 x 330 cm)
The Saint Louis Art Museum; Bequest of Morton D. May

12. Max Beckmann in his studio, Berlin, 1912–13, with *The Sinking of the Titanic*

14

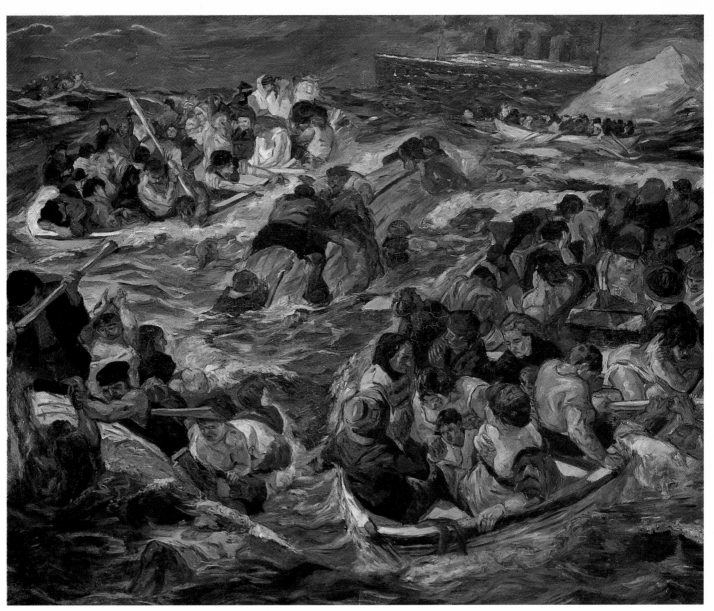

11

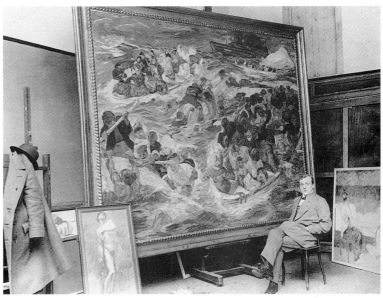

12

larly the pink background—adds to the eloquence of the picture precisely because it is so unexpected. There is little doubt that the melancholic quality of this picture was influenced by the work of Edvard Munch, who was held in high esteem by the younger generation in Germany. After seeing the painting Liebermann encouraged Beckmann to orient his future work along the lines suggested by this tragic scene, but for the time being the young artist headed in different directions.

13

That Beckmann at this time was much too positive, even optimistic, to sustain such sorrow is apparent in the worldly *Self-Portrait, Florence*. Behind the young artist and in the background below are the trees of the Tuscan hills; Florence itself is on the left, painted in lively Impressionist tones. This is a romantic portrait of the artist as an expectant young man, conscious of early success. The painter outlined the head in light color so that the brushwork suggests a halo—an unconscious effect, perhaps, but a halo nevertheless.

Beckmann returned to Berlin and settled in the suburb of Hermsdorf. After seeing the important Delacroix exhibition organized by Julius Meier-Graefe at Paul Cassirer's gallery in 1907, he turned to colossal compositions that are often more rhetorical than eloquent. His huge *Resurrection* is modeled after compositions by Peter Paul Rubens and El Greco, with the artist himself appearing at lower right as a modern witness—or perhaps as the stage manager.

Like Delacroix and Théodore Géricault, Beckmann now made large compositions inspired by current cataclysms, such as *Scene from the Destruction of Messina* and *The Sinking of the Titanic*. If the latter lacks the feeling for human tragedy and the inventiveness of composition—as well as the brilliant sense of color—seen in Géricault's *Raft of the Medusa* (1819; Musée du Louvre, Paris), it is nonetheless remarkable as a technical accomplishment. The masses of shipwrecked survivors in their small liferafts are interlinked in one sweeping rhythm. Certain details of the convoluted action are infused with a vitality much like that soon to be seen in mob scenes on film. In fact, the whole picture resembles a frame from an old newsreel, although it goes beyond the melodramatic reportage.

Paintings like this were greatly acclaimed, and Beckmann was lauded as "the German Delacroix." As early as 1910 he was appointed to the executive board of the Berlin Secession, an honor generally reserved for artists twice his age. Even though he resigned from this position the following year in order to devote all his energies to painting, he remained the great white hope of the older Secessionists. Beckmann's first solo exhibition took place in Magdeburg, Germany, in 1912, where his work was seen as "a grand synthesis of the pathos of Rubens, the light of Rembrandt, and the brushstroke of the Impressionists."[7] Early the next year Karl Scheffler, editor of the Secession-oriented magazine *Kunst und Künstler,* lauded him as one of the most promising young artists in Germany.[8]

It was in 1912 that Beckmann took the conservative position in a controversy with the Expressionist painter Franz Marc, who had written in the German periodical *Pan* about seeking "the inner,

13. *Scene from the Destruction of Messina,* 1909
Oil on canvas, 100¼ x 105⅜ in. (253 x 262 cm)
The Saint Louis Art Museum; Bequest of Morton D. May

14. *Resurrection,* 1908
Oil on canvas, 12 ft. 11 in. x 8 ft. 2 in. (3.95 x 2.5 m)
Staatsgalerie Stuttgart, Stuttgart, Germany

14

spiritual side of nature," which ultimately led toward abstraction.[9] Beckmann, who felt disinclined to abandon the representational, countered at once:

There is something that repeats itself in all good art, that is artistic sensuousness, combined with artistic objectivity toward the things represented. If that is abandoned, one arrives involuntarily in the realm of handicraft. . . . I, too, want to speak about quality. Quality, as I understand it. That is, the feeling for the peach-colored glimmer of the skin, for the glow of a nail, for the artistic sensuality that is located in the softness of the flesh and in the graduated depth of space—not only in the plane but also in depth. And then, above all, the appeal of the material. The surface of the oil pigment, when I think of Rembrandt, Leibl, Cézanne, or the spirited structure of the line of Hals. . . . The rules of art are eternal and, like the moral art in each of us, cannot be altered.[10]

Even later, when Beckmann stated that he wanted to show "the idea that hides itself behind so-called reality" in his search for "the bridge which leads from the visible to the invisible,"[11] he spoke about a move toward the invisible that was very different from Franz Marc's or Kandinsky's in that direction. While the abstractionists of the group Der Blaue Reiter (The Blue Rider) were concerned with the spiritual and with cosmic space, the young Beckmann continued to explore the sensual object itself, finding mystery in its very objectness.

16 Space is crammed in *The Street,* one of Beckmann's most successful prewar paintings. Its effect of being highly concentrated may have been enhanced years later, in 1928 in Frankfurt, when Beckmann cut it down to its present dimensions, one third its original size. What he preserved in this detail is an animated scene of people rushing through a narrow city street. Beckmann himself is at the center, with his wife hurrying off to the left and his son, Peter, approaching the viewer at the front. On the right, a poor woman carries her child; in the back is a beautifully painted horse and driver. As in a Mannerist canvas, the figures are compressed into a space too narrow to hold their movements comfortably, so that the whole action is pushed forward, out of the picture plane.

15 Compared with *Street, Berlin,* painted by Ernst Ludwig Kirchner the year before in the same city, Beckmann's picture seems much more conservative. He carefully weighed the nuances of his colors, whereas Kirchner used stridently bold hues. Beckmann's forms are still modeled in a traditional manner, whereas Kirchner flattened his into largely two-dimensional shapes. Beckmann's light seems to have a natural source, coming onto the scene from the right, whereas Kirchner's light belongs solely to his picture. A comparison with other avant-garde paintings of similar subjects from this period—Robert Delaunay's *Windows on the Street* (Solomon R. Guggenheim Museum, New York), Umberto Boccioni's *Power of the Street* (Museum of Modern Art, New York), Fernand Léger's views of the city—makes Beckmann's paintings look very traditional. Indeed, he was not an important experimenter with form at the time. His modernity consisted rather in his attitude of cool sobriety.

"The unhealthy and repulsive aspects of the prewar years were the commercial haste and the quest for success and influence with which each of us was infected in some way. Now, every day for four years, we have looked horror in the face. Perhaps this has touched some of us deeply."[12] Thus Beckmann wrote after the war. He was indeed profoundly affected by what he saw. At the outbreak of the war, when most of the men of his generation jubilantly

18 flocked to the colors, he made the etching *Weeping Woman,* showing a pitiful, dumbfounded woman in a funny little hat, clutching a handkerchief and crying helplessly. This print, like the slightly

17 later *Declaration of War,* although still largely narrative, no longer focuses on a heroic theme but instead presents the great tragedy of war as it affected the man and woman on the street.

Wanting to avoid the business of killing, Beckmann volunteered for the medical corps of the German army. By the end of September 1914 he was on the Russian front. His letters from the war tes-

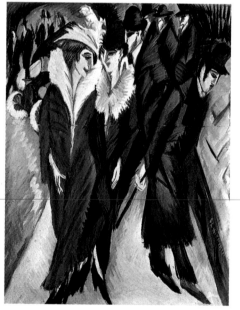

15

15. Ernst Ludwig Kirchner (1880–1938)
Street, Berlin, 1913
Oil on canvas, 47½ x 35⅞ in. (120.6 x 91.1 cm)
The Museum of Modern Art, New York; Purchase

16. *The Street,* 1914
Oil on canvas, 67½ x 28½ in. (171 x 72 cm)
Berlinische Galerie, Landesmuseum für Moderne Kunst, Photographie und Architektur, Berlin

18

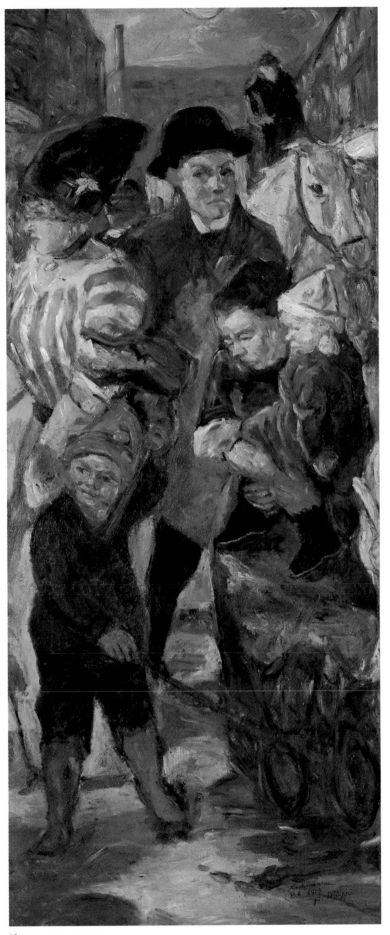

16

17

18

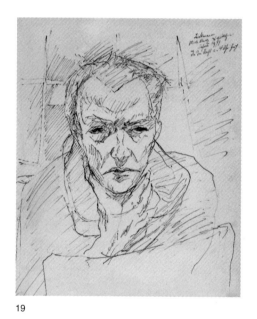

19

tify to a change of attitude during his service in the army.[13] At first he seemed to perceive the war mostly as a potential source of material for great history painting—what a stage for pictorial reportage! Slowly, though, Beckmann was overcome by the sobering reality of intimate daily contact with the wounded and the dying. Only his work as an artist—the drawings and etchings he was able to do in his spare moments—kept him going. "My will to live is at present stronger than ever, although I have already experienced great horror and have seemed to die with the others several times. But the more often one dies, the more intensely one lives. I have drawn—this is what keeps one from death and danger."[14]

The experience of war changed Beckmann's life and his art. In his letters written during the war—unlike his diaries of the preceding ten years—he recorded his thoughts on art and his plans for the future as a painter. Beckmann hoped to make his work ever more simple and more concentrated in expression, but without giving up the fullness and the roundness of plastic form.[15] He constantly drew and etched, depicting soldiers just standing around, horses, the wounded, the operating room, destroyed cities. As always he found time to read and was enthusiastic about Heinrich von Kleist's *Amphytrion* (1807). He was deeply moved by the Lucas Cranach the Elder portraits and by the fifteenth-century German paintings he saw in Brussels during the war. His wartime encounters with Erich Heckel and Ludwig Meidner in Flanders were of great importance to Beckmann's development. He kept writing about his "passion for painting" and how much he missed having paints: "If I only think of gray, green, and purple, or of black-yellow, sulphur yellow, and purple, I am overcome by a voluptuous shiver. I wish the war were over and I could paint again."[16]

17. *Declaration of War,* 1914
Drypoint, first state, plate: 7 13/16 x 9 3/4 in. (19.8 x 24.8 cm)
The Museum of Modern Art, New York; Abby Aldrich Rockefeller Fund

18. *Weeping Woman,* 1914
Drypoint, plate: 9 13/16 x 7 7/16 in. (24.3 x 19 cm)
The Museum of Modern Art, New York; Gift of Abby Aldrich Rockefeller

19. *Self-Portrait,* 1917
Pen and black ink on cream laid paper, 15 1/2 x 12 1/2 in. (38.5 x 31.5 cm)
The Art Institute of Chicago; Gift of Mr. and Mrs. Allan Frumkin, Chicago

20. *Self-Portrait as a Medical Orderly,* 1915
Oil on canvas, 21 3/4 x 15 in. (55.5 x 38.5 cm)
Von der Heydt Museum, Wuppertal, Germany

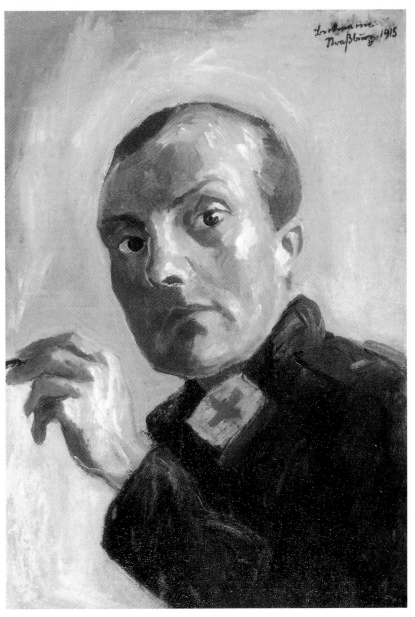

20

By the summer of 1915 Beckmann, who had so recently hoped to be an objective chronicler of the war, had suffered such total physical and mental exhaustion that he was discharged from the army and was sent to Strasbourg. There he painted *Self-Portrait as* 20 *a Medical Orderly*, in which he apprehensively turns to face the viewer in an arrested motion that reveals his disturbed condition. The only color accent in this somber painting is the Red Cross emblem on the collar of his military tunic. Thirty-four years later, when he was suffering from a heart condition, he wrote to his son, who had become an eminent heart specialist. "Could it be that my pains are still connected to the injuries of the soul I suffered during the war?"[17]

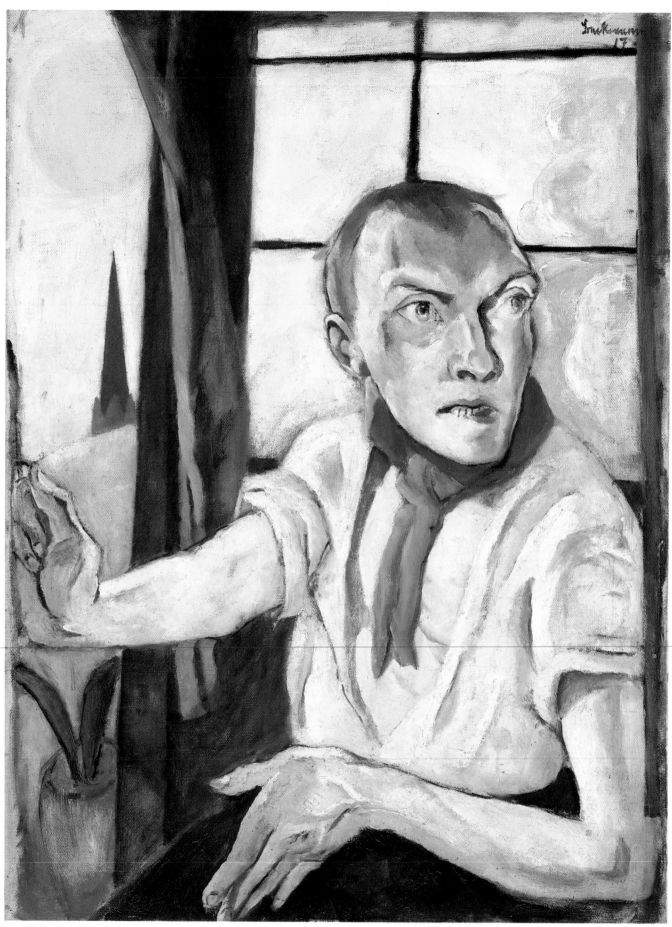

21

2 Frankfurt

After leaving the army Beckmann settled in Frankfurt because his friend Ugi Battenberg, formerly a fellow student in Weimar, invited him to live with his family and share his studio. Beckmann's wife, Minna, had become a professional opera singer during the war and was now living in Graz, Austria; in any case, it seemed impossible for him to share his life with anyone after his war experiences. Art, as well as life, had to be started over from scratch, and Beckmann renounced all his former achievements and the success that had resulted from them. Alfred Kubin observed that "a frantic pressure must have weighed upon Beckmann to toss out all this beautiful, hard-learned craft."[18]

In *Self-Portrait with Red Scarf,* Beckmann sits at his easel, looking more like a man hunted by pursuers than a painter in his studio. His shirt is torn and a red scarf is tied carelessly around his neck. His mouth is half-open; his left eye, larger than the right, stares out in defiance. This is the romantically conceived portrait of a rebel accusing society and reproaching God. A comparison with the *Self-Portrait, Florence* of ten years earlier shows a drastic change in style. Beckmann now used violent foreshortening and distortion. Pigment is applied thinly, and the color is light and cold, as if to counteract the emotionalism of the expression and the exaggeration of the gesture. Both violent and stylized, this gesture is related to the German style of acting favored during the war and postwar years, known to us now through the abrupt movements of early Expressionist films. The only thing carried over from Beckmann's earlier *Self-Portrait* is the window frame behind the artist's head; now, instead of yielding a view of the beautiful hills of Fiesole, it encloses a blank yellow area that, like a closed door, shuts out space.

Space for Beckmann was a fearful, terrible thing. Whereas his prewar *Street* was filled with people, the roadway in *Landscape with Balloon* is alarmingly empty, suggesting the frightening depths of space. The viewer is thrown into those depths very abruptly by the rapid foreshortening of the houses on the left. A woman carrying an umbrella has walked by the foreboding gray green trees,

21. *Self-Portrait with Red Scarf,* 1917
Oil on canvas, 31½ x 25⅝ in. (80 x 60 cm)
Staatsgalerie Stuttgart, Stuttgart, Germany

23

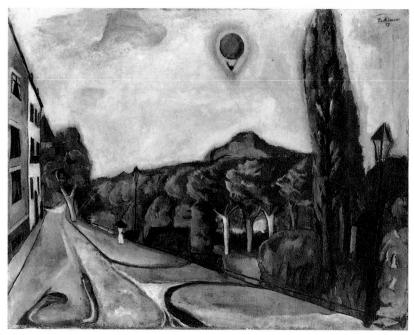

22

while the gray pavement suggests strange snakelike curves and a balloon hovers in the empty gray sky. Munch had expressed similar anxiety in his paintings and prints, but for him the cause of anguish was the failure of human contact; Beckmann located it in his dread of space.

This dread is evident even in his religious pictures. After his return from the war Beckmann painted a series of biblical subjects that were in great contrast to the romantically conceived and thickly painted dark canvases of his earlier Berlin period. Once more he turned to the theme of the Resurrection, but instead of a traditional composition he created a huge mural of doom (Staatsgalerie, Stuttgart, Germany), expressing his feelings about the war, destruction, man's fate in a world out of joint. The sun is an extinguished black disk, and little light brightens the pallid gray of the scene. Elongated figures reminiscent of those by El Greco emerge from the bursting pavements. Some of these are portraits; the Beckmanns and the Battenbergs appear at lower right. Higher up are ghostlike figures who are distorted and foreshortened as if seen from below. These specters in their bandages and winding sheets stalk across the ruins. Following the intertwining lines across the ever-shifting planes, the eye moves from scene to scene, and again we are reminded of frames in a film. But this montage seems to look ahead to the total destruction of cities to come twenty-five years later, in the next world war.

Beckmann worked on this picture for three years, from 1916 until 1918, when he left it unfinished.[19] He kept it standing upright and facing outward in his studio in Frankfurt, so that he and his visitors confronted it constantly. It served as a major source for the dramatis personae of his later works, with their flying, foreshortened figures, stylized gestures, and hooded garments. Ambitious in size as well as meaning, focused on death and transfiguration, enigmatic in iconography, it is the prototype of Beckmann's triptychs. When the artist had to leave his large studio in Frankfurt in 1933,

22. *Landscape with Balloon*, 1917
Oil on canvas, 29¾ x 39½ in. (34.5 x 49.7 cm)
Museum Ludwig, Cologne, Germany

23. *The Descent from the Cross*, 1917
Oil on canvas, 59½ x 50¾ in. (151.2 x 128.9 cm)
The Museum of Modern Art, New York; Curt Valentin Bequest

24. *Portrait of J. B. Neumann*, 1919
Drypoint, 15¾ x 12 in. (40 x 30.2 cm)
The Art Institute of Chicago; on loan from Allan Frumkin, Chicago

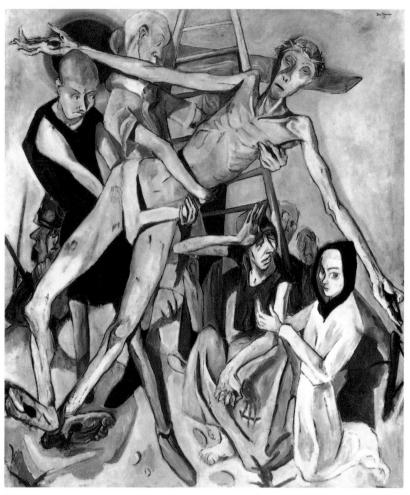

23

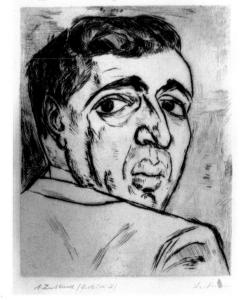

24

he took it off its stretcher, rolled it up, and carried it with him in his progression from Berlin to Amsterdam, Saint Louis, and New York.

The principals in Beckmann's *Descent from the Cross* are stiff, sober figures. Did the war cause this fundamental change in style or did it derive from the evolution of his nature and talent? Partly it was Beckmann's new interest in Northern Gothic painting, which he shared with many German painters of the time. Visiting the Musées Royaux des Beaux-Arts in Brussels during his service in the army, he wrote about being enormously moved by paintings by Rogier van der Weiden, Bruegel, and Lucas Cranach.[20] When asked by J. B. Neumann, his dealer and publisher of his prints, to produce an introduction for the catalog of a show of his graphic work in Berlin, Beckmann wrote: "I do not have much to write: To be the child of one's time. Naturalism against your own Self. Objectivity of the inner vision. My heart goes out to the four great painters of masculine mysticism: Mälesskircher, Grünewald, Bruegel, and van Gogh."[21]

Gabriel Mälesskircher was a Bavarian painter, active after the middle of the fifteenth century, to whom the large Tegernsee Altar was then ascribed.[22] Grünewald's work first impressed Beckmann as early as 1903 when, on his return from Paris, Beckmann visited Colmar at a time when the Isenheim Altar was little known. As soon as the war broke out, he wrote to Wilhelm von Bode, direc-

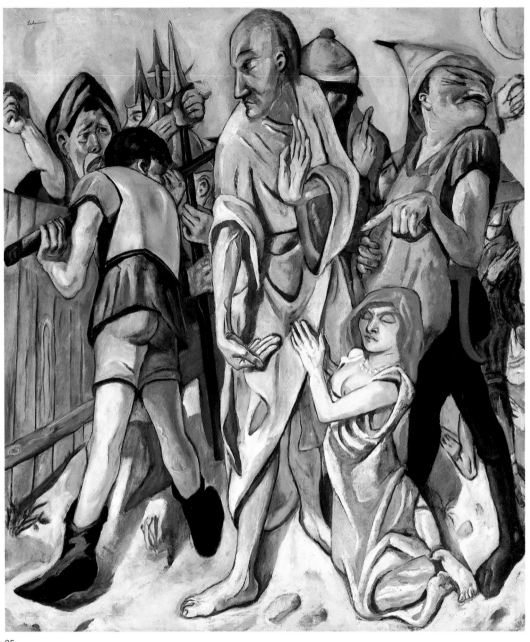

25

tor of the Kaiser-Friedrich Museum, suggesting that he move the great altarpiece from Alsace to Berlin for the duration of the war;[23] Bode showed little interest, so it went instead to Munich, where it was to exert considerable influence on artists and to become recognized as one of the world's great masterpieces.

This anecdote indicates Beckmann's great interest in early German art. Other names he mentioned include Hans Baldung Grien, Lucas Cranach the Elder, Hans Holbein the Elder, and Jörg Ratgeb. His dialogue with the art of the past continued, and awareness of Beckmann's enthusiasm for German Gothic painting is essential to a full understanding of his postwar work.[24] What Beckmann liked in the work of the old German painters was the direct impact of the intense colors and forms, whatever the story. He also liked the narrow and compressed stagelike space, in which the figures appeared to be performers enacting a rite. Their importance in the

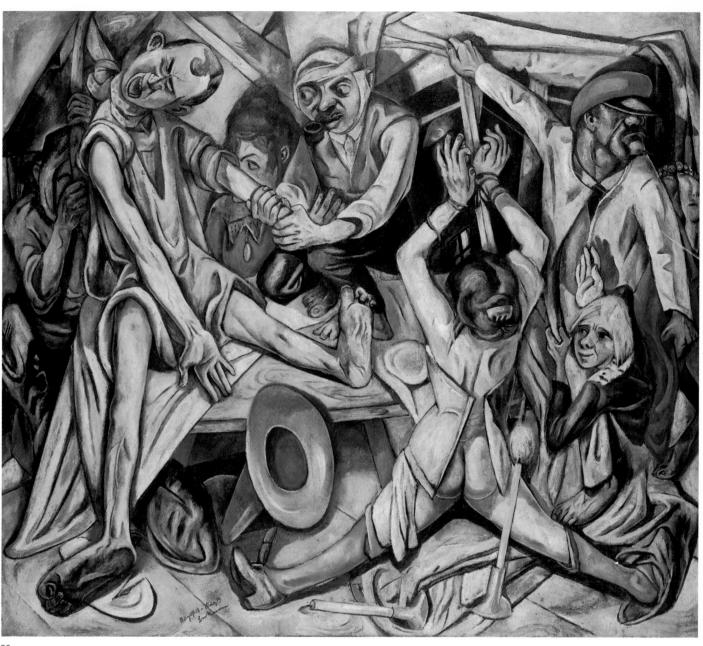

26

25. *Christ and the Woman Taken in Adultery,*
1917
Oil on canvas, 58¾ x 49⅞ in. (150 x 126.7 cm)
The Saint Louis Art Museum; Bequest of Curt
Valentin

26. *The Night,* 1918–19
Oil on canvas, 52⅜ x 60¼ in. (133 x 154 cm)
Kunstsammlung Nordrhein-Westfalen,
Düsseldorf

pictorial and psychological context, rather than any scientific laws of perspective, determined their size. In a painting like his *Descent from the Cross*, the figures, thin and two-dimensional though they are, create the space, which recedes and advances with them in a zigzag movement while closely adhering to the picture plane. The large body of Christ extends diagonally across the whole plane. The soldiers on the left are seen from below, while the mourning women kneeling at lower right are seen from above; this twist of perspectives forces the eye to return constantly to the pale figure of Christ, who, with his arms radiating from his angular body, is one of the most compelling representations of Christ in modern art.

Christ and the Woman Taken in Adultery, the pendant to the *Descent from the Cross,* has the same pale color, the same painful angularity of linear forms, the same narrow space, and similar principles of rotating composition. But this agitated scene—in

25

27

which all the characters are going their own way, crowded together but with no psychological contact, stresses the nightmarish aspects of Beckmann's vision. Except for Christ and the man with the troubled face behind the fence, all the characters have their eyes shut, as if to accentuate their detachment. The figure of the striding Christ, with his white shroud and dramatically gesticulating hands, relates closely to the ghostlike apparitions of *Resurrection,* except that this Christ embodies both wisdom and benevolence.

If his religious scenes from between 1916 and 1918 indicate Beckmann's feelings of anxiety and disquiet, *The Night,* a painting that occupied the artist from August 1918 until March 1919, is a statement of outraged protest. Following the abortive revolution of 1918, life in Germany was marked by hunger, disease, unemployment, incipient inflation, and bloody, savage revolts. As the soldiers returned from the trenches, violence became as much a part of the newly declared peace as it had been of war. In rapid succession Kurt Eisner (premier of the revolutionary government of Bavaria) was shot in the streets of Munich; Gustav Landauer (a great ethical philosopher and teacher of Martin Buber, who had joined the Bavarian government) was brutally beaten to death; and in Berlin the leaders of the Left, Karl Liebknecht and Rosa Luxemburg, were murdered in cruel fashion.

Beckmann, who himself had no political affiliations, used his art to reflect the life around him.

Just now, even more than before the war, I feel the need to be in the cities among my fellow men. This is where our place is. We must take part in the whole misery that is to come. We must surrender our heart and our nerves to the dreadful screams of pain of the poor disillusioned people. . . . Our superfluous, self-filled existence can now be motivated only by giving our fellow men a picture of their fate and this can be done only if you love them.[25]

The Night, which has its source in Beckmann's drawings of wartime operating rooms in Flanders, is a ghastly recording of physical torment that takes place not in a medieval torture chamber but in the here and now of somebody's attic. The hoodlums and assassins have arrived. The man with the soldier's cap pulled over his eyes shuts out any witnesses by pulling down the shade. The deed must be performed secretly and silently: even the victim's last scream has been choked and the old gramophone has been muffled. The only source of light is a single candle, a symbol of hope, burning next to the nude buttocks of the bound woman. This lone standing candle—another one has fallen over—somehow sheds enough light on the scene so that each person and object is clearly defined with the "objectivity of the inner vision."

There is nothing romantic or tenuous about this murder. In reaction against the feverish hot colors and thick brushstrokes of the Expressionists, Beckmann painted this canvas thinly in cold colors and approached his monstrous subject with a surgical clarity, registering each heinous action with careful objectivity. These men could be executioners carrying out the sentence from a Kafkaesque trial, taking charge of a night without morning. They and their victims are depicted with careful attention to specific details that reinforce the gruesomeness of the scene by divorcing

the actors from a familiar context, just as in a nightmare a single detail may be invested with more horror when it is isolated from a normal background. Yet the presence here of certain details—the hands bound to the window frame, the blue corset, the torturer's pipe—situate the atrocity in a realistic locale, thus intensifying its horror.

Unlike Pablo Picasso's *Guernica* (1937; Museo del Prado, Madrid), which represents only the victims of human brutality, Beckmann's *Night* discloses the perpetrators as well. His premonitions were uncannily accurate. After recording his vision of the brutal murder in *The Night,* he looked outdoors and used a similarly agitated composition for *The Synagogue,* a painting of the 27 building that would be burned to the ground seventeen years later, during the infamous Kristallnacht, while scenes similar to those in *The Night* took place all over Frankfurt.

The bright pink synagogue is topped by an onion-shaped cupola. This spherical green shape is the central object in the picture, to which the eye keeps returning. The whole composition is again based on the Gothic zigzag line; the bottom of the synagogue forms the first chevron and the wooden fence the second, with the cupola crowning the intersection of both lines. The curve of the waxing moon repeats the convex bulge of the cupola, as do the other rounded shapes, such as the small balloon behind the telephone wires, the streetlamps, the kiosk, the toy trumpet (or is it a dunce's cap?) hanging down in the immediate foreground. The painter must have looked out at this scene from a window, past the Egyptian-looking cat on the windowsill. No vertical or horizontal lines steady this painting, which consists solely of acute angles. The synagogue and other buildings seem to be shaking; the whole city is aquiver, as if during an earthquake or a bombing. The buildings, especially the synagogue, are lit up, but the windows look like empty eye sockets. The city is silent. The doors are closed. The streets are empty except for three drunken merrymakers who climb up the narrow street toward the only escape route; soon the scene will be completely deserted.

Even life in the circle of Beckmann's family yielded no relief from anxiety. In *Family Picture* six disparate people are compressed into 29 a small, crowded, low-ceilinged room. The artist himself, clutching a horn and wearing bright yellow shoes, lies on a narrow piano bench. Next to him stands his wife, whose gray face is reflected in an oval mirror and whose state of undress reminds one immediately of the bound woman in *The Night.* Frau Tube, Beckmann's mother-in-law, is seated at the table, hiding her face in her large hand. A sister-in-law stares out into the room, while a servant reads the newspaper at right. Peter Beckmann, the son, is stretched out on the floor, and a mysterious, small, crowned figure enters the space on the left from behind the piano. This personage—possibly related to the mysterious king in the central panel of *Departure,* 50 painted some twelve years later—functions in Beckmann's iconography as a symbol of the painter himself. At any rate, only the cramped physical space is shared by this uncommunicating group. Any more meaningful contact seems impossible. Indeed, Beckmann was living apart from his family when this was painted.

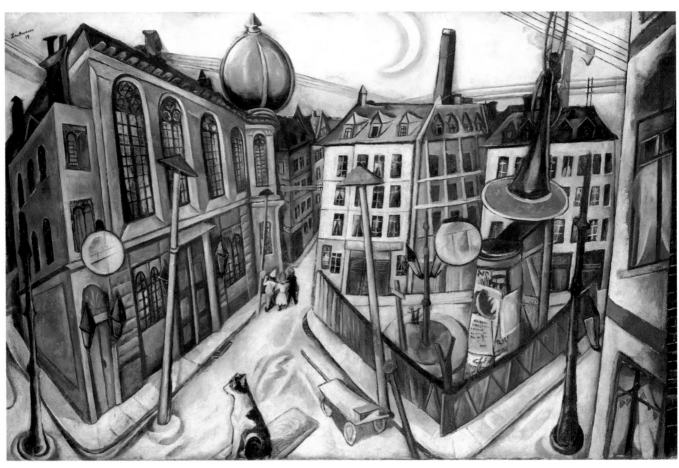

27

28

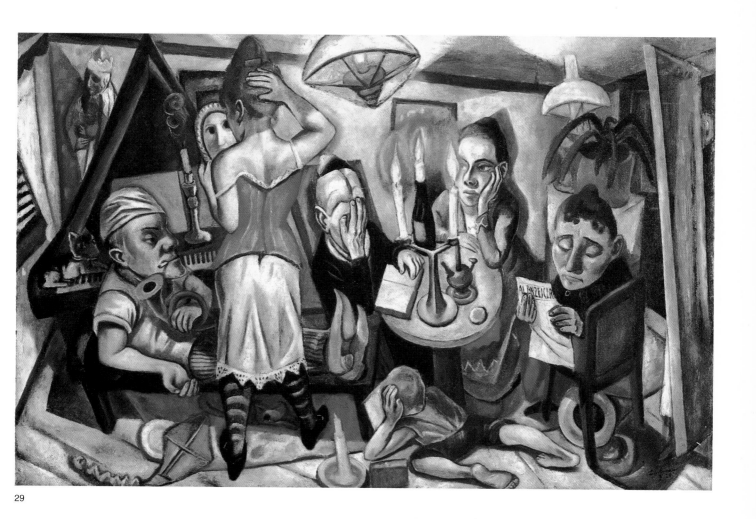

29

27. *The Synagogue,* 1919
Oil on canvas, 35½ x 55⅛ in. (89 x 140 cm)
Städtische Galerie im Städelscher Kunst-
institut, Frankfurt

28. Synagogue on Börsenplatz, Frankfurt,
Germany, c. 1910

29. *Family Picture,* 1920
Oil on canvas, 25⅝ x 39¾ in. (65.1 x 100.9 cm)
The Museum of Modern Art, New York; Gift of
Abby Aldrich Rockefeller

30

31 *The Dream* is also a picture of anxiety and estrangement. Again we find a strange assemblage of people compressed into an attic, but the static scene is quieter and calmer than in *The Night*. A blind beggar grinds his hand organ and blows a trumpet. A mutilated, lame, and blind prisoner has climbed a ladder and holds a fish that confronts the trumpet's bell. At the bottom a drunken maid rolls on the floor and in her dream fondles a cello clasped between her legs. Above her is a horribly crippled clown, and in the center of it all, with hand outstretched, is an innocent country girl, sitting on her trunk and holding her toy clown. The whole thing (titled *Madhouse* when it was first reproduced, in 1921[26]) is a pantomime of misery, madness, and crime. Its complex symbols—ladder, fish, trumpet, hand organ, doll, guitar, cello, lamp, and mirror, as well as mutilated extremities—suggest an allegorical meaning to the confusion.

30 Beckmann's interest in Northern Gothic painting apparently led him to *The Nailing to the Cross*, a panel of the Karlsruhe Passion by the Master of the Karlsruhe Passion, which seems to be the prototype for *The Dream*.[27] The unexpected peasant boy kneeling on the cross and staring out at the spectator in the Karlsruhe panel occupies precisely the same place—both formally and psychologically—as the similar-looking girl in Beckmann's *Dream*. The sleeping maid has assumed the position of the soldier tying the rope at

30. Master of the Karlsruhe Passion
The Nailing to the Cross, from the Karlsruhe Passion, n.d.
Oil on wood, 26 x 18½ in. (66 x 47 cm)
Staatliche Kunsthalle, Karlsruhe, Germany

31. *The Dream,* 1921
Oil on canvas, 73⅛ x 35 in. (182 x 91 cm)
The Saint Louis Art Museum; Bequest of Morton D. May

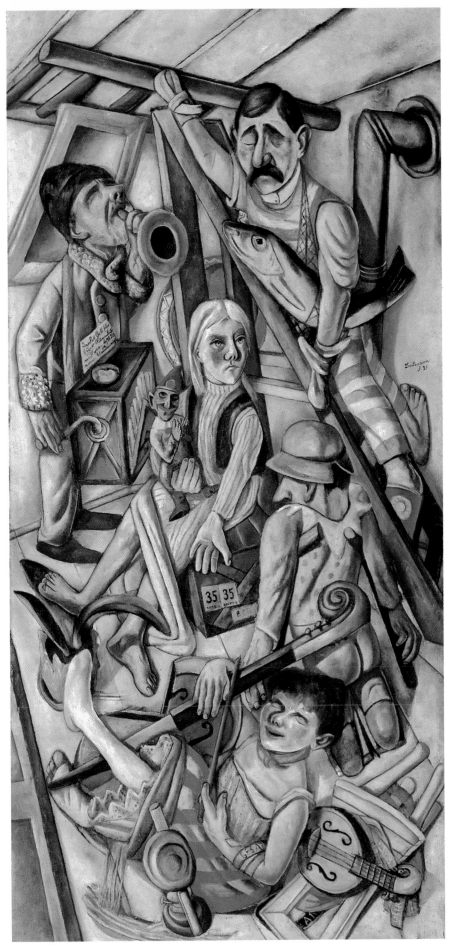

the bottom of the picture. Less striking but perhaps even more telling is the parallel between the man driving the nail into Christ's hand on the upper right and the man with his hands cut off in a similar position in Beckmann's canvas—significantly, the torturer has become the victim in the twentieth century. The diagonal ladder, an important symbol both of agony and of achievement in Beckmann's iconography, has taken the place of the cross. It is also probable that the fish in *The Dream* has been substituted for the Christ in the medieval panel. The fish traditionally has been a symbol for Christ as well as of fertility and creativity, and Beckmann, with his preference for fluid, shifting symbolism open to many interpretations, could easily have merged the mystical and the sexual by including the fish.

Having endowed *The Dream* with precise structure and meticulous detail, Beckmann belongs to the mainstream of modernism that has its parallels in the writings of Franz Kafka and James Joyce, in the paintings of Giorgio de Chirico and Francis Bacon, and the films of Michelangelo Antonioni and Ingmar Bergman. In all their work the feeling of human estrangement is intensified by the use of hard physical reality. Beckmann's endeavor to grasp the phantom world by means of a precise rendering of visible reality had other parallels in the Germany of the early 1920s. It was, in fact, part of a general postwar reaction against the romantic— often even apocalyptic—prewar movements of Expressionism, Orphism, and Futurism. A new aesthetic of palpable reality had been developing in Europe ever since Picasso drew a precise, realistic portrait of Ambroise Vollard in 1915. In Italy the disquieting sense of mystery of Pittura Metafisica was succeeded by the calmer and more contemplative objectivity of Valori Plastici.[28]

In Germany, where Expressionist abstraction had been established as an avant-garde aesthetic before World War I, it was Beckmann who, after the war, appeared as one of the founders of a new realism that would isolate the object in order to create a sense of heightened awareness.[29] Beckmann emphasized his opposition to Expressionism by warning his students in Frankfurt against communicating their emotional states directly, without transmuting them into a rational, formal structure. Always opposed to naturalism, he characteristically referred to Expressionism as "reversed naturalism."[30]

Aware of this new realism, G. F. Hartlaub, director of the Kunsthalle in Mannheim, coined the term Neue Sachlichkeit (New Objectivity) for a projected exhibition that was to

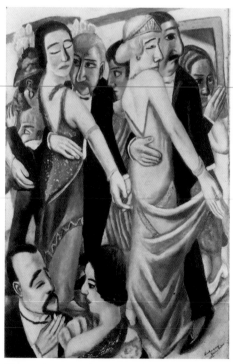

bring together representative works of those artists who in the last ten years have been neither impressionistically relaxed nor expressionistically abstract. . . . I wish to exhibit those artists who have remained unswervingly faithful to positive palpable reality, or who have become faithful to it once more. . . . Both the "right wing" (the Neo-Classicists, if one so cares to describe them), as exemplified by certain things of Picasso . . . etc., and the "veristic" left wing to which Beckmann, Grosz, Dix, Drexel, Scholz, etc., can be assigned, fall within the scope of my intentions.[31]

The New Objectivity would have been unthinkable without Expressionism. Like Expressionism it made use of distortion, exag-

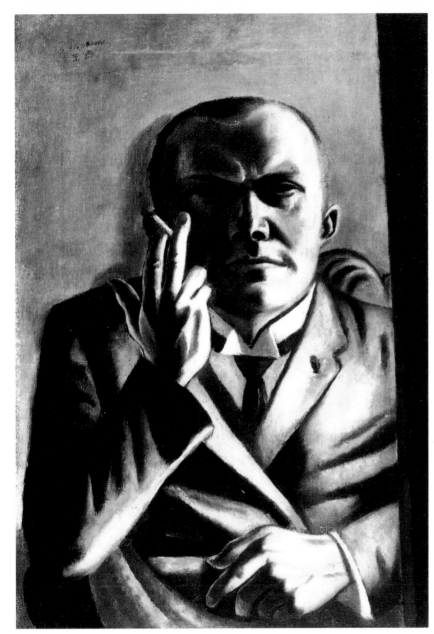

33

geration, and shock, but rather than being used to express the artist's own subjective emotion—which often led to abstraction—these devices were applied to the presentation of the object itself. Beckmann wrote a letter to Reinhard Piper in 1922 relating his gratification that his paintings and prints were able to prove to a number of people that "this Expressionist business was really only a decorative and literary matter, having nothing to do with vital feeling for art. . . . One can be new without engaging in Expressionism or Impressionism. New and based on the old laws of art: plasticity in the plane."[32]

The new realism, with its bitter and often dry take on reality, was to dominate much of German literature (Erich Maria Remarque is a good example) and art between the wars. Hartlaub saw in it resignation and cynicism on the one hand and enthusiasm for observed reality on the other. The outstanding artists in Hartlaub's Mannheim exhibition of 1925 were Beckmann, Otto Dix, and George Grosz. Although Beckmann certainly engaged in social criticism, he did so less exclusively than Dix and Grosz. Beckmann's unique construction of space and personal symbolism transports paintings like *The Night, The Synagogue,* and *The Dream* far beyond verist reportage and social comment. Even when painting a sober and matter-of-fact portrait like that of Frau Tube, his mother-in-law (1919; Staadtische Kunsthalle, Mannheim, Germany), he achieved monumentality by means of an unfailing sense of composition, especially the way he related the sitter to the room, solid volume to engulfing space.

In his splendid *Self-Portrait with a Cigarette,* Beckmann painted 33 himself as a robust, solid figure with hard contours. Within the narrow surrounding space he cut out a niche for himself. Posing somewhat haughtily, he seems ready simultaneously to take the stand as a witness of his time and to explore his own self. "For the visible world in combination with our inner selves provides the realm where we may seek infinitely for the individuality of our own souls," he was to write years later in his "Letters to a Woman Painter."[33]

32. *Dance in Baden-Baden,* 1923
Oil on canvas, 39⅜ x 25⅝ in. (100 x 65.6 cm)
Staatsgalerie Moderner Kunst, Munich

33. *Self-Portrait with a Cigarette,* 1923
Oil on canvas, 23¾ x 15⅞ in. (60.2 x 40.3 cm)
The Museum of Modern Art, New York; Gift of
Dr. and Mrs. F. H. Hirschland

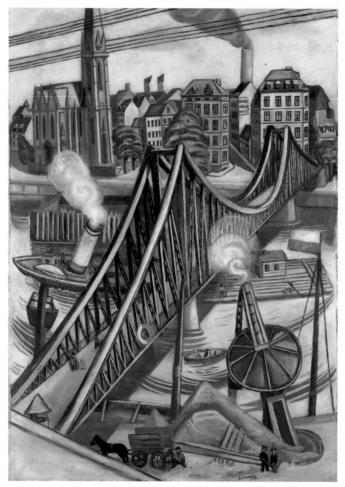

34

A painting like *The Iron Footbridge,* possibly inspired by his "grand old friend Henri Rousseau, that Homer in the porter's lodge,"[34] is a great deal bolder than any Rousseau in its composition. The picture is so high-keyed in its hues that it almost looks bleached. The eye does not enter the painting slowly but races into it, pursuing the light blue iron bridge—that memento of the early machine age—and jumping diagonally across the picture to the riverbank with its depressing nineteenth-century houses, fuming smokestack, and mechanistic Gothic Revival church. In order to enhance the primitive quality of the painting, Beckmann has put some of the telephone wires in front of the steeple and some behind it. This also serves to constrain the tower, which thrusts its way out of the picture at this point.

The dirty gray Main River is filled with traffic: a barge, tugboat, a smaller vessel, and the floating public swimming pool with its preposterous green fence. In the foreground is an odd-looking crane, reminiscent of similar contraptions in the distant landscapes of early Flemish panels, as well as a horse cart and a little building site. All kinds of machines rattle and puff and crowd out the people, who look more like ants than human beings and appear to be trapped wherever they are. Much as Cézanne did in many of his landscapes, Beckmann made this scene inaccessible: we are confronted with a painting, not invited to enter into the cityscape.

Space, so frightening in its emptiness in *Landscape with Balloon,* has now been filled up with equipment that may be utilitarian but

35

34. *The Iron Footbridge,* 1922
Oil on canvas, 47⅜ x 33⅜ in. (120.5 x 84.5 cm)
Kunstsammlung Nordrhein-Westfalen,
Düsseldorf

35. *Der Eiserne Steg (Iron Footbridge),* 1923,
published 1924
Drypoint, plate: 8½ x 10¾ in. (21.7 x 27.3 cm)
The Museum of Modern Art, New York;
A. Conger Goodyear Fund (by exchange)

36. *Carnival (Pierrette and Clown),* 1925
Oil on canvas, 63 x 39½ in. (160 x 100 cm)
Städtische Kunsthalle, Mannheim, Germany

37. *Double Portrait: Carnival, Max Beckmann
and Quappi,* 1925
Oil on canvas, 63 x 41½ in. (160 x 105.5 cm)
Kunstmuseum der Stadt Düsseldorf

is surely also bizarre. Beckmann fortified himself against the void by using aggressive, thrusting objects to construct his space. For the same purpose of defense against the void, he used framing devices such as the telephone wires at the top of the picture.

Beckmann's position as a leader of the New Objectivity in the Mannheim exhibition coincided with a more general recognition, for the second time in his life. In 1924 a major monograph with essays by four outstanding critics and scholars—Curt Glaser, Wilhelm Fraenger, Wilhelm Hausenstein, and Julius Meier-Graefe—had been published in Munich.[35] In 1925 Beckmann was appointed professor at the Städelsches Kunstinstitut in Frankfurt, to teach the master class. He was well established in Frankfurt now and counted among his friends such men as the director of the museum, Georg Swarzenski; the important art critics Hausenstein and Meier-Graefe; and the publisher of the *Frankfurter Zeitung*, Heinrich Simon, who was soon to write a brief monograph on the artist.[36] In 1925 Beckmann also had another important exhibition, at Cassirer's in Berlin, to be followed in 1926 by his first one-man show in New York, at J. B. Neumann's New Art Circle. Also in 1925 he obtained a divorce from Minna and married the young violinist Mathilde Q. von Kaulbach (known as Quappi), daughter of the celebrated Munich portraitist Friedrich von Kaulbach.

In a painting of that time, *Carnival (Pierrette and Clown)*, the artist masked himself by wrapping his face in a white cowl[37] and

36

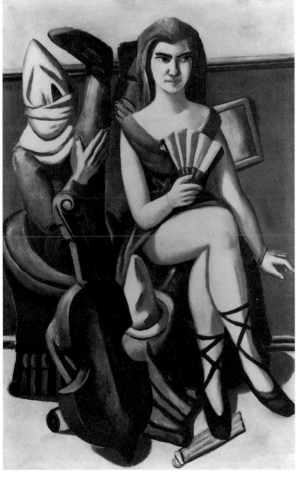

36

37

showed himself sitting with his legs stretched high in the air—a rather odd position. His new wife stands nearby, dressed as Pierrette, paying no attention to the buffoon beside her. Although the artist often spoke of his happiness in the new marriage, this picture with its icy colors and its sense of wary distance conveys little sense of joy.

When depicting himself Beckmann often hid behind various disguises. His quest for self-understanding meant that he constantly held up a mirror to study himself, but rarely did he disclose his soul. Instead, he used the armor of concealment. He is the master of ceremonies, the announcer of the act, the ringmaster. He appeared with musical instruments—usually brass—such as the saxophone and trumpet. He might be dressed as a prisoner or in full evening wear or as a clown. He might hold handcuffs or a crystal ball or show himself painting or modeling in clay. *Self-Portrait in Sailor Hat* is done in the light palette typical of the early 1920s, but a red undercoat is allowed to show through, resulting in the fiery red outlines around the hands and other areas that give the painting an aspect of mystery. This tension between the strength and solidity of the figure and the mystery of the color and what Beckmann frequently referred to as the anxiety of space is so basic to his work that it rarely fails to appear.

Beckmann's compositions achieved a classic monumentality during the late 1920s, clearly structured by means of large areas of color and simple geometric shapes. One of the most powerful examples of this new grand style, and one of the great self-portraits in the history of art, is *Self-Portrait in Tuxedo,* undoubtedly the most magisterial portrait of his oeuvre. A powerful, full-sized figure, self-conscious, brutal, and proud, the artist confronts his public with great self-confidence. Whereas diagonals were essential to his paintings of violence of the immediate postwar years, a severe structure of horizontal and vertical planes make up this rigidly frontal, highly formal portrait. Facing the viewer in a pose reminiscent of the classical contrapposto of heroic statues,[38] Beckmann presented himself at the height of his powers. At that time he also published a treatise in which he pronounced that artists were of "vital significance to the state" and rather ostentatiously described artists as "new priests of a new cultural center" in a "conscious and organized drive to become God ourselves."[39]

The colors of this self-portrait are chiefly black and white. Beckmann needed this contrast of values in order to encompass the dichotomy of black and white and good and evil that is so basic to the Judeo-Christian tradition and to achieve a new unity of opposites in his work. In his 1938 essay "On My Painting," he wrote: "It is the dream of many to see only the white and truly beautiful, or the black, ugly and destructive. But I cannot help realizing both, for only in the two, only in black and white, can I see God as a unity creating again and again a great and eternally changing terrestrial drama."[40]

In a cityscape of the same year Beckmann looked down on Genoa and its harbor and took visual possession of the panoramic view below him. *The Harbor of Genoa* was one of the most recent paintings to be included in the retrospective exhibition of his work,

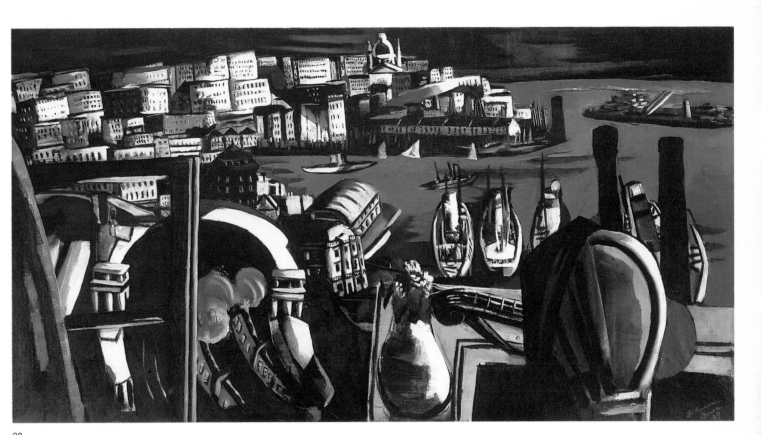

38

39

38. *The Harbor of Genoa,* 1927
Oil on canvas, 35½ x 66⅝ in. (90 x 169 cm)
The Saint Louis Art Museum; Bequest of
Morton D. May

39. View of the Beckmann gallery, National-
galerie, Berlin, 1933

PAGE 40
40. *Self-Portrait in Sailor Hat,* 1926
Oil on canvas, 39⅛ x 28 in. (100 x 71 cm)
Private collection, New York

PAGE 41
41. *Self-Portrait in Tuxedo,* 1927
Oil on canvas, 55½ x 37¾ in. (141 x 96 cm)
Busch-Reisinger Museum, Harvard University
Art Museums, Cambridge, Massachusetts;
Association Fund

directed by Hartlaub, that opened in Mannheim in February 1928. Included in this major show were 106 oils, 56 drawings, and 110 prints. The catalog contained some statements by Beckmann about his art and his aesthetics. The Mannheim show was followed two years later by another important retrospective, arranged by Georg Schmidt, in the Kunsthalle in Basel. In March 1931 eight of his paintings were included by Alfred H. Barr Jr. in *German Painting and Sculpture* at the Museum of Modern Art, New York, and an exhibition of his current work appeared at J. B. Neumann's gallery in that city. The same year Justus Bier assembled an important Beckmann show at Hanover's avant-garde Kestner Gesellschaft, and in 1932 the Nationalgalerie in Berlin established a special room to house its recently acquired collection of ten Beckmann paintings—an honor given to very few living artists.

All this time Beckmann continued teaching at the academy in Frankfurt. Even when he was living in Paris during the winters (beginning in 1929), he would return to teach one week of every month. He inspired the students in his classes (which were kept small); they "had no doubt that the world really looked the way Beckmann saw it" because "if, by the power of his insight, an artist has given a face to the world, then the face is there."[41] Beckmann would guide his students to find their own answers. He would make them aware of their dreams and fantasies and then help them transform these images into pictorial compositions that depicted real objects. The purpose of painting was not to present a fragment of nature but to use the forms of nature to communicate ideas. In

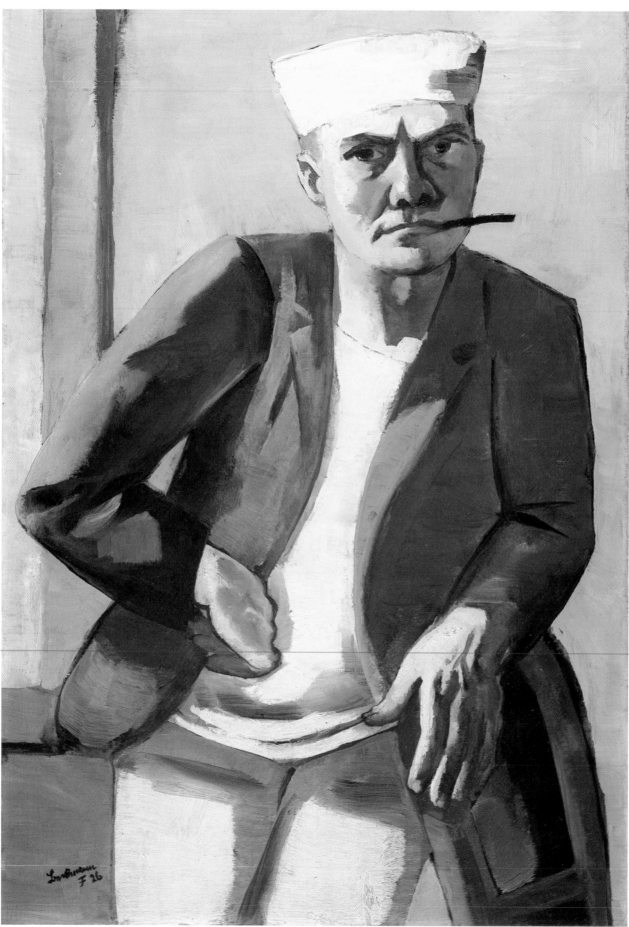

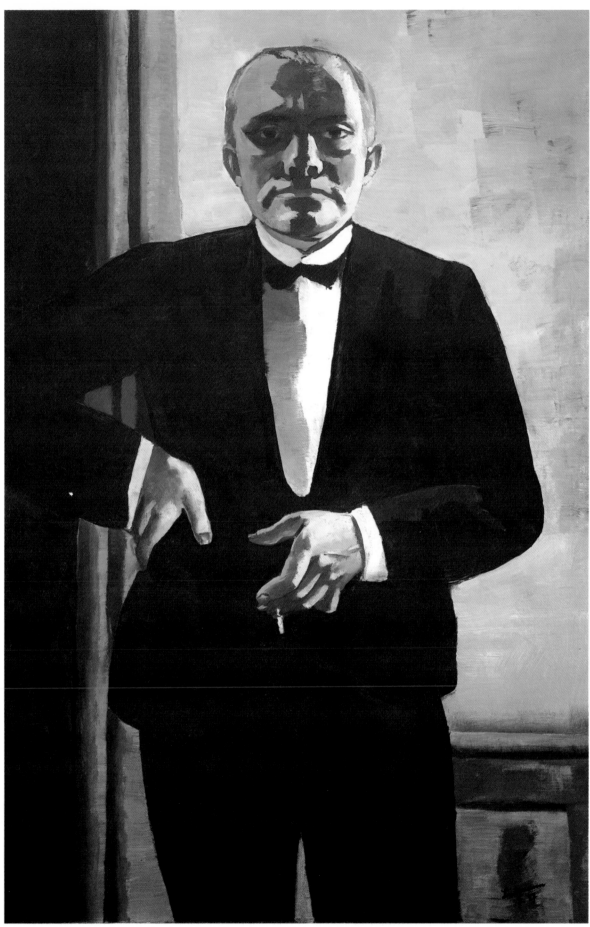

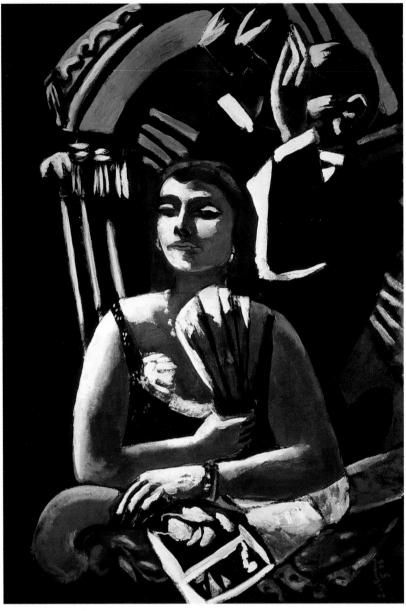

42

order to help his students progress to this advanced stage, he constantly encouraged them to go to museums and to study whatever art of the past was most congenial to their personalities.

Beckmann's familiarity with world literature was extensive, and he frequently would recommend specific reading to his students. This might be work by Gustave Flaubert and Stendhal; Charles Baudelaire, E.T.A. Hoffmann, and Jean Paul; or Friedrich Hölderlin, James Joyce, and John Dos Passos. Beckmann might, in fact, cite a book like Dos Passos's *Manhattan Transfer* (1925) to illustrate his concept of the simultaneity of events.[42]

The development of Beckmann's art toward simplified form and beautifully painted surfaces at this time has often been ascribed to his prolonged stay in Paris, where he now had his own studio on the avenue des Marronniers. In the spring of 1931 he held his first solo exhibition in Paris, at the Galerie de la Renaissance, which included work going back to 1907. Waldemar George, the eminent

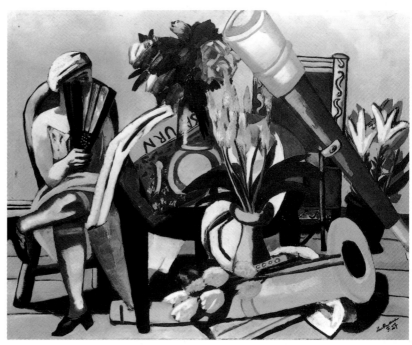

43

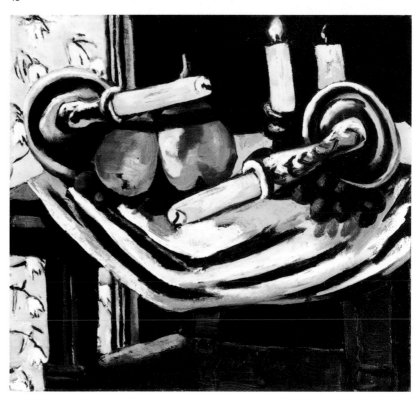

44

42. *The Loge,* 1928
Oil on canvas, 47⅝ x 33½ in. (121 x 85 cm)
Staatsgalerie Stuttgart, Stuttgart, Germany

43. *Large Still Life with Telescope,* 1927
Oil on canvas, 55½ x 81½ in. (141 x 207 cm)
Staatsgalerie Moderner Kunst, Munich

44. *Still Life with Fallen Candles,* 1929
Oil on canvas, 22 x 24¾ in. (55.9 x 62.9 cm)
The Detroit Institute of Arts; City of Detroit
Purchase

critic, wrote the introduction to the catalog, and Wilhelm Uhde, Ambroise Vollard, and Picasso seem to have admired the show.[43] Two of his paintings were acquired by the Musée du Jeu de Paume—a very unusual event for a foreigner. Beckmann now made plans for a permanent move from Frankfurt to Paris, a move that was prevented by the worsening political situation in Germany.

Beckmann's interest in French painting is clearly evident in *The Loge,* a variant of Pierre-Auguste Renoir's *Loge* (1874; Courtauld

Institute Galleries, London). Whereas the nineteenth-century painting is lovely, charming, and gay, the twentieth-century version is hard and dramatic. If the couple in Renoir's box suggests a comparison with growing flowers, Beckmann's mechanical pair, with their pistonlike movements, belongs to the machine age. The woman, holding her fan and rearing back slightly, gazes over the balustrade at the performance. Open to all glances, she is nonetheless impersonal and aloof, enigmatic and sphinxlike. Her escort pays no attention to the scene. Armed with large opera glasses that hide his face, he examines the audience. These glasses resemble the barrels of a gun, and even though they conceal him he also projects outward with them, which gives him a most ambivalent character. There are highlights of white, purple, and yellow, but Beckmann's painting is mostly velvety black. Like Diego Velázquez, Francisco Goya, and Edouard Manet, Beckmann was always preoccupied with exploring the properties of black. In *The Loge* a few restricted colors indicate the ornate architecture of the theater, establishing the simplified volumes of the space.

Like Renoir's *Loge,* which was among his chief entries in the first Impressionist show of 1874, Beckmann's *Loge* became a milestone in his career. Awarded honorable mention in the 1929 Carnegie International, it again brought Beckmann to the attention of the art world. America's leading art critic, Henry McBride, spoke of an "impact from his brushes that even Picasso might envy."[44] The same year Beckmann had his first painting enter an American collection when W. R. Valentiner bought *Still Life with Fallen Candles* from the Galerie Alfred Flechtheim in Berlin for the Detroit Institute of Arts. Here again, black is the dominant color and sets the tragic mood. In contrast to the Cubists, who would transform a woman with a guitar into a still life, Beckmann endowed his still lifes with human qualities. The table here has become a stage, and no shadows are allowed to obscure the austere integrity of the mysterious event. This simple still life, like Cézanne's *Black Clock* (c. 1870; private collection), is a memento mori: the two largest candles are fallen heroes, while the other two stand in mourning, guarding against the "dark black hole" of space and infinity behind them.

44

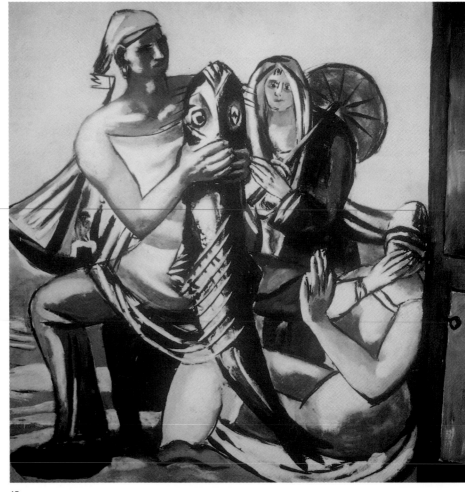

45

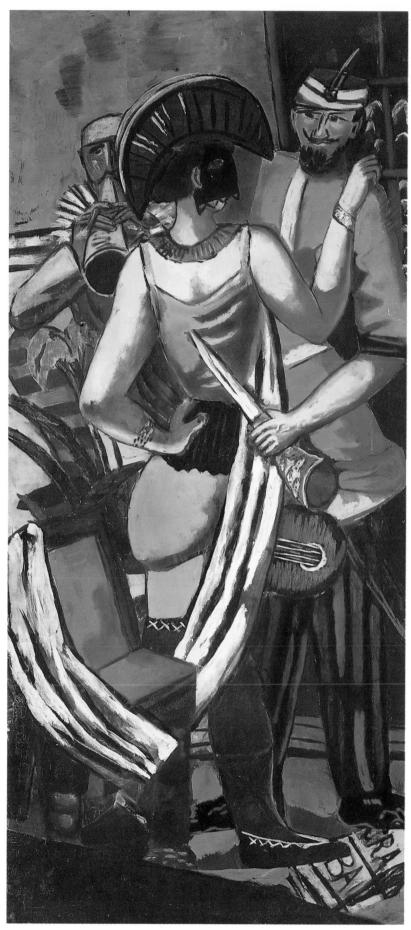

45. *The Big Catfish,* 1929
Oil on canvas, 49¼ x 49⅜ in. (125.3 x
125.5 cm)
Private collection

46. *Carnival in Paris,* 1930
Oil on canvas, 82⅝ x 39⅜ in. (214.5 x
100.5 cm)
Staatsgalerie Moderner Kunst, Munich

46

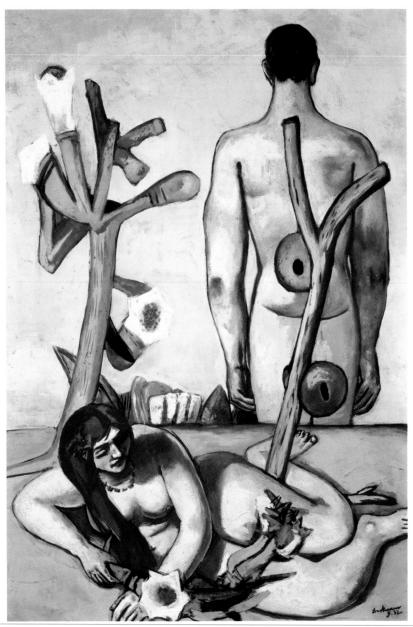

47

Indeed, a year later he painted a similar composition on a larger scale and introduced a book—a script, as it were—with the word *Eternity* on its title page (*Large Still Life with Candles and Mirror,* Staatliche Kunsthalle, Karlsruhe, Germany).

Symbols of sexual virility—the candle, the fish, the horn—occur with great frequency in Beckmann's work, but rarely are they as overt as in *The Big Catfish.* An athletic young fisherman has emerged from the sea, and grasping a gigantic fish with both hands he displays this amazing catch to two women. The fish, which has huge eyes, is at the very center of the painting. One of the women approaches with eager curiosity, while the other averts her face from this phallic apparition, covering her nose and eyes as she leans against a wooden door that seems out of place in this beach scene. Significantly, it is this refusing woman in the blue bathing

47. *Man and Woman,* 1932
Oil on canvas, 69 x 47¼ in. (175 x 120 cm)
Private collection; Courtesy of Thomas Ammann Fine Art, Zurich

48. *Self-Portrait in Hotel,* 1932
Oil on canvas, 46½ x 19¾ in. (118.5 x 50.5 cm)
Westdeutsche Landesbank, Düsseldorf

45

suit who is tied compositionally to the blue fish and completes its curvature.

Carnival in Paris, painted in 1930, again consists of large planes 46 of flat, opaque color, and there seems little doubt that during these years in Paris the work of Matisse in particular exerted influence on Beckmann's palette. Here he used a simple system of intense complementaries: the scarlet red of the man's blouse and the chair are played against the insistent shades of green in the lady's dress, the wall, and the carpet. All of this color is compressed into a narrow space between a black diagonal at lower left and the black door behind the soldier—a spatial construction used quite frequently by Beckmann during this time. In this carnival scene the woman wears a Greek helmet above her mask, while her mustachioed escort sports the red blouse and striped pants of a hussar. Most startling is the complex interplay of the dancers' arms, a wheellike motion that is brought to a stop by the tin horn in the cavalier's left hand. But this carnival trumpet is also a sword with which he stabs his masked lady in the back, while a clown blows a hollow accompaniment to this ominous love scene.

After about 1930, as the political situation in Germany became progressively more alarming, Beckmann's paintings became increasingly introverted. He began to seek greater understanding of himself through ancient myths; though he never stopped portraying elements from the real, objective world, he concentrated on "this Self for which I am searching in my life and in my art."[45] In 1932 Beckmann produced *Man and Woman,* which is probably 47 the closest he ever came to Surrealism. A sensuous young woman reclines in the foreground of a desert landscape; self-satisfied as a cat, she is flanked by two fantastic desert plants and contemplates an exotic flower. Behind a small rise in the earth looms the large figure of a man, seen from the back. Standing rigidly at attention, he is turned away from the viewer as well as the woman, in an attitude of expectation, just as the artist might wait during a fallow period (analogous to this dry scene) for the fructifying force of inspiration.

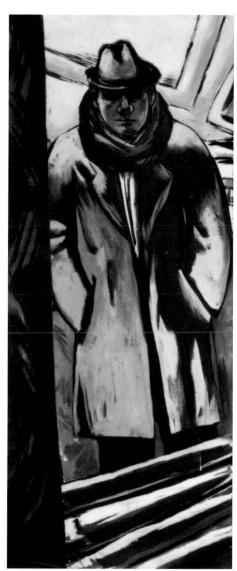

In *Self-Portrait in Hotel,* Beckmann, too, stands waiting, hud- 48 dled in his overcoat, his hat pulled down over his face, his muffler high around his neck, and his hands in his pockets. He looks cold, an impression intensified by the cold gray tones of the paint. Again, as in the earlier *Self-Portrait in Sailor Hat,* he allowed the underpaint to show through, resulting in a tension between this red primer and the gray top layer. Beckmann squeezed himself into a narrow vertical space, as if behind the invisible barrier of the picture plane, which makes access impossible. All the strength and apparent self-confidence of the *Self-Portrait in Tuxedo* of five years earlier seem to have vanished as he stands here, hunched over, dejected, alone. Those who knew Beckmann well have often remarked on both aspects of his personality: the imposing figure with a sense of his own importance, and the withdrawn, extremely lonely individual. In 1932, with the imminent rise to power of the Nazi Party, the artist faced an increasingly hostile world in which art would be threatened and life itself uncertain.

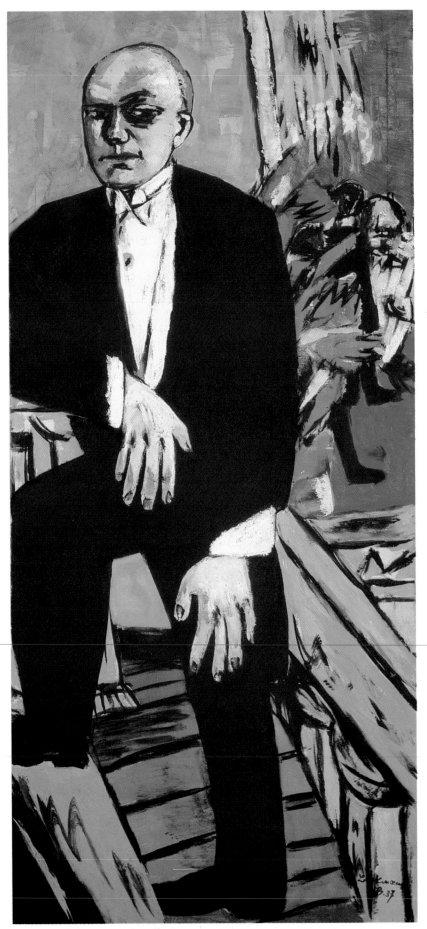

49

3 Berlin

With the Nazi takeover in 1933, Beckmann was promptly decried as a "degenerate artist" and immediately dismissed from his teaching position at the Städelsches Kunstinstitut. He left Frankfurt, where he felt his fame made him too visible a target, and moved to Berlin, which gave him the shelter of a big city, at least for a while. During these years he began his investigations of Greek and Norse mythology, seeking universal prototypes in the ancient myths. It was in 1933, when moving to his apartment in the Graf Spee Strasse in Berlin, that Beckmann worked in the triptych format as part of his endeavor to show past, present, and future simultaneously.

Beckmann's interest in the triptych did not come solely from his preoccupation with German medieval art. The triptych had been revived by the nineteenth-century German artist Hans von Marées, whom Beckmann admired, especially for his *Hesperides* (c. 1888) and *The Golden Age* (1879–85; both Bayerische Staatsgemäldesammlungen, Munich). Subsequently the triptych form was used in Germany by Max Klinger, Franz von Stuck, and Fritz von Uhde. Emil Nolde painted his highly Expressionist triptych of Mary of Egypt in 1912 (Kunsthalle, Hamburg). Outside Germany, Edvard Munch and Félix Vallotton executed three-panel compositions, and even Gauguin's masterpiece, *Where Do We Come From? What Are We? Where Are We Going?* (Museum of Fine Arts, Boston) is conceptually a triptych. Although most of these triptychs are no longer religious in connotation, they were conceived as large public statements, and often were hieratic in character.

Beckmann began his great triptych *Departure* in May 1932 [50] while he was still in Frankfurt; he took the half-finished panels to Berlin with him and finished the triptych there on December 31, 1933.[46] Although he began his famous lecture "On My Painting" (1938) by asserting that he had never been politically active in any way, Beckmann was deeply troubled by the rise of fascism in Germany and *Departure* reflects the cruelty of the time. But it is far more universal than one commentator's description of it as the "symbolic portrayal of the artist's departure from his homeland

49. *Self-Portrait*, 1937
Oil on canvas, 75¾ x 35 in. (192.5 x 89 cm)
The Art Institute of Chicago; Gift of Lotta
Hesse Ackerman and Philip Ringer

and the reasons for it," in which he "symbolized the cruelty of the Nazi torturer on the left-hand side and the madness and despair of the era on the right. . . . To avoid trouble with the Nazis, Beckmann hid the picture in an attic and affixed the cryptic label *Scenes from Shakespeare's Tempest.*"[47]

Such explanations are of little help in deciphering the triptych. Not only was *Departure* completed in 1933, long before Beckmann left his homeland in 1937, but the artist himself pointed out that it "bears no tendentious meaning." And surely his reference to the *Tempest* was no mere ruse; he did, in fact, re-create the world of Caliban and Prospero. *Departure*, as Alfred Barr aptly stated at the time the triptych was shown as a memorial to Beckmann at the Museum of Modern Art in January 1951, is "an allegory of the triumphal voyage of the modern spirit through and beyond the agony of the modern world."[48]

In the left panel an executioner in a striped shirt swings an apparently murderous weapon that, at closer inspection, turns out to be an ineffectual bludgeon with fish heads coming out of the maul.[49] A woman, whose location in the panel recalls that of the drunken maid in *The Dream,* has her wrists bound and kneels over a glass globe. Poised directly above the woman's trussed form, and enigmatic in the context of this painting of sadomasochistic brutality, the enormous still life seems erotically charged. Placed on a cart, it seems to be a prop, belonging either on a stage or in an artist's studio.[50] At the upper left of the panel appears a man who has been bound and discarded in a trash can—an image that suggests a device used effectively a generation later by Samuel Beckett in *Endgame* and *Play*. Next to this discarded figure is a hideously mutilated man, gagged and trussed to a column, who lifts his bloody stumps of arms like great emblems of torture. The columns themselves suggest that the action might be taking place in some ornate palace or temple.

The right panel seems to represent a narrow stage with stairs, or does the bellboy indicate that we are in the corridor of a hotel? (Among the few remarks that Beckmann made that might shed light on the symbolism here is that the bellboy is the modern messenger of fate.) In this panel the central place is occupied by a woman who holds a lamp. Tied to her, standing on his head, is a male companion, suggesting an obsessive relationship. On the couple's left is a horrible dwarflike Eros; on the right the blindfolded bellboy holds a thin green fish whose sly expression parallels the one on the woman's face; this fish is also in contrast to the large fish grasped by the masked figure in the central panel.

The darkness, the crowded space, the oppressiveness and horror of the side panels are in total opposition to the bright, open, colorful center panel, with its broad midday light. "Out of this earthly night of torment and mental anguish, the figures of the central panel emerge into the clear light of redemption and release, embarked for Eternity."[51] Floating in their barge on the luminous blue sea are figures whose scale is larger, as

31

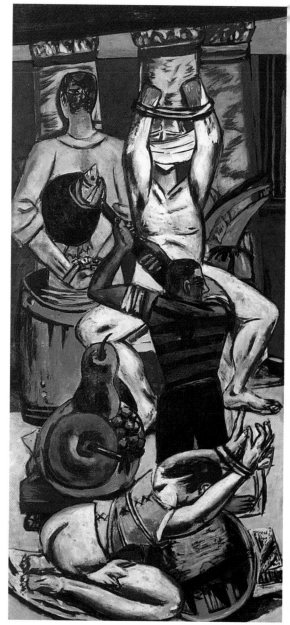

50

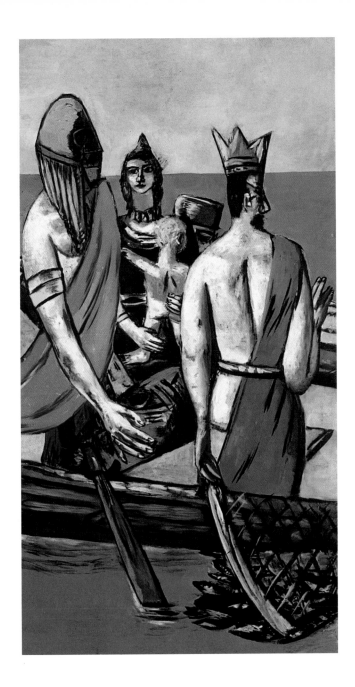

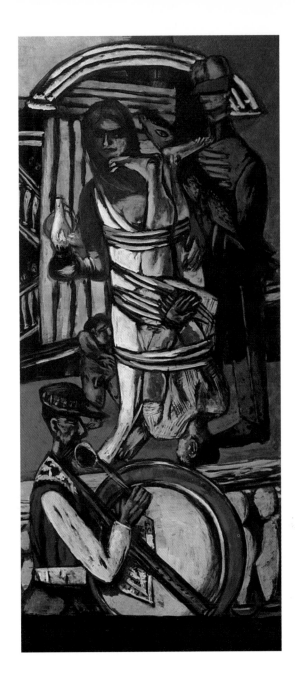

50. *Departure,* 1932–33
Oil on canvas, center panel: 84¾ x 45⅜ in.
(215.3 x 115.2 cm); side panels: 84¾ x 39¼ in.
(215.3 x 99.7 cm), each
The Museum of Modern Art, New York; Given
anonymously (by exchange)

their pace is slower, than those on the flanking panels. On the left, standing erect and holding a large fish between outstretched arms, is a large masked personage.

In the center of the boat a woman, who bears a clear resemblance to portraits of Quappi, holds a child. Her frontal stance and detached look give her the appearance of universality. Beckmann, who, like many of his great contemporaries—Joyce, T. S. Eliot, Thomas Mann, and Picasso come to mind—often quoted from classical sources, has given this woman a classical appearance, with the almond-shaped eyes and Phrygian cap of fifth-century Greece. And if the woman recalls classical antiquity, the fisher king on the right reminds us of the Middle Ages. With his three-pointed crown and angular profile he evokes the saints and kings on the portals of Reims and Bamberg and in the choir of Naumburg.

The infant, who may represent the hope embodied in youth, is

at the very center of the three-panel composition. Next to the mother and child is the largely hidden male figure, who has been interpreted as a Joseph accompanying the central Madonna and Child; as Charon steering the boat to an unknown port; and as a veiled self-portrait.[52] The fisher king, pulling in a full net and gazing across the sea into space, raises his right hand in a magnificent gesture that rejects the despair of the side panels and at the same time points ahead to an unknown future.

One friend remembers Beckmann's telling her that "the King and Queen have freed themselves, freed themselves of the tortures of life—they have overcome them. The Queen carries the greatest treasure—Freedom—as her child in her lap. Freedom is the one thing that matters—it is the departure, the new start."[53] Interpretation of this great triptych—or of any of Beckmann's later paintings, which are so deeply involved in a personal symbolism—can probably be carried no further. *Departure*, as James Thrall Soby once said, is "one of the major works of art our century has thus far produced," and he pointed out that it "often hung in the Museum of Modern Art on the same floor with Picasso's *Guernica*. Between them, the two so different works furnish proof that modern art's symbolism can be as forceful, moving and impressive as anything produced in earlier centuries."[54]

Even though the symbolism of the great works of our century can be "forceful, moving and impressive," it is also different in kind from earlier symbolism. Painting can no longer communicate with the same clarity as did works in the past. The meaning of the iconographic program on the walls of San Francesco in Arezzo, Italy, or on the ceiling of the Sistine Chapel or in the Ajanta caves in India becomes clear once the key to the imagery has been found. But it is an essential aspect of modern art that even when identifiable forms are retained much of the work's meaning must remain unintelligible. (And that is even truer of *Departure* than it is of *Guernica*, a painting that makes reference to a specific historic event.) At a time when newspapers, magazines, radio, and television aim to communicate in instantly understandable "sound bites" and other predigested information, the poet and painter set up all kinds of traps and impediments precisely to resist such easy comprehension. Ambiguity and unpredictability, so germane to the modern spirit, must find expression, as so clearly stated by Meyer Schapiro: "The artist does not wish to create a work in which he transmits an already prepared and complete message to a relatively indifferent and impersonal receiver. The painter aims rather at such a quality of the whole that, unless you achieve the proper set of mind and feeling towards it, you will not experience anything of it at all."[55]

Beckmann himself would have been in complete agreement with Schapiro. When Curt Valentin wrote to Beckmann that clients wanted an explanation of *Departure*, the painter replied:

Take the picture away or send it back to me, dear Valentin. If people cannot understand it of their own accord, of their own inner "creative sympathy," there is no sense in showing it. . . . The picture speaks to me of truths impossible for me to put in words and of which I did not ever know before. I can only speak to people who, consciously or unconsciously, already carry within them a similar meta-

51

physical code. Departure, yes departure, from the illusions of life toward the essential realities that lie hidden beyond. . . . It is to be said that *Departure* bears no tendentious meaning—it could well be applied to all times.[56]

Beckmann always wished his paintings to remain private and personal, to communicate a feeling but not necessarily to be understood in the literal sense. The woman and child in the center of *Departure,* the fisher king with his royal gesture, the man tied to the woman searching with her lamp are allusive symbols whose precise meaning must remain as enigmatic—or perhaps as multi-faceted—to the viewer as it was to the artist. This is why the interpreter who believes he has discovered the key to Beckmann's iconography is likely to find that it may open one door but not all.

As a rule, if someone asked Beckmann about the meaning of one of his triptychs, he was likely to whistle through his teeth, point to the ceiling with his thumb and say, "You'll have to ask the one up there."[57] With this evasive response, he again seemed to be looking at himself as a divine spokesman for the great Christian drama. In the contrast between the central panel and the side wings of *Departure* can be seen another of his dramatic interpretations of dark and light, hell and heaven, the damned and the blessed, sin and guilt on the one hand and redemption on the other. This is certainly one level on which the symbolism of *Departure* and a great many of Beckmann's works appears to take place; it must be emphasized, however, that this is not the only level.

51. *Brother and Sister,* 1933
Oil on canvas, 52½ x 39 in. (135 x 100.5 cm)
Private collection, United States

During his years in Berlin, Beckmann became increasingly involved with a highly personal and disquieting symbolism. There is an eerie and highly romantic landscape painted at that time: a night view of the Walchensee during a fog, with the crescent moon sitting on top of jagged, pyramidal mountains. The rocks in the foreground resemble a shoal of fishes in rapid upward movement. This small, lonely landscape conveys the feeling of shifting earth, water, and mountains. Communicating the artist's highly charged emotions almost directly, it is the closest Beckmann ever came to painting an Expressionist picture.

At the same time Beckmann found the composure to paint as carefully structured a picture as *Self-Portrait with Black Cap*. The semicircle of the black cap forces the viewer's eye down to the face, and we follow the sharp vertical line that separates light from dark

52

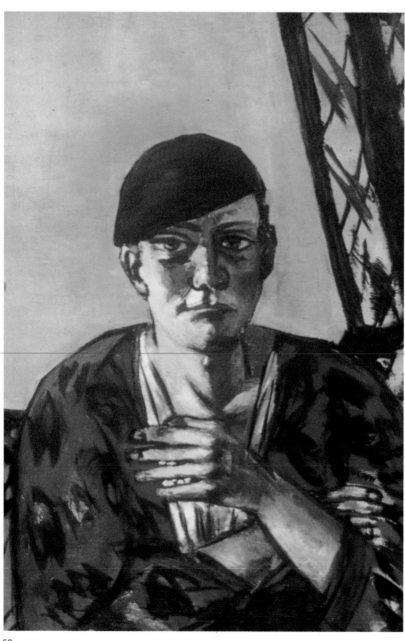

53

54

52. *Walchensee: Moon Landscape in the Mountains,* 1933
Oil on canvas, 29½ x 30¾ in. (75 x 78 cm)
Museum Ludwig, Cologne, Germany

53. *Self-Portrait with Black Cap,* 1934
Oil on canvas, 39½ x 27½ in. (100 x 70 cm)
Museum Ludwig, Cologne, Germany

54. *The Organ Grinder,* 1935
Oil on canvas, 68⅞ x 49⅜ in. (175 x 120.5 cm)
Museum Ludwig, Cologne, Germany

along the nose, chin, neck, and the knuckles of the left hand through the exact center of the picture. While the left hand establishes the horizontal balance, the right hand is concealed in a manner traditional in self-portraits. Beckmann once referred to this painting as "Gilles," suggesting a dialogue with Antoine Watteau that continued Beckmann's ongoing conversation with the art of the past. The languid character of Watteau's sad and gentle clown—the famous Pierrot of the Italian comedy, who is everybody's poor fool—appealed to Beckmann at this time. He portrayed himself romantically, with large, liquid, almost hypnotic eyes, but unlike Watteau's famous Gilles, whose arms hang down

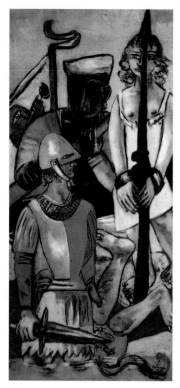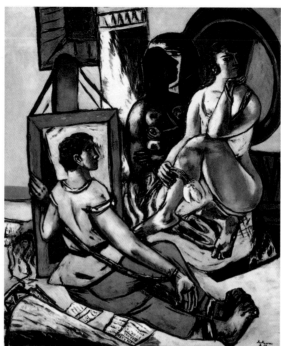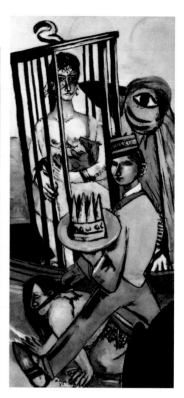

55

loosely, Beckmann's arms are folded in self-protection. The gesture of the folded arms denotes the artist's desire to withdraw, despite presenting himself in such an open, frontal view. For all its pride, this is the portrait of a vulnerable man. Evident in all his self-portraits is Beckmann's ambivalence between his desire to retreat into himself and his need for public adulation. The painting is made all the more stunning by its boldness of composition. No longer needing a window frame to anchor the figure, he placed the bust against an empty, soft, purplish gray background; a pink Matisse-like pattern gives dramatic vitality to the painting, which like so many of Beckmann's self-portraits is composed with a limited palette.

The heavy application of pigment in the face of the *Self-Portrait with Black Cap* prevails also in a revealing painting of 1935, *The Organ Grinder*. This large picture, painted soon after the completion of *Departure*, is even more veiled in its meaning than the triptych. A woman standing on the upper left seems to wish to retain her newborn child. Next to her is a warlike female figure with a wooden leg, who carries a black bowl and a bundle of spears. The uniformed organ grinder himself, sitting below the bellicose female, is placed between a sensuous woman and a cryptically inventive figure on the lower right—a blindfolded woman, covered with blue eyes, who holds a great anchor or arrow. Was Beckmann implying that this figure feels with her body what she cannot see with her eyes? Again he left no clues to decode these images.

The painting was later called *Lebenslied* ("The Song of Life") by its owner. But this is a ritualistic rather than a sentimental song, and ritual became increasingly important to Beckmann as a source of imagery to convey emotion. The rhetoric of his pre–World War I scenes made way during the 1920s for a more realistic treatment

54

55. *Temptation,* 1936–37
Oil on canvas, center panel: 78¾ x 67 in. (200 x 170 cm); side panels: 84¾ x 39⅜ in. (215.5 x 100 cm), each
Bayerische Staatsgemäldesammlungen, Munich

56. Paintings by Max Beckmann in the *Degenerate Art* exhibition, Munich, 1937

of tragedy, one that actually bordered on reportage. Now, in the late 1930s, Beckmann's feelings about morality and criminality, abuse and constraint, affirmation of life and anxiety about death, found expression in a stylized imagery. This is evidenced again in his second triptych, *Temptation,* inspired by Gustave Flaubert's 55 *Temptation of Saint Anthony* (1874) but probably related more closely to an East Indian legend he was reading at the time. In this highly colorful triptych, figures are again chained, caged, and gagged. This parable of man's impotence and frustration was completed toward the end of Beckmann's stay in Berlin, when he himself acted as forcefully as possible.

As early as 1933 Beckmann's paintings were included in several of the exhibitions defaming modern art that began to tour Germany years before the notorious *Degenerate Art* show opened in 56 Munich in 1937. As the attacks on culture increased in violence, many of Beckmann's pictures—ultimately a total of 590 works—were removed from museums throughout Germany. On July 18, 1937, Adolf Hitler opened the brutally propagandistic *Great German Art Exhibition* at the new Haus der Deutschen Kunst in Munich, decreeing that the type of art in the exhibition was not to change for the duration of his thousand-year Reich. He also

56

declared that any artist who would persist in distorting nature would do so either to defy the state, in which case criminal punishment would be in order, or because of some malfunctioning of the eye, which, being hereditary, would call for sterilization.[58] The very next day Professor Adolf Ziegler opened the *Degenerate Art* exhibition—which included painting and sculpture by Germany's finest contemporary artists, including Otto Dix, Wassily Kandinsky, Paul Klee, Franz Marc, Emil Nolde, and Kurt Schwitters—by calling it an accumulation of monstrosities by the insane, the insolent, the incompetent, and the degenerate.[59] Ten of Beckmann's major paintings were in the exhibition. The day after the opening Beckmann and his wife took the train to Amsterdam, where Quappi's sister was living. Beckmann never returned to Germany.

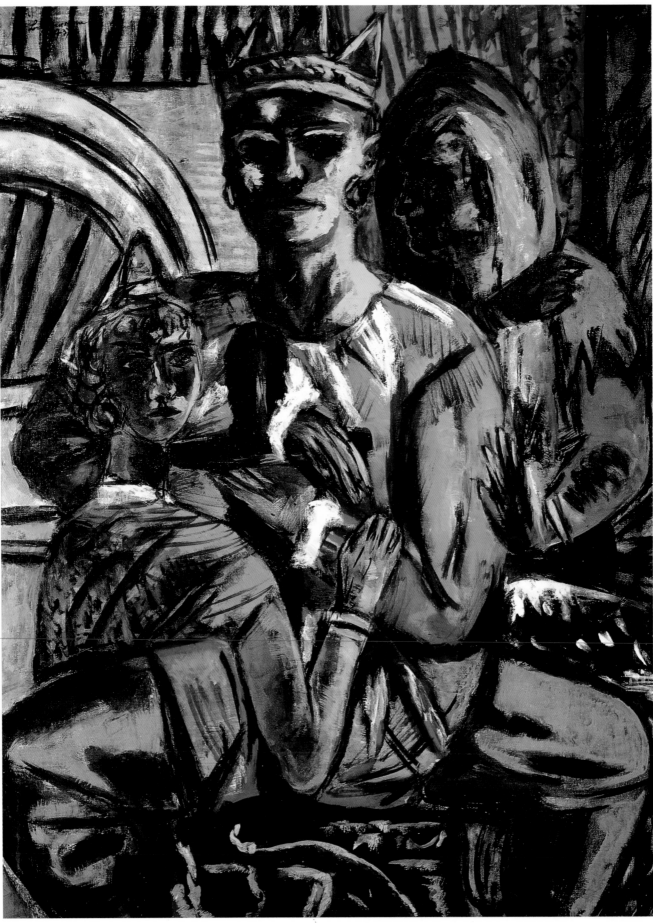

4 Amsterdam

In Amsterdam the Beckmanns rented a modest walk-up apartment in a narrow gabled house on the Rokin in the center of the city. In the attic above them was a tobacco storeroom with a skylight; Beckmann converted this into his studio and worked there almost obsessively, often for ten hours a day. The Beckmanns' life in Amsterdam had few distractions, and they were to become even more isolated during the Nazi occupation. Although Beckmann loved being among people, his primary need was for the privacy of his studio. He had to be able to return from the day's or night's excursions to the complete quiet of his retreat. He liked having his studio close to his living quarters and was glad that this was possible in Amsterdam, as it had been in Berlin (and as he was to manage again in both his New York residences). The secluded years in the Netherlands were certainly among his most productive ones, and the *A,* for Amsterdam, stands with his signature in over two hundred paintings.[60]

Soon after his flight to the Netherlands, Beckmann made a carefree and enchanting portrait of Quappi. *Quappi with White Fur* recalls the gracefulness of his first portrait of her, in 1925, but instead of the inhibited elegance revealed in that earlier picture, his wife is now endowed with worldly sophistication. This is a cosmopolitan traveler, not a refugee. Clad in a stylish coat with white fur, topped by a delightful little hat whose veil only emphasizes the provocative black eyes, holding a flower and Butshy, the Beckmanns' Pekinese, Quappi faces the spectator in self-assured calm; the dashingly painted orange blooms behind her accentuate her elegance. What saves this painting from becoming a fashion plate is the inventiveness of the composition, the painter's insight into his model, and, above all, the sheer beauty of the paint on canvas.

Such gaiety, however, is the exception in Beckmann's work of this period. *The King,* finished in 1937, conveys a moody sense of foreboding. Dressed in a rich maroon garment, the king sits in a hierarchic position, his legs spread in a manner that reminds us of the earlier *Portrait of N. M. Zeretelli* or the later drum-beating savage in *Blindman's Buff.* Crowned, wearing a royal collar, and

58

57

2

69

57. *The King,* 1933–37
Oil on canvas, 53½ x 39½ in. (135.9 x 100.3 cm)
The Saint Louis Art Museum; Bequest of
Morton D. May

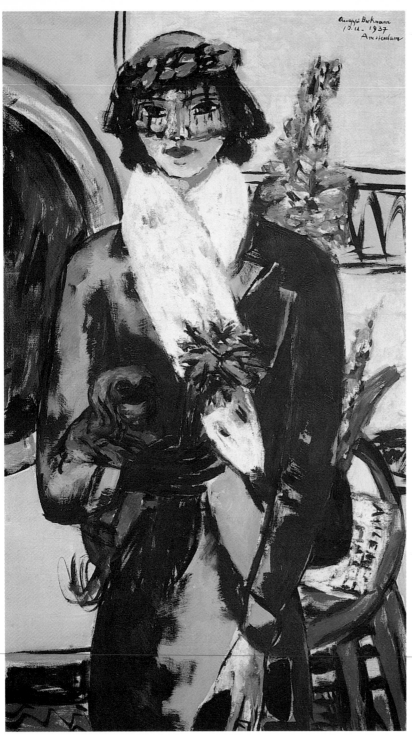

58

bedecked with earrings, this man of unquestionably royal bearing supports himself on his large sword, staring at the viewer from cavernous eye sockets. His features identify the monarch as an only slightly disguised self-portrait. The woman on his right, who peers at us with an apprehensive, childlike expression, resembles Quappi; the older, hooded woman veiled in dark shadow behind the king brings to mind portraits of Minna Beckmann-Tube, the artist's first wife. Her gestures suggest rejection and denial.

The large wheel on the left has been interpreted as a reference to the Buddha, who put the wheel of sacred teaching into motion.[61]

58. *Quappi with White Fur,* 1937
Oil on canvas, 42⅞ x 25½ in. (111 x 65.5 cm)
Artothek, Peissenberg, Germany

59. *Apache Dance,* 1938
Oil on canvas, 67 x 59½ in. (171.5 x 151 cm)
Kunsthalle Bremen, Bremen, Germany

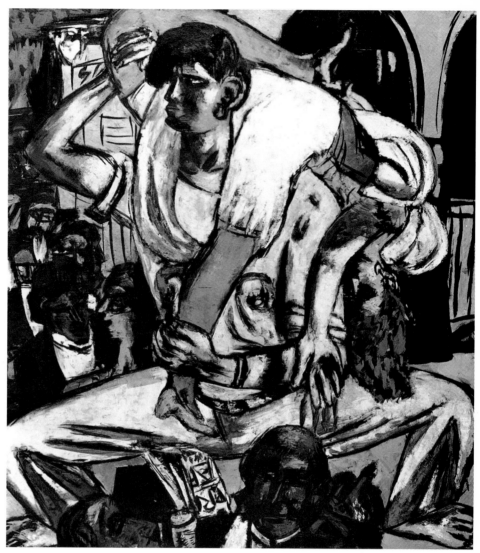

59

During his years in Amsterdam the artist spent much of his time studying Buddhist and Hindu texts. These writings he felt might be helpful in his constant search for his self, a search "that drives us along the eternal and never-ending journey we must all make."[62] It is not surprising that he would turn to the two certainties in human existence, in *Birth* and *Death*.

Birth is composed in the manner of a traditional Renaissance scene of the birth of the Virgin. But the central position here is occupied by a large, rather grotesque mother with swollen breasts and legs spread apart. Her attendants—the small clown on the left, the stately midwife holding the baby, the odd entourage of exotic personages on the right—locate the confinement room in the crammed backstage of a circus. That this is specifically a gypsy circus is made clear by the lettering in mirror image on the left and the poster spelling CIRCUS ROMANY at the very center. Beckmann was always captivated by the circus, that site of make-believe and disguise where actuality, ritual, and illusion constantly shift to provide a deeper reality nourished by fantasy.

60, 61

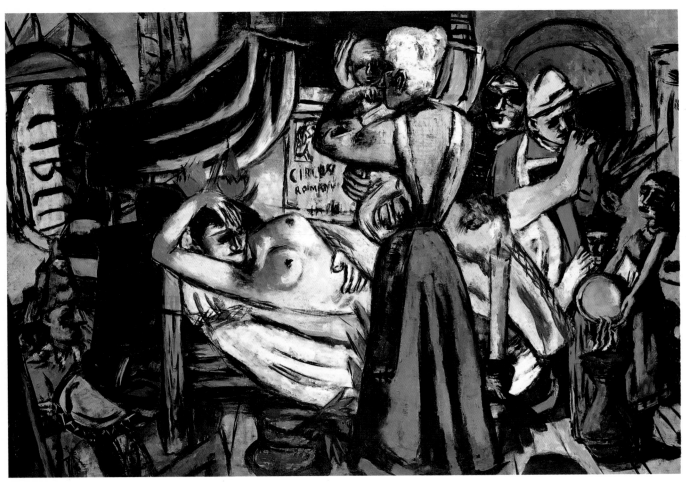

60

While the birth takes place in a circus tent, the death occurs on a nightclub stage. The men at upper right, singing their dirge in ensemble, seem to be reflected in a ceiling mirror (common in cabaret decor)—why else would they stand upside down, hanging from the canopy? The leader of this chorus has multiple faces and sings out of several mouths. The dead woman is attended by other figures extending from the ceiling: a disembodied head, a horrible little winged monster surrounding a huge horn, various disjointed demons of an inventiveness that recalls the bestiary of Hieronymus Bosch, whose work would leave Beckmann in a "shattered state."[63] When contemplating the woman riding away on the back of a fish as well as the other mourners in this unholy ritual, we are transported to a modern Walpurgis Night, in which Beckmann managed simultaneously to evoke moods of disgust and desire. He himself spoke of being impelled by visions that would sing to him in the night: "Stars are our eyes and the nebulae our beards. . . . We have people's souls for our hearts. We hide ourselves and you cannot see us, which is just what we want when the skies are red at dawn, at midday, and in the blackest night."[64]

59 Less visionary and much less disturbing is *Apache Dance*. Here

60. *Birth*, 1937
Oil on canvas, 47⅝ x 69½ in. (121 x 176.5 cm)
Preussischer Kulturbesitz, Berlin

61. *Death*, 1938
Oil on canvas, 47⅝ x 69½ in. (121 x 176.5 cm)
Preussischer Kulturbesitz, Berlin

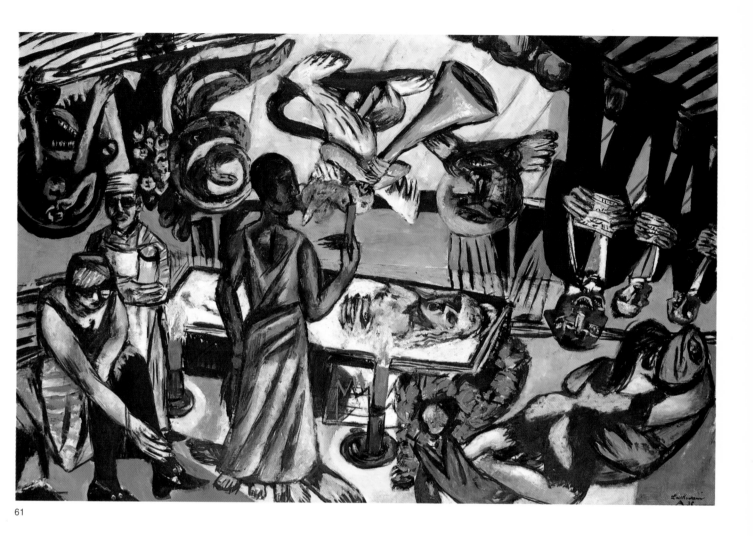

61

the artist takes us onstage in the cabaret. A heroic dancer stands with legs spread wide. The powerful legs—typical of many of Beckmann's male figures at this time, be they kings, clowns, dancers, or musicians—support a huge torso. The Apache has thrown the girl over his giant shoulders. There is a garish clash of colors between his chartreuse shirt and her fiery red stockings, echoed clangorously by the flames of her red hair. The girl, limp as a rag doll, seems to enjoy being carried off by her assertive partner.

Although Beckmann felt at home in large cities, he always had a need for the countryside, for trees and flowers, fields and open sky. His diary mentions frequent excursions by train or bicycle to the Dutch seashore or countryside. Throughout his life, from his pictures of sea and beach painted in 1905 to those made on the Mills College campus (in Oakland, California) in 1950, he frequently turned to landscape. In his landscapes, as in his still lifes, he was able to relax from the tensions so evident in his bristling figure compositions. This relaxation at times resulted in somewhat softer pictures; perhaps because he was less directly involved in the theme, they reveal his compositional devices and formal means more clearly and add to our insight into his creative formulation.

During the late 1930s Beckmann also depicted himself in prison garb, holding a horn to his ear and listening to whatever secret message it might have to tell. Although the artist's torso is strong and powerful, the painting transmits a sense of dark mystery and veiled desperation. There is a suggestion of a synaesthetic relationship between the sound of the horn and the insistent orange-black alternation of the stripes on the artist's uniform. The cellist Frederick Zimmermann—a great admirer of Beckmann and a collector of his work—pointed out in a lecture delivered to the Max Beckmann Society in 1962 that the painter knew the sound and pitch of every musical instrument and painted each in order to evoke a specific response.[65]

Beckmann, who visualized himself as spokesman and conscience of his time, has placed his head in this painting against a golden frame, which the writer Stephan Lackner interpreted as "a square halo."[66] Lackner, who has owned this magnificent self-portrait since Beckmann completed it in 1938, recalls his father's asking Beckmann at the time, "Have you always looked so imposing, or is your head, too, the result of artistic effort?" Beckmann nodded pleasantly and replied, "Oh well, you know, after all, aren't all phases of this world of appearances the result of our own efforts?"[67]

The well-to-do young writer Stephan Lackner had first met Beckmann in Frankfurt in 1927 and began buying his work in 1933, at the very time the artist needed support most urgently.

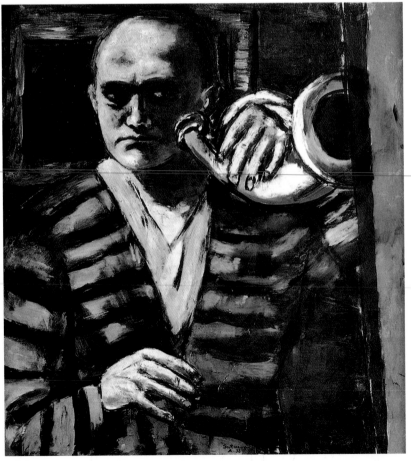

62

62. *Self-Portrait with Horn,* 1938
Oil on canvas, 42¼ x 39¾ in. (107 x 101 cm)
Dr. Stephan Lackner, Santa Barbara, California

63. *Portrait of Stephan Lackner,* 1939
Oil on canvas, 28½ x 21 in. (73 x 54 cm)
Dr. Stephan Lackner, Santa Barbara, California

They met again in Paris in 1937, at which point Lackner "bought an even dozen of Beckmann's canvases, among them the tremendous triptych *Temptation.*"[68] Beckmann illustrated Lackner's play, *Der Mensch ist kein Haustier,*[69] with seven lithographs, and Lackner acquired paintings by Beckmann at regular intervals for a specific monthly rate. They remained close friends, visiting each other in Amsterdam and Paris until Lackner left in 1939 for America, where they met again in 1950.[70]

During the last prewar years Beckmann hoped to leave the narrow confines of Amsterdam, which he had always considered only a temporary abode. He vacillated between attempting to settle in Paris and contemplating a move to America. His exhibition in New York at Curt Valentin's new Buchholz Gallery in January 1938 had considerable critical acclaim here as well as on its tour to Kansas City, Los Angeles, San Francisco, Saint Louis, Portland, and Seattle. In July 1939 *Temptation* was awarded the first prize of one thousand dollars at the Golden Gate World's Fair in San Francisco. In March he had written to his old friend J. B. Neumann: "I should like to look into your suggestion to come to America for good, since this country has always struck me as the fitting place to spend the last part of my life. If you could manage to have me called to a post somewhere, even a very modest one, I would leave at once, in spite of the fact that I like it here quite well."[71]

This letter was written from Paris, where Beckmann was preparing an exhibition at the Galerie Poyet. A bit later he felt that per-

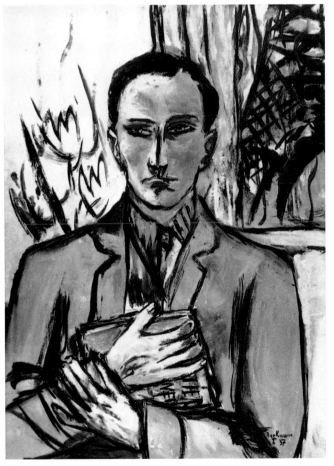

63

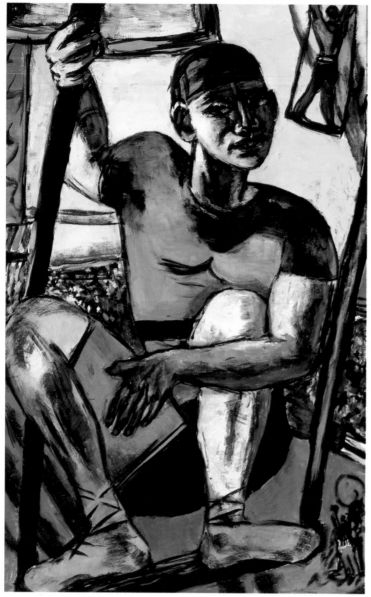

64

haps Paris might be the best place to stay. That May he announced to Neumann, "Now I am back in Paris, where I shall settle finally in August."[72] But war broke out before the show could take place, and since Beckmann was in danger of internment, he returned to Amsterdam. He made plans to leave for America, where Daniel Catton Rich had invited him to teach at the Art Institute of Chicago, but the American consul in Amsterdam would not give him a visa. The first entry, May 4, 1940, in Beckmann's published diary mournfully remarks: "America is waiting for me with a job in Chicago, yet the American consulate here issues no visa."[73] A few days later the Nazis were in Amsterdam.

The first sentences in this diary entry read: "I began this new notebook in a condition of complete uncertainty about my own existence and the state of our planet. Wherever one looks: chaos and disorder." At the same time he portrayed himself high in the air in *Acrobat on Trapeze.* Squatting at this dizzying height with a quizzical expression in his almond-shaped eyes, Beckmann faces us

64

64. *Acrobat on Trapeze,* 1940
Oil on canvas, 57⅜ x 35⅞ in. (146 x 90 cm)
The Saint Louis Art Museum; Bequest of Morton D. May

65. *Double Portrait: Max and Quappi Beckmann,* 1941
Oil on canvas, 76⅜ x 35 in. (194 x 89 cm)
Stedelijk Museum, Amsterdam

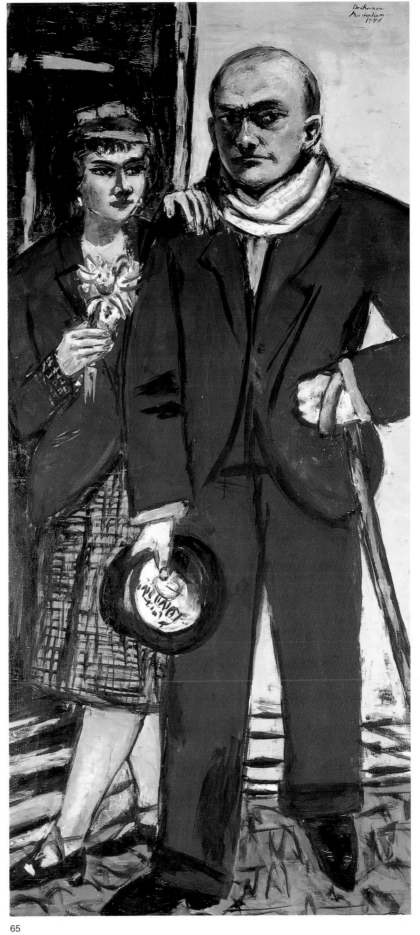

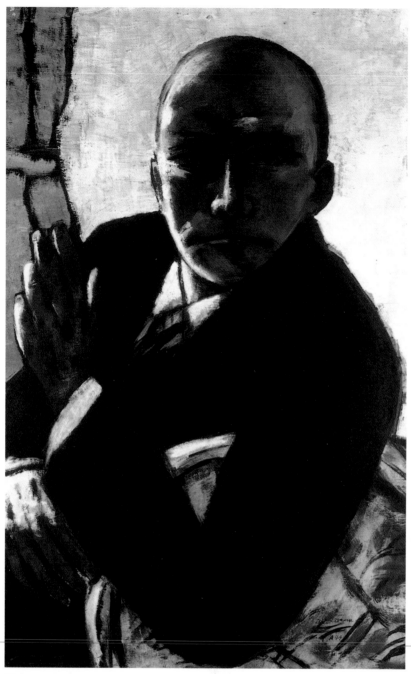

66

in a startlingly close-up encounter in this unlikely spot. Below can be seen the orange floor of the tent and cursory indications of the public. The colors, bluish green heavily outlined against chartreuse, are used with startling boldness. The artist delighted in colors that helped him penetrate inner reality more deeply. But color had to be subordinated to the treatment of form in space. *Acrobat on Trapeze* brings the viewer into almost physical contact with a subject that is pushed up close: man swinging perilously through the void.

If *Acrobat on Trapeze* seems like an apprehensive parable on
65 man's place in the modern world, *Double Portrait: Max and Quappi Beckmann* of the following year is a much more positive and less troubled statement. Here, acting as protector to his young wife, Beckmann stands firmly on the ground. Again he emphasized

66. *Self-Portrait in Black,* 1944
Oil on canvas, 27½ x 23½ in. (95 x 60 cm)
Staatsgalerie Moderner Kunst, Munich

67. *City of Brass,* 1944
Oil on canvas, 41¾ x 59 in. (115 x 150 cm)
Saarland Museum, Stiftung Saarländischer
Kulturbesitz, Saarbrücken, Germany

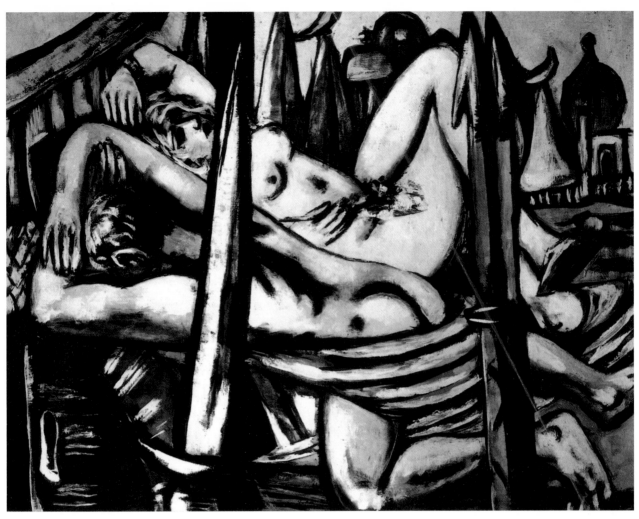

67

his aspiration to worldliness by presenting himself as an elegant gentleman, white scarf around his neck, cane swinging from his wrist, holding a top hat on whose silk lining the word *London* has been inscribed in huge letters. Slightly behind him is Quappi, with her hand placed gently on his shoulder. She stands close to him yet separated; not only is she smaller in scale but she is also protected by the wall of a house, whereas he stands against empty yellow space. In 1945, after the artist had been living in the Netherlands for eight years, this painting was acquired by the Stedelijk Museum in Amsterdam.

In general, Beckmann was little appreciated and very lonely during the war. He lived in partial hiding much of the time and maintained few contacts with Germany. His son, Peter Beckmann, a medical officer in the German Luftwaffe, was able to come to Amsterdam fairly often; the diaries are filled with references to these visits. Through Peter, Beckmann could maintain contact with his friend and dealer in Munich, Günther Franke. Old friends like Lilly von Schnitzler would visit him on occasion, and it was in Amsterdam that the German art historian Erhard Göpel first encountered the artist to whom he would become totally committed. Göpel, with Hans Martin von Erffa, became editor of the large anthology *Blick auf Beckmann*; he also was the founder of the

Beckmann Society and with his wife, Barbara Göpel, wrote the catalogue raisonné of Beckmann's paintings.

In 1944 the Germans attempted to draft the sixty-year-old painter, who had suffered a heart condition for some time, into their depleted army. From then on he filled his diary with apprehensive notices about his heart. But Beckmann lived through the unending air raids and through that terrible last winter of the war with its great frosts, when the Beckmanns were able to heat only one small room in which they slept, cooked, ate, and worked. There was no artificial light; even candles were unobtainable. There was almost no food; even bread was scarce. Yet in spite of cold, malnutrition, and physical exhaustion, Beckmann continued painting; nothing was allowed to interfere with his work. His monumental triptych *Blindman's Buff* was painted during the worst months.

Beckmann was a man who was greatly concerned with physical well-being. He loved to eat and drink well—desires that were probably intensified by the terrible scarcities of the war years—and his diary is sprinkled liberally with entries about the food he ate, the champagne he drank (or would have liked to drink), the cigarettes and cigars he managed to procure. Contemplative thoughts about art, on the other hand, are rare in these diaries, which served primarily to register his activities: the books read, the people seen, the walks taken, the pictures painted, and the meals eaten. Beckmann shrank from verbalizing his feelings about art and giving away secrets.[74] He knew that the meaning of art could not be defined; even so brief a remark as the one made about *Odysseus and Calypso* is more than he was usually willing to say: "In the morning worked too intensively and with much melancholy on Odysseus and Calypso."[75]

In Beckmann's picture Odysseus is most tenderly caressed by the nymph, yet she cannot keep him from pursuing his own thoughts. This is an Odysseus who, even in the arms of the ardent Calypso, knows he must return home to Ithaca. A purple snake winds around his leg, while a fantastic green bird with a large golden beak crouches by his side and a statuesque, sphinxlike cat watches the futile embrace. The beautiful nymph's Greek profile, the meander pattern on the luxurious bed, the sword resting behind the hero's head, and the armor protecting his legs all refer to Homer's epic. But this painting also relates to those poignant carvings of farewell in the fifth-century burial steles of Greece. But it is a modern version: the sense of loss and isolation, the futility of human contact, and the essential solitude of man exist here and now, no longer waiting for the world beyond the Styx. We know that Beckmann identified with the gods of antiquity: arriving in Saint Louis in September 1947, he wrote, "How pauvre 'Odysseus' sits again at his green table"; a little later he appeared at a masquerade party with a black domino over his eyes, announcing facetiously, "I am Jupiter."[76]

In his triptychs Beckmann addressed significant themes and portrayed dramatic action carried out by heroic personages under supernatural guidance. These works stand as evidence that epic painting was still possible in the twentieth century. During his ten

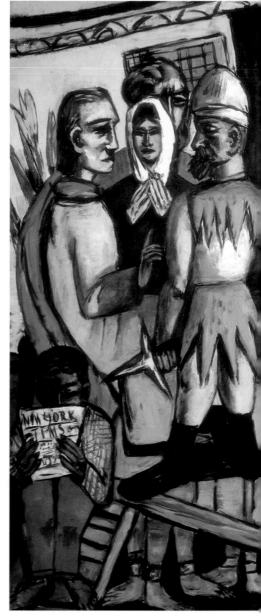

68

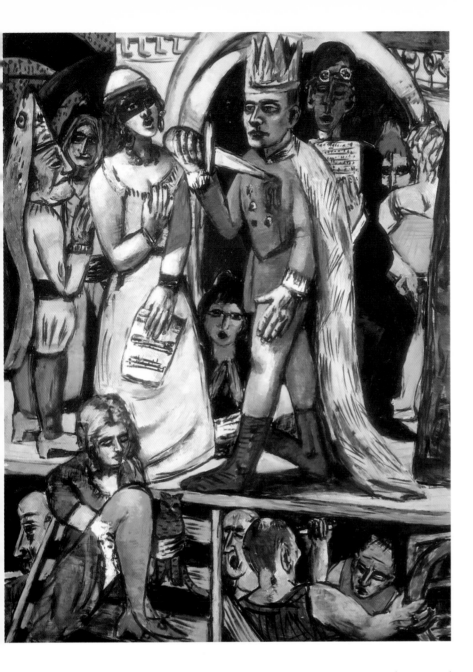

68. *The Actors*, 1941–42
Oil on canvas, center panel: 78½ x 59 in.
(200 x 150 cm); left panel: 78½ x 33 in. (200 x
84 cm); right panel: 78½ x 33 in. (200 x 84 cm)
Fogg Art Museum, Harvard University Art
Museums, Cambridge, Massachusetts;
Gift of Lois Orswell

years in Amsterdam, Beckmann was able to complete no fewer
than five of these grand and mysterious compositions,[77] works that
are veiled in mystery and defy literal interpretation. "With furious
tension one waits for the explanation of the secret. I *believe* in the
unknown,"[78] Beckmann noted in his diary while working on the
central panel of *The Actors*. There the king in the play thrusts a
sword into his own heart. This theater king seems to be an enig-
matic self-portrait of the artist as a younger man enacting his own
suicide. But what is the reason for this public act of desperation?
Are we spectators in some radical Piscator theater, where several
actions are being presented simultaneously on different stages?[79]

 In *The Actors*, Beckmann divided the space not only horizon-
tally, into the triptych format, but also vertically.[80] In the upper reg-
isters we see on the left an embodiment of the human spirit
confronting brute force. It has been suggested that this may refer
to a specific event: a Nazi patrolman broke into a clandestine meet-

68

71

ing of the Dutch underground and was miraculously dissuaded from making any arrests by the interference of a Christ-like figure.[81] In the center panel is the king, wearing a paper crown, while a masked woman trills a song and a man dressed in black behind the king awaits his turn.

Is this, perhaps, more than playacting? Is this suicide a portentous metaphor of the desperate role played by the dedicated artist—a gnostic messenger of the world of the spirit—who performs his task with deadly seriousness?[82] Other interpretations are also possible, such as a literary reading relating the king to a character in one of Beckmann's favorite novels, Jean Paul's *Titan* (1800–1803), in which "Roquairol, the daemonic antagonist of the novel's hero, shoots himself during the performance of an autobiographical play. . . . In this triptych, Beckmann seems to draw a parallel between the self-sacrifice of Christ, and the self-sacrifice of those who define the conditions of their existence for their fellow-humans."[83] In the right wing, a girl dressed as a harlot observes herself apprehensively in front of a Janus head that has one face in the light and one in the dark; a bellhop, Beckmann's messenger of fate, stands by backstage.

Simultaneously with all these disparate activities a man reads an American newspaper, the *New York Times*, in the occupied Netherlands. Clearly, Beckmann was concerned with the events of the time, a concern that is also suggested by the shackled feet in the dark cellar. We wonder about the meaning of the languorous girl holding an owl, in the center panel, while actors seem to be brawling and a jazz band plays in the pit with low, dark tones emerging from the tuba. The artist has provided just enough clues to arrest the eye and the mind, but never enough to unravel the thread of mystery. He rejected publicly understood, single-minded allegories in favor of a complex reality filled with many possible meanings.

The Actors was followed by *Carnival* (1942–43; University of Iowa Museum of Art, Iowa City) and then by a masterpiece that Beckmann entitled *Blindman's Buff*. The colors are now considerably warmer. A high-keyed yellow connects the three panels into a visual unit, from the railing and candle in the left-hand panel to the lamp in the right. Luxurious black and deep blue-violets also exert a powerful visual presence. When seen in daylight this triptych has the dazzling luminosity of stained glass. The personages are again cramped and confined in claustrophobic space, which Beckmann needed in order to contain the threat of the void.

Like all painters, Beckmann took on the task of transforming the three dimensions of actual appearance into the two dimensions of the canvas. This, to him, was "an experience full of magic in which I glimpse for a moment that fourth dimension which my whole being is seeking."[84] If we think of the fourth dimension as time we can see that it, too, is represented quite literally in such devices as clock, candle, and fire, as well as by the tempo of the music implicit in so many of his images. For many artists of Beckmann's generation the fourth dimension also signified the world of spirit. This is particularly true of Beckmann, immersed as he was in esoteric and mystical texts, whether gnostic revelations, the Vedanta, or the Cabala.

69

69

Blindman's Buff is Beckmann's largest and probably most complex painting in both iconography and composition. While working on it, he felt that it was going to be his most outstanding painting.[85] Among other things it deals with the conflict between civilization and barbarism—certainly between different cultures—as embodied in the pipe player in classical repose and the young harpist, both of whom exemplify exact opposites to the savage drummer who calls the tune.

Les Artistes mit Gemüse (Artists with Vegetables) provides some 70 insight into Beckmann's life in Amsterdam. It depicts an imaginary gathering of the artist and his friends during their years in exile in Amsterdam. This encounter is only imaginary, for Beckmann could meet with only one at a time. Rather than engaging in casual conversation, each man seems absorbed in his own thoughts. A sense of ritual pervades this painting. Each of the men, except Beckmann, holds something to eat. In the lower left Friedrich Vordemberge-Gildewart, the Constructivist painter and Beckmann's closest confidant during this period, holds a turnip—the only vegetable in the painting, despite its title. Next to him, wearing a fur hat and scarf, is the painter Herbert Fiedler,[86] holding a fish. On Beckmann's right is the poet Wolfgang Frommel, who holds a loaf of bread in an almost sacrificial gesture. Frommel, whose head is enframed by a large mirror or painting, was a disciple of the Symbolist poet Stefan George and also a student of alchemical texts; he may have inspired some of Beckmann's late work.

69. *Blindman's Buff*, 1945
Oil on canvas, center panel: 81¼ x 91¼ in.
(205 x 230 cm); side panels: 75½ x 43½ in.
(191 x 110 cm), each
The Minneapolis Institute of Arts; Gift of Mr.
and Mrs. Donald Winston

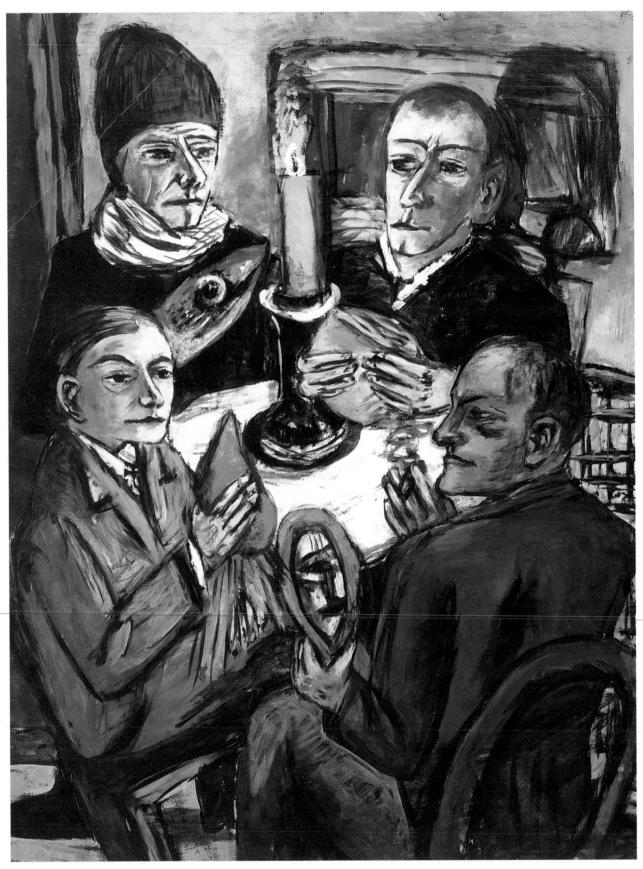

70

These are the men with whom Beckmann was often engaged in serious discussion about everything from the political situation during the war to the meaning of life and theories of the cosmos. Beckmann himself is shown clutching a mirror that reflects a distorted mask, or possibly the face of a foolish painted clown. The mirror may be a reference to the *Seelenspiegel* or "mirror of the soul," which appears in the romantic literature of E.T.A. Hoffman and Jean Paul, German writers whose work Beckmann read with frequency. In the center of the white table and directly above the mirror, creating the central vertical axis, is a flickering candle—a sign of light and a symbol of truth as well as of temporal existence. These men seem to be meeting secretly at night. They are crowded together, and the sense of unease is intensified by the tilt of both floor and table. It seem unlikely that Beckmann and his three exiled friends were engaged in some underground resistance conspiracy. It seems, rather, that Beckmann assembled these men in this ritualistic setting at the round table as a gathering of an intellectual elite. "Art," he had written earlier, "is the mirror of God, embodied by man."[87]

70. *Les Artistes mit Gemüse (Artists with Vegetables)*, 1943
Oil on canvas, 59 x 45½ in. (150 x 115.5 cm)
Washington University Gallery of Art, Saint Louis

71. *Quappi in Blue and Gray*, 1944
Oil on canvas, 38¼ x 30¼ in. (98.5 x 76.5 cm)
Kunstmuseum der Stadt Düsseldorf

71

72

72 In *Removal of the Sphinxes,* Beckmann seems to have recast a current event—the withdrawal of the Nazi forces from the Netherlands in the spring of 1945—in terms of ancient mythology; the

73 result remains enigmatic. In *Studio* he contraposed a most voluptuous, earthy woman to the coolly sophisticated demimondaine in Manet's *Olympia* (1863; Musée d'Orsay, Paris). Beckmann's "Olympia" consists of one great undulating curve. Everything about her—her fleshy color, round belly, bulging breasts, and the provocative position of her arms and hands—contributes to the great sensuality of this nude. For Manet's brightly colored bouquet of flowers, Beckmann substituted a vigorously growing succulent. Negress and black cat have made way for a strange black unfinished bust, whose upraised arm may indicate a Nazi salute or just a gesture of command. But the arm is cut off, ending in a stump—an image that alludes to some act of violence but also is frankly phallic.

 A certain sensual quality is rarely absent from Beckmann's still

74 lifes. In *Still Life with Two Large Candles,* it is elicited by the luxuriously erotic purple orchids that are juxtaposed to two candles.

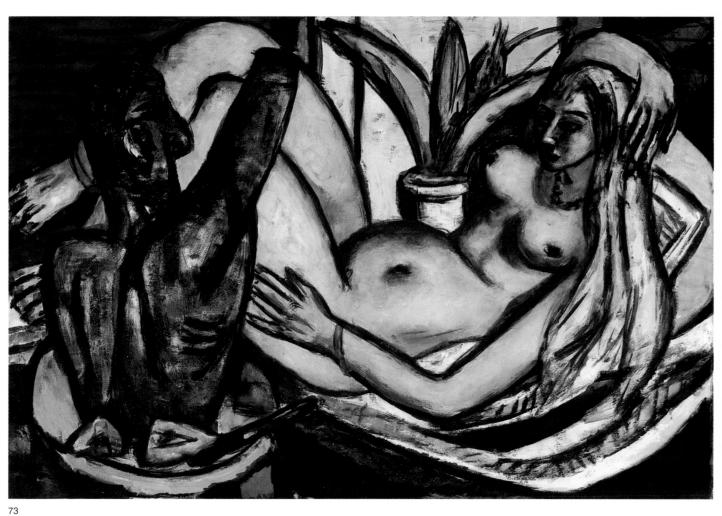

73

72. *Removal of the Sphinxes,* 1945
Oil on canvas, 51 x 55 in. (130.5 x 140.5 cm)
Staatliche Kunsthalle, Karlsruhe, Germany

73. *Studio,* 1946
Oil on linen, 35¾ x 53¼ in. (91 x 135.5 cm)
The Saint Louis Art Museum; Bequest of
Morton D. May

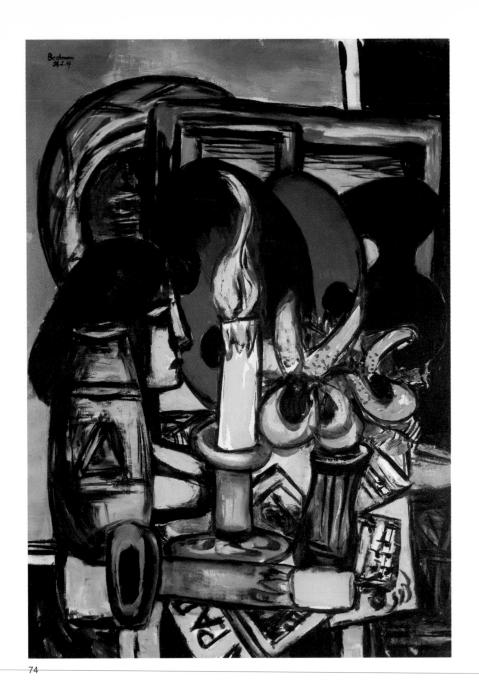

74

But the candles, one upright and burning, the other fallen and extinguished, once again relate to the tradition of the vanitas still life. In addition to serving as a metaphor for sexuality and death, the painting is also an allegory of art. We see again a sculpture—this time a woman in classical profile—as well as three painters' palettes. As in many works by Beckmann, mirrors make an enigmatic appearance in the background. Although the picture was made soon after the painter's arrival in Saint Louis, his attention was still directed toward European art. The table itself is painted in a vertical position, which indicates Beckmann's concern with and response to Cubist still lifes, and it is worth noting that the letters on the green paper probably spell PARIS when completed. The cramped composition and the dark coloration as well as the fallen candle that emphasizes the bottom edge of the picture evoke a sense of grave solemnity.

74. *Still Life with Two Large Candles,* 1947
Oil on canvas, 43 x 31⅛ in. (109.2 x 79.1 cm)
The Saint Louis Art Museum; Bequest of
Morton D. May

75. *Begin the Beguine,* 1946
Oil on canvas, 68 x 47 in. (178 x 121 cm)
University of Michigan Museum of Art,
Ann Arbor

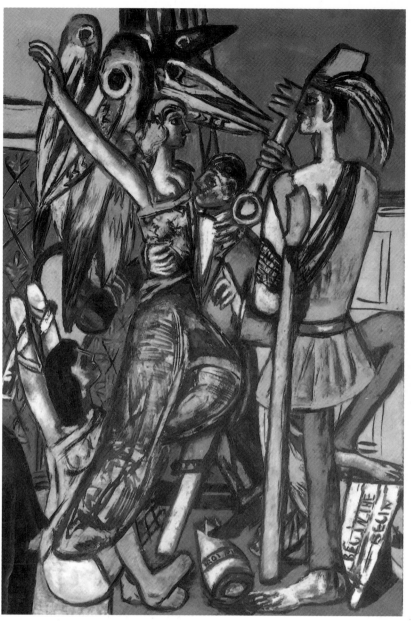

75

The liberation of the Netherlands brought about important changes in Beckmann's life. His diary entries for September 1945 register a small exhibition at the Stedelijk Museum, which was his first show in Europe since the war. During the summer of 1945 he was able to resume his relationship with his American dealer, Curt Valentin—a connection that made him feel part of the "world's nervous system" again; now he could start sending drawings to New York. In January 1946 Beckmann was able to ship paintings for his first important postwar show, which opened in April 1946 at Valentin's Buchholz Gallery, on Fifty-seventh Street. Beckmann was apprehensive about the show but then noted with real joy that it was extremely successful and sold out almost entirely. In July, Günther Franke opened a large Beckmann exhibition, with eighty-one pictures, in Munich.

During that summer Valentin came to visit Beckmann in Am-

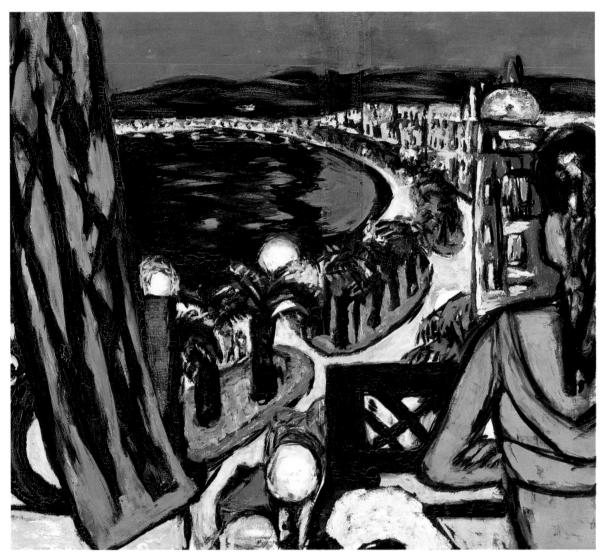

76

sterdam, and his diary entry is typical of the whole *Tagebuch:* "Valentin was here, saw a lot, ate with us at the Pays Bas, came on time by plane—2 bottles of champagne, whiskeys, Q. and Butshy [the Pekinese] were very happy."[88] Hanns Swarzenski, a good younger friend from the Frankfurt days and son of the former director of the Städelsches Kunstinstitut, also came to see the Beckmanns during that summer. In October, Beckmann made the first sketch for *Curt Valentin and Hanns Swarzenski* (Swarzenski Collection, Rye, New York), one of his most striking double portraits. He spent a great deal of time and effort on this dark, evocative painting of friends who never actually posed together. Swarzenski, in the back, looks straight at the viewer. His compressed lips, lean cheeks, and folded hands give him a withdrawn, almost ascetic expression in contrast to Valentin who, grasping a large candle, appears more sensuous and outgoing. On December 26, when Valentin visited him again, Beckmann presented it to his friend and dealer as a gift. At the end of the month the artist was able to conclude the year with confidence: "Ah '46 is finished and it cannot be denied that the sphere has turned a little from black to white."[89]

76. *Promenade des Anglais, Nice,* 1947
Oil on canvas, 31¼ x 35¼ in. (80.5 x 90.5 cm)
Museen Folkwang, Essen, Germany

During the cold and isolated years in the Netherlands, Beckmann had yearned particularly for the warmth, colors, and life of the south. In the spring of 1947, at the very first opportunity that the "enemy alien" was able to obtain a passport and visa, he took the train to the Côte d'Azur and spent a few weeks in Nice, Cannes, and Monte Carlo. The warm colors, the balmy nights, the water lapping quietly against the sandy shore are reflected in his painting of the Promenade des Anglais in Nice. It is a night scene, 76 but the velvety blacks are relieved by the rusty rose color and the blues and metallic greens. This canvas is at a vast remove from a cityscape like *The Iron Footbridge,* done twenty-five years earlier. 34 The agitated linear framework of that earlier painting has given way to subtler nuances of color. Now in his full maturity, and on the eve of his departure from Europe, Beckmann was clearly working in the tradition of modern European painting, which had been dominated for so long by the School of Paris.

Soon after Beckmann's return to Amsterdam from France he received an invitation to teach at Indiana University. While he was giving serious consideration to this offer, a second one arrived, from Washington University in Saint Louis, which he decided to accept. Though worried (as always), he was also very pleased at the prospect of a new life in the New World, and he began to take lessons in English, which are reflected in his diary: "The bettering is beginning." Beckmann and Quappi finally received their visas for the United States and sailed on the SS *Westerdam* on August 29, 1947. "Slowly Europe began to sink back—weather is splendid."[90]

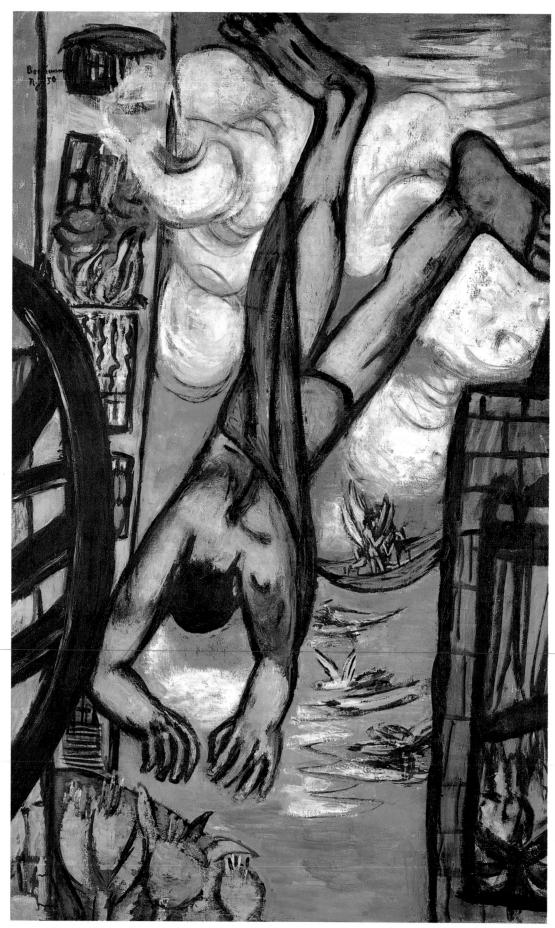

5 Saint Louis and New York

Aboard the SS *Westerdam*, Germany's foremost painter met Germany's leading author, but the encounter had few rewards for either. Thomas Mann eagerly showed Beckmann a series of woodcuts by the Belgian artist Frans Masereel, for which he was writing a preface. Beckmann crisply commented in his diary: "Quite nice for a fourteen-year-old."[91] He had only a little over a week to spend in New York, where he seemed to enjoy chiefly the gorillas in the Central Park Zoo, which he discovered on his second day, and Henri Rousseau's *Sleeping Gypsy* at the Museum of Modern Art. Exhausted by interviews, parties, and receptions, he was happy to leave for Saint Louis, where he arrived September 18, 1947.

Beckmann's two years in Saint Louis were active, fruitful, and happy.[92] They were punctuated by visits to New York and to many other cities throughout the United States, by a brief return to the Netherlands in the summer of 1948, and by his teaching the summer session at the University of Colorado in 1949. Beckmann enjoyed teaching and was glad to be surrounded once more by the young, in whom he hoped to instill creative independence. When Beckmann took over Philip Guston's advanced painting class, the students were already prepared for his presence. To his first class he said—as translated by Quappi Beckmann, who attended all his classes in order to help overcome the language barrier:

I wish you to discover your own selves, and to that end many ways and many detours are necessary.
I do not have to tell you that there can be no question of thoughtless imitation of nature.
Please do remember this maxim—the most important I can give you: If you want to reproduce an object, two elements are required: first, the identification with the object must be perfect; and secondly, it should contain, in addition, something quite different. This second element is difficult to explain. Almost as difficult as to discover one's self. In fact, it's just this element of our own self that we are all in search of.[93]

Capturing this second element meant that the student had to create his own images, and to that end he had to discover his own personality. Beckmann's help in this inward search was perhaps his

77. *Falling Man*, 1950
Oil on canvas, 55½ x 35 in. (141 x 89 cm)
National Gallery of Art, Washington, D.C.; Gift of Mrs. Max Beckmann

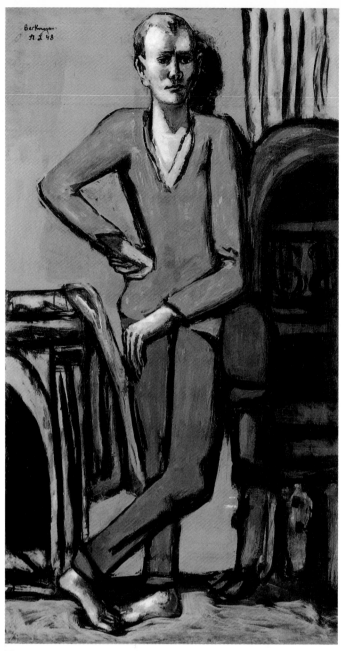

78

greatest contribution to his students. In addition, they admired the directness and clarity of his approach, the power of his execution, and his steadfast individuality in the face of very different fashions—abstraction now was ascendant. Beckmann was, as Walter Barker has said, the great grammarian, who could serve as point of reference. Some of the students and assistants who were closest to him, such as Albert Urban in Frankfurt and Barker in Saint Louis, eventually developed styles completely different from Beckmann's, yet they were significantly aided in their development by the work and personality of their teacher. Beckmann's relationship to Barker is reflected in the portrait he worked on between February and May 1948. The figure looms large, occupying virtually the entire height of the picture. The barefoot young painter is appealing in his boyish awkwardness and vulnerable sensitivity.

Beckmann's attitude toward teaching and his concern about the

78. *Portrait of Wally Barker*, 1948
Oil on canvas, 45 x 25⅛ in. (114 x 63.5 cm)
Milwaukee Art Museum; Gift of Mr. and Mrs. Malcolm K. Whyte

next generation of painters found poetic expression in his "Letters to a Woman Painter," which he wrote for a lecture at Stephens College in Columbia, Missouri, in February 1948 and which, as translated by Quappi Beckmann and Perry Rathbone, were also read by Mrs. Beckmann to audiences at the Boston Museum School, the University of Colorado, and Mills College in Oakland, California, during the following years. During Beckmann's brief visit to the Boston Museum School in 1948, Ellsworth Kelly experienced the power of Beckmann's drawings, which had an impact on his own work.[94] Nathan Oliveira, who studied with Beckmann at Mills College in the summer of 1950, recalls: "He was pivotal to me because he assured me that the solutions were within myself, that I didn't have to go following after abstract worlds."[95]

The splendid exhibition organized by Perry Rathbone at the City Art Museum of Saint Louis in 1948 began to establish Beckmann as "one of the most important living European artists."[96] This recognition had been slow in coming because ever since the dominance of French modernism in the pivotal Armory Show of 1913, modern art in America had largely been equated with French art. Also, other groups were imbued with a reactionary chauvinism that came amazingly close to the Nazi view that Beckmann had battled many years earlier.[97] And, finally, Beckmann's arrival in the United States coincided with the emergence of an Abstract Expressionist idiom, which was considerably at odds with his own style.

In spite of a contract with Curt Valentin and frequent and enthusiastic purchases by Morton D. May, who began acquiring works by the artist even prior to their meeting in 1949 and eventually assembled the most important collection of Beckmann's work, prices for his work were still very low and the artist was never without financial worries. For that reason, and because of a desire to see as much of the new country as possible, he would travel across the continent when requested to lecture. He expressed delight about being asked to teach summer school at the University of Colorado. "It's like being invited in Europe to teach at an art school in St. Moritz," he wrote to Minna Beckmann-Tube.[98] Finally, in October 1949, he was able to enter in his diary: "Well, well, one has it: First Prize of the Carnegie (1500 D[ollars].)"[99]

Twenty years earlier Beckmann had been awarded honorable mention at the Pittsburgh International for the powerful *Loge,* 42 whose emphatic, rigid forms make it seem spare when contrasted to the later prizewinner, *Fisherwomen.* The forms are dense and 79 highly complex, tangled in a space they fill and crowd. The colors are much richer and deeper, their heavy luxuriousness adding to the sensuality of this painting of four women fondling enormous fishes. "These women," Beckmann told Quappi, "are fishing for husbands, not lover-boys."[100] The three young girls make use of all their female attractions. The black stockings and garters, the tight corsets, the uncovered breasts and thighs, the exposed buttocks seen through the stem of a suggestively shaped vase, the placement of the fishes—everything is most provocative. The three alluring young women are contrasted to a withered old hag holding a thin eel in the background, a juxtaposition that Beckmann had also used in a slightly earlier painting—*Girls' Room (Siesta)*—in which 80

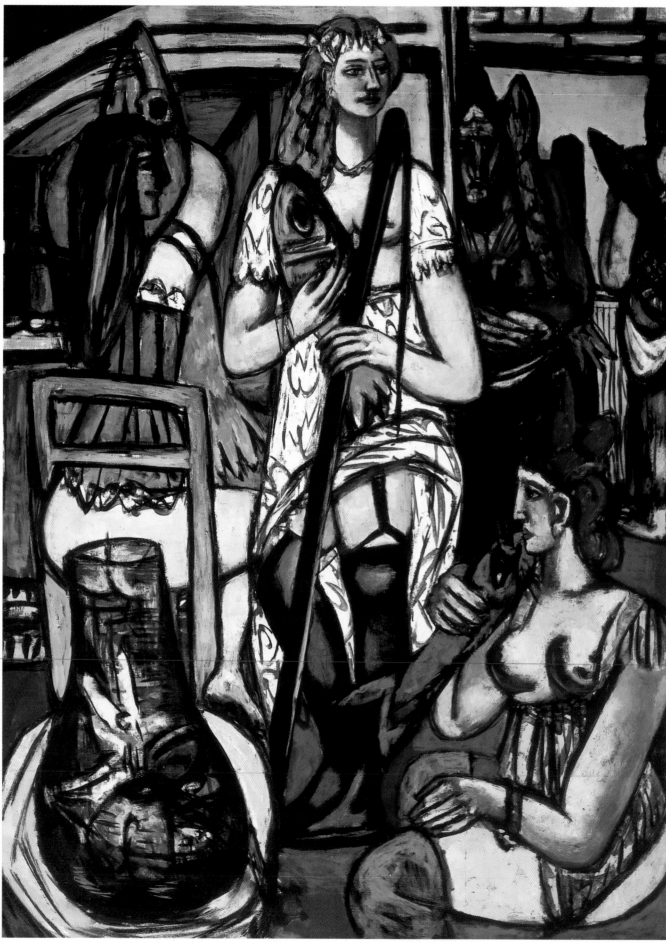

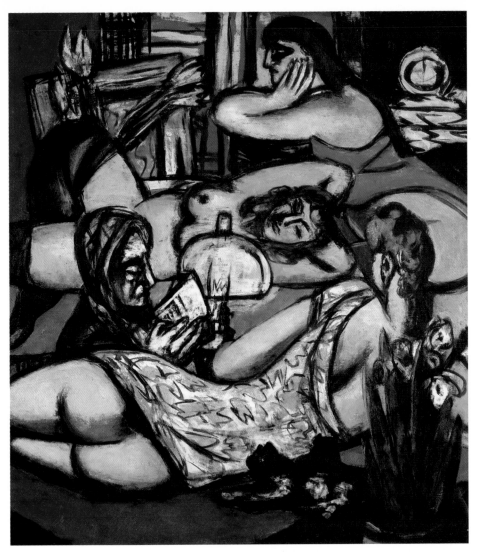

80

79. *Fisherwomen,* 1948
Oil on canvas, 75¼ x 55¼ in. (188 x
139.5 cm)
The Saint Louis Art Museum; Bequest of
Morton D. May

80. *Girls' Room (Siesta),* 1947
Oil on canvas, 51½ x 55½ in. (130.5 x
140.5 cm)
Preussischer Kulturbesitz, Berlin

81. *The Cabins,* 1948
Oil on canvas, 55⅜ x 75 in. (140.5 x
190.5 cm)
Kunstsammlung Nordrhein-Westfalen,
Düsseldorf

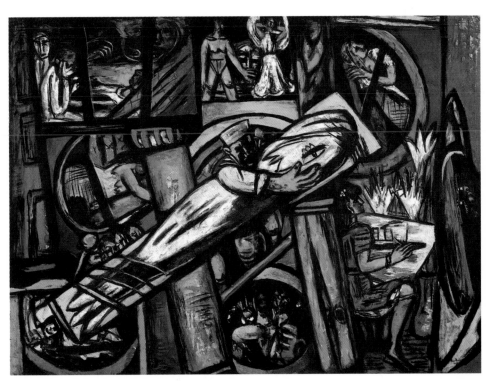

81

young women recline in suggestive positions while an old crone seems to be reading to them.[101]

Sexual themes had occupied Beckmann for decades, but now the symbol of the fish has assumed paramount importance. A huge fish is the central object in the large dark canvas *The Cabins*. A sailor is trying to grasp it, but his passions—symbolized by the fish—are too much for him to hold. Behind this central image can be seen shifting facets of human life in the boat's cabins: the expectation of love on the part of the girl combing her hair in the upper right, perhaps its fulfillment in the girl lying on a couch in the central tier at left. There is creative activity on the part of the young painter at lower right, the toil of working in the lower center, a vision of an angel in the theatrical scene in the upper center, and death and mourning on the upper left. Life consists of hope, tenderness, love, adventure, drama, death: this variety has been communicated by a complex interaction of figures, forms, and colors impinging on each other within a tight space.

Shortly after Beckmann completed this compelling painting, he stated: "Indulge in your subconscious, or intoxicate yourself with wine, for all I care, love the dance, love joy and melancholy, and even death!" The task of the artist, he explained, is to live fully, to experience, to understand, and then to distill art from all the confusion of life. "Art, with religion and the sciences, has always supported and liberated man on his path. Art resolves through Form the many paradoxes of life, and sometimes permits us to glimpse behind the dark curtain which hides those spaces unknown and where one day we shall be unified."[102]

It is possible to infer from this comment that the remarkable shallowness of Beckmann's space—the narrow stage upon which the crowded action of his pictures almost always takes place, before a blank abrupt backdrop—was caused by the fact that he equated space with death. Only rarely, in *Falling Man* and in the center panel of the *Argonauts,* both of 1950, as well as in the central panel of the earlier *Departure,* did the artist use open space without an evocation of horror. At this time he frequently referred to "the unknown space" of another existence. Like Piet Mondrian, W. B. Yeats, and Wassily Kandinsky, Beckmann was interested in the Theosophical theories of Helena Blavatsky (he owned a copy of her *Secret Doctrine,* 1888) and delved deeply into the Vedas in his study of Indian philosophy. He became convinced of the existence of the soul and believed in some kind of transmigration of the spirit. Stephan Lackner recounted a visit to the Musée de l'Homme in Paris with Beckmann during which the artist nodded toward a large Easter Island head and said, "This too I once was."[103] When Mrs. Beckmann's mother died in the spring of 1948, he wrote in his diary: "Her excellency Frau Frieda von Kaulbach has died . . . well perhaps she will be happier on another plane."[104] And later he stated: "I've continued reading in Pythagoras and determined that one cannot conceive of death but as being called to another level of consciousness."[105]

Falling Man is one of the most remarkable paintings in Beckmann's oeuvre. A large, heavy body falls through the sky. Coming from heavenly regions, he is on his way to earth, passing in his

82

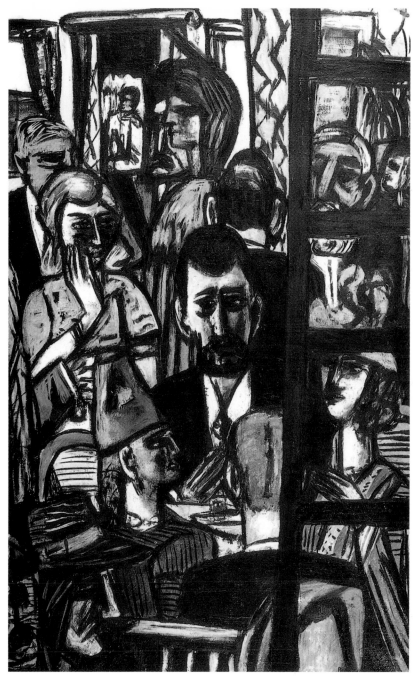

83

82. *Large Still Life/Interior (Blue),* 1949
Oil on canvas, 56⅜ x 35¼ in. (142 x 89 cm)
The Saint Louis Art Museum; Bequest of
Morton D. May

83. *Hotel Lobby,* 1950
Oil on canvas, 56 x 35 in. (142 x 89 cm)
Albright-Knox Art Gallery, Buffalo; Room of
Contemporary Art Fund, 1950

flight a burning house whose smoke intermingles with the clouds. He travels past the crowded and burning dwellings of mankind toward magnificent burgeoning plants, while supernatural winged beings—part bird, part angel—float in ethereal boats. Most of the painting is occupied by the intense cerulean blue of the sky. Never before had Beckmann opened up a picture in this manner in order to make room for space. "For, in the beginning there was space, that frightening and unthinkable invention of the Force of the Universe. Time is the invention of mankind; space or volume, the palace of the gods."[106]

Falling Man was made in New York, the final station on his long odyssey. His position in Saint Louis had been tenuous, and during a trip to New York in January 1949 he was happy to accept

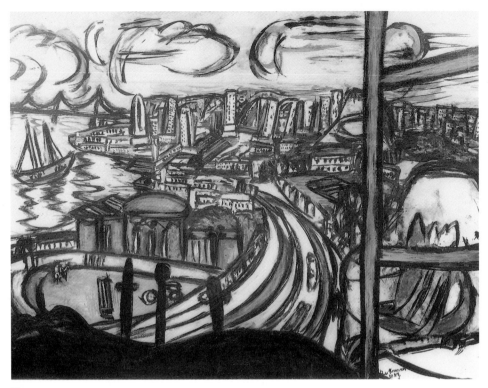

84

a tenured position to teach advanced painting at the Brooklyn Museum Art School, starting in September. He anticipated New York with both eagerness and trepidation, but eventually Beckmann became extremely fond of his new environment and made it his own. In September he moved into a studio apartment on East Nineteenth Street and began teaching. Almost at once he remarked on the "great impression of the gigantic city in which I am beginning to feel at home."[107] Fascinated by all aspects of New York, he constantly discovered new sections of the city in his neverending walks and subway rides. He was happy just to observe life in little dives in the Bowery or Chinatown, or to sip champagne while noting the "amusing types" in the Oak Room of the Plaza Hotel. In May 1950, after moving to a new apartment on West Sixty-ninth Street, he began to explore Central Park.

Earlier that year Beckmann had once more turned to a subject of erotic fantasy. While working on this enigmatic painting he referred to it in his diary as "Pierrette," "Yellow Stockings," and 85 "Mardi Gras Nude," finally settling on *Carnival Mask, Green, Violet, and Pink*. Beckmann, like Picasso, often painted circus performers, mountebanks, clowns, saltimbanques, harlequins, and pierrots—people who, like artists, are marginal to society. In this painting, composed of dissonant colors, Columbine wears a black mask through which she glares at the viewer head-on; her lips are sealed. The upper part of her broad-shouldered body is held firm and straight. She sits on a table or drum, with legs splayed out—a pose the artist often used to denote sexual enticement. Carelessly thrown down in front of her are playing cards marked with rough crosses suggesting death. As Friedhelm W. Fischer has pointed out, both the discordant color and the woman's body are threatening.[108]

84. *San Francisco*, 1950
Oil on canvas, 39¾ x 55⅛ in. (102 x 140 cm)
Hessisches Landesmuseum, Darmstadt, Germany

85. *Carnival Mask, Green, Violet, and Pink*, 1950
Oil on canvas, 53½ x 39½ in. (135.5 x 100.5 cm)
The Saint Louis Art Museum; Bequest of Morton D. May

90

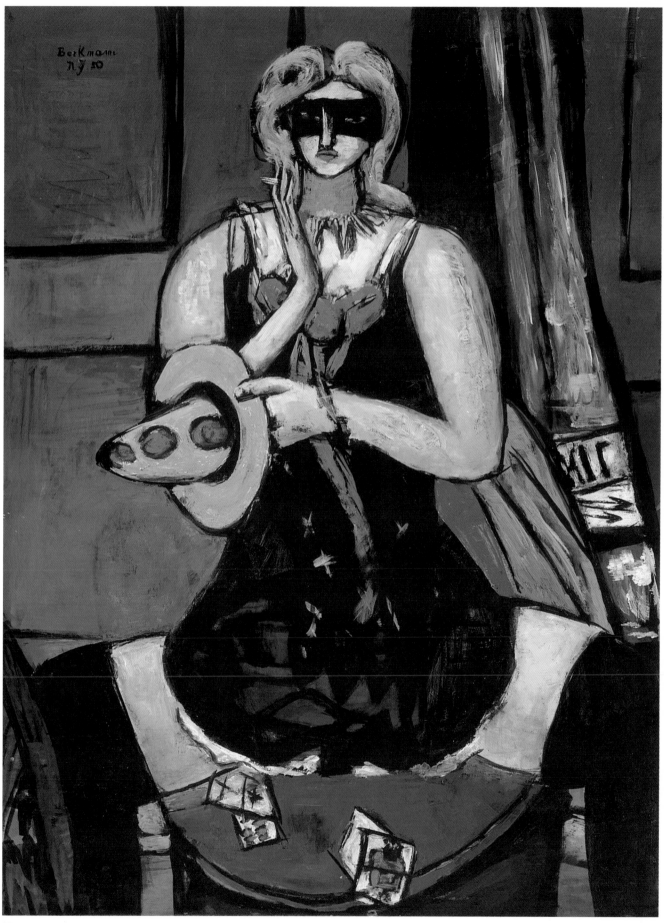

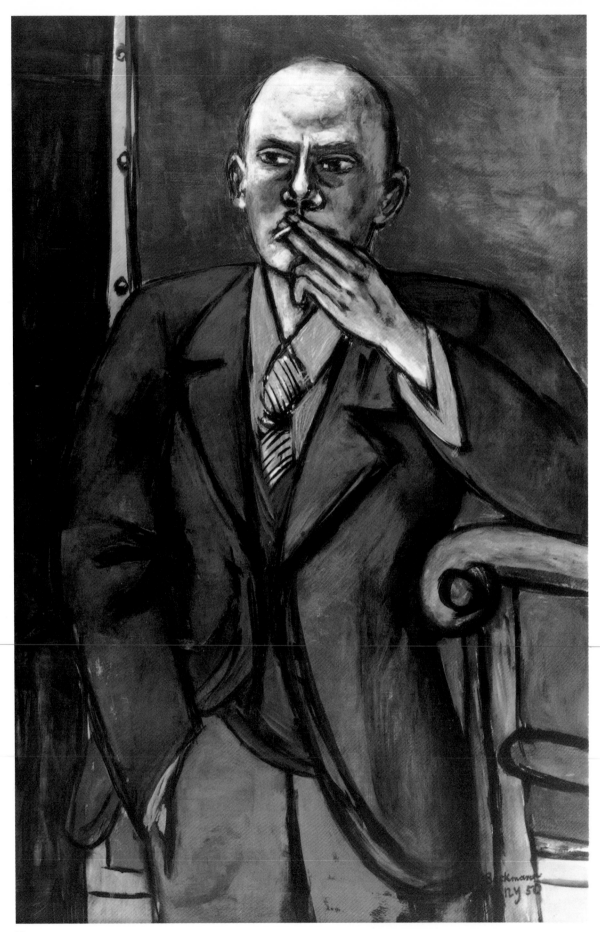

With her open thighs, both welcoming and menacing, Columbine is a symbol simultaneously for eros (love) and thanatos (death). In the same place (New York) and the same year (1950), Willem de Kooning, a major artist of the next generation, painted *Woman I* (Museum of Modern Art, New York), a ferocious and predatory woman. Its distortions make those of *Columbine* seem mild in comparison, as de Kooning seems to have taken the parts of the woman's body apart and reassembled them at random. Also in the same year Jean Dubuffet presented women as flattened skins or anatomic maps in his Corps des Dames series.

At that time Beckmann also painted his last self-portrait. He 86 stands alone, leaning against the chairback, drawing on a cigarette as if for nourishment. The most startling aspect of this work is the brilliance of its colors: the unrelenting cobalt blue of the jacket, the bright orange shirt, and the green chair set against a deep maroon background. The brightness of the hues contributes to the two-dimensional appearance of the work; the disparate quality of these colors gives a rather insolent air to this wistful, contemplative figure. He looks worn but still defiant. On the left, extending the whole height of the picture, looms the frightening black emptiness of space. But the large surface directly behind the painter is a newly stretched canvas ready to be painted. The artist had to go on painting no matter how apparently dark and empty existence might be.

In April 1949, while still in Saint Louis, Beckmann had begun working on his last and his most resolved triptych, *The Argo-* 87 *nauts*.[109] He completed it in New York on December 26, 1950, the day before he died, and it can be seen as his last testament. The left panel, originally called "The Artist and His Model," shows the painter practically attacking his canvas; the man corresponds to Vincent van Gogh in Paul Gauguin's portrait of his painter friend at work (1888; Rijksmuseum Vincent van Gogh, Amsterdam). During the time Beckmann was working on this triptych—March 1949–December 1950—his diaries contain several sympathetic references to "Vincent." In April 1949 Beckmann noted that he was rereading van Gogh's letters, and in November he went to see a van Gogh exhibition at the Metropolitan Museum. Beckmann must have identified with the energetic painter in his canvas, yet it is the mask on which the woman is seated that most resembles his own features. The woman, representing Medea in the Argonaut saga, brandishes a sword that also looks like a symbol of virility. She can be seen as threatening, but she is probably meant to be a protectress or an inspiring muse.

The right panel depicts the chorus of Greek tragedy—the intermediary between the action on the stage and the audience, whose measured commentary provides both psychological distance and dramatic structure. Beckmann's chorus is a chamber orchestra of beautiful, calm women. While man creates and engages in the adventures of life, woman guards and inspires his genius, or sings to celebrate his exploits. This panel—with the women rising in tiers, the stringed instruments on their necks reversed to fit into the oblong composition, and the deeply reverberating colors that resemble stained glass—is one of the most beautifully resolved paintings in Beckmann's oeuvre.

86. *Self-Portrait in Blue Jacket,* 1950
Oil on canvas, 55⅛ x 36 in. (140 x 91 cm)
The Saint Louis Art Museum; Bequest of
Morton D. May

The painter's canvas in the left wing forms an acute triangle with the ladder in the central part. The two are related. In fact, in South German dialect the word *Staffelei* signifies both an artist's easel and a ladder. The ladder has often served Beckmann as a symbol of anguish, longing, and fulfillment, just as the canvas is the artist's proving ground. Here the ladder no longer stands empty. The wise old man emerging from the sea has withstood all his trials and has completed the long journey. He now beckons with a prophetic gesture to the two young Argonauts setting out on their heroic adventure. On the right is Jason, a beautiful youth—the final state of an ideal figure that had made its first appearance in *Young Men by the Sea* (1905) and had occupied Beckmann for a lifetime. We see the same basic composition again in *Young Men by the Sea* (1943); both of these paintings were important landmarks in his career. The elbow of Jason rests on red rocks, their color inspired by the Garden of the Gods in the Rocky Mountains near Boulder. On his wrist is a fabulous bird whose blue head and brown and green feathers may refer to the magical wryneck (a small bird related to the woodpecker) that Aphrodite gave Jason to help the Argonauts pass through the Clashing Rocks of Symplegades. The gentle youth in the center, with a wreath of flowers in his hair and golden bracelets on his arm, must be Orpheus, whose orange lyre lies on the yellow beach beside him. The old man may be Phineas, the king who had advised the Argonauts to send a dove out from their boat to explore the way and who had been blinded by the gods for prophesying the future. But he could also be Glaucus, builder of the Argo, who later became a sea god endowed with the gift of prophesy.

The painting may be indebted to the reading of the Argonaut myth by the Swiss cultural historian J. J. Bachofen, which was known to Beckmann. Bachofen interpreted the myth, which describes the first encounter of the Greeks with the barbarians, as referring to the revolutionary change from a more ancient culture, in which the "female principle" and greater harmony with nature prevailed, to a culture of male dominance and Promethean striving.[110] In the pink sky above the heroes Beckmann painted a purple eclipse of the sun, outlined by the fiery orange ring. On September 4, 1949, he expressed his astonishment when reading about sunspots in Alexander von Humboldt and wrote: "Never knew that the sun was dark—am very shaken."[111] Two new orange planets were included at this historic moment, and they orbit between the sun and the crescent of the waxing moon.

The space in *Argonauts* is less jammed than that of the earlier triptychs and other compositions. Neither violent nor compressed, the painting is imbued with calm serenity. The struggle between good and evil no longer fully engaged the mature painter. He now was concerned with that spark of

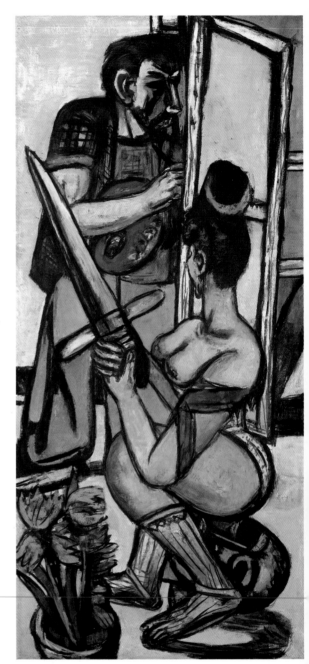

87

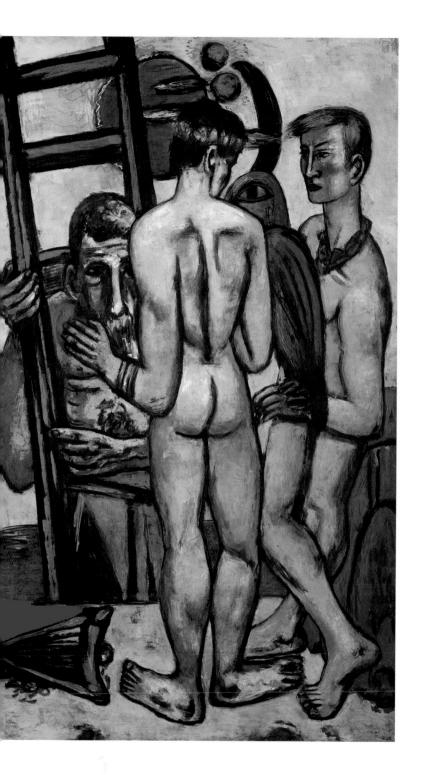
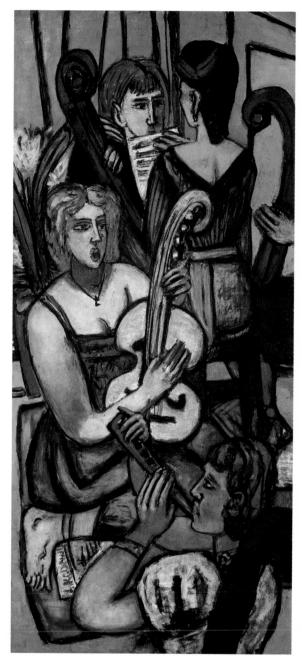

87. *The Argonauts,* 1949–50
Oil on canvas, center panel: 81 x 48 in. (206 x
122 cm); left panel: 73¾ x 34⅛ in. (187 x 87
cm); right panel: 73 x 33 in. (185 x 85 cm)
National Gallery of Art, Washington, D.C.; Gift
of Mrs. Max Beckmann

human activity that beckons the hero to great adventure, the quest for the Golden Fleece, and beyond that, to the achievements of peace and transfiguration. The old man-god points, as Beckmann might have said, to a plane of different consciousness.

On December 17, 1950, Beckmann sent his last letter to his son. He wrote: "I am just painting a triptych, *Argonauts,* and in 'Dodona' we shall see each other again."[112] This was ten days before he died of a heart attack during one of his regular morning walks in Central Park. Dodona was the sanctuary of Zeus, where an ancient sacred oak communicated the will of the god by the rustle of its leaves to those mortals who could understand the sound.

88

88. Max Beckmann's studio in New York, 38 West Sixty-ninth Street

NOTES

Unless otherwise noted, all translations are by the author.

1. Max Beckmann, notes of conversation with Reinhard Piper, 1919, *Max Beckmann: Die Realität der Träume in den Bildern: Schriften und Gespräche 1911 bis 1950* (Munich: R. Piper, 1990), p. 28.

2. Hans Kaiser, *Max Beckmann* (Berlin: Paul Cassirer, 1913). This is an incomplete listing; Benno Reifenberg and Wilhelm Hausenstein, in *Max Beckmann* (Munich: R. Piper, 1949), list 139 paintings through 1912. The actual number of finished works exceeded this by far, for Beckmann burned many of his earliest paintings.

3. Max Beckmann, "Letters to a Woman Painter." These letters were composed during the first weeks of January 1949 in response to an invitation to speak at Stephens College, Columbia, Missouri. The lecture was translated by Beckmann's second wife (known as Quappi) and Perry Rathbone and read by Mrs. Beckmann at Stephens College on February 3, 1948. It was first published in *Art Journal* 9 (autumn 1949): 39–43.

4. Beckmann, in J. B. Neumann, "Die Künstler und die Zeitgenossen, eine Diskussion," in *Blick auf Beckmann*, ed. Hans Martin Freiherr von Erffa and Erhard Göpel (Munich: R. Piper, 1962), p. 223. A few years earlier Emil Nolde had recalled a similar reaction: "Paris has given me very little, and I had expected so much"; in Nolde, *Das eigene Leben* (Berlin: Rembrandt, 1931), p. 152.

5. Max Beckmann, *Tagebücher 1940–1950* (Munich: Albert Langen–Georg Müller, 1955), p. 335, entry for August 31, 1949.

6. Ibid., p. 124, entry for September 27, 1945.

7. Paul F. Schmidt, "Die Beckmann-Austellung in Magdeburg," *Cicerone* 4 (April 1, 1912): 314.

8. Karl Scheffler, "Max Beckmann," *Kunst und Künstler* 11 (March 1913): 297 ff.

9. Franz Marc, "Anti-Beckmann," *Pan* 2 (March 1912): 469.

10. Max Beckmann, "Gedanken über zeitgemässige und unzeitgemässige Kunst," *Pan* 2 (April 1912): 499.

11. Max Beckmann, "On My Painting," in Robert Herbert, *Modern Artists on Art* (Englewood Cliffs, N.J.: Prentice-Hall, 1964), p. 132. This lecture was given by Beckmann at the New Burlington Galleries, London, in 1938. Originally written in German, it was translated into English and published in condensed form in *Centaur* (vol. 1, no. 6) in Amsterdam in 1946. Mr. Herbert, with the assistance of Quappi Beckmann, later produced a revised translation, which is used here.

12. Max Beckmann, "Creative Credo" (1918), in Kasimir Edschmid, ed., *Schöpferische Konfession: Tribüne der Kunst und Zeit* (Berlin: Erich Reiss, 1918), p. 65.

13. Max Beckmann, *Briefe im Kriege* (Berlin: Bruno Cassirer, 1916).

14. Ibid., p. 13, letter of October 3, 1914.

15. Ibid., p. 27, letter of March 16, 1915.

16. Ibid., pp. 72–73, letter of June 8, 1915.

17. Max Beckmann to Peter Beckmann, April 1949; in Lothar-Günther Buchheim, *Max Beckmann* (Feldafing, Germany: Buchheim, 1959), p. 34.

18. Alfred Kubin, in Benno Reifenberg, "Der Zeichner Max Beckmann," in *Blick auf Beckmann*, p. 142.

19. He did an etched version of this scene in 1917.

20. Beckmann to Minna Beckmann-Tube, April 17, 1915; in *Max Beckmann Briefe*, vol. 1, *1899–1924* (Munich: R. Piper, 1993), p. 117.

21. Beckmann, introductory statement to *Max Beckmann Graphik* (Berlin: Graphische Kabinett I. B. Neumann, 1917), unpaginated.

22. Gabriel Mälesskircher is not to be confused with the sixteenth-century Swabian Master of Messkirch; Mälesskircher's emotional style and crowded compositions mark him as a pupil of Hans Multscher. The altarpiece in the Alte Pinakothek in Munich is now given to the Master of the Tegernsee Tabula Magna.

23. Beckmann, interview with author, Chicago, January 18, 1948.

24. In this connection it is interesting to note that before he died Beckmann gave a book on early German painting (Curt Glaser, *Zwei Jahrhunderte deutscher Malerei*, Munich, 1916) to Jane Sabarsky in New York, telling her how important these artists were to his own work.

25. Beckmann, "Creative Credo," pp. 63–64.

26. *Der Ararat* 2 (November 1921): 276.

27. This panel was acquired by the Staatliche Kunsthalle, Karlsruhe, Germany, in 1920 and was widely published at the time of acquisition.

28. Largely inspired by Friedrich Wilhelm Nietzsche's idea of melancholy and his investigation of myths, the brothers Giorgio di Chirico and Alberto Savino established Pittura Metafisica in 1913; the group also included artists such as Carlo Carrà and Giorgio Morandi. Their work was characterized by a sense of enigma that was created by the evocative juxtaposition of unexpected objects. Valori Plastici, which was an important movement in Italian art during the interwar period, took its name from Mario Broglio's magazine of the same name. Founded in 1918, it stood for the reinstatement of formal values and pictorial discipline in painting.

29. See L. Moser, "Mannheim Kunsthalle-Ausstellung: Die neue Sachlichkeit," *Kunst und Künstler* 23 (September 1925): 474.

30. Marielouise Motesiczky, interview with author, London, September 12, 1963.

31. G. F. Hartlaub, circular letter dated May 18, 1923; in Fritz Schmalenbach, "The Term *Neue Sachlichkeit*," *Art Bulletin* 22 (September 1940): 161.

32. Beckmann to Reinhard Piper, 1922; in Piper, *Nachmittag* (Munich: R. Piper, 1950), p. 40.

33. Beckmann, "Letters to a Woman Painter," p. 40.

34. Beckmann, "On My Painting," p. 137.

35. Curt Glaser, Wilhelm Fraenger, Wilhelm Hausenstein, and Julius Meier-Graefe, *Max Beckmann* (Munich: R. Piper, 1924). This book was a remarkable homage to a forty-year-old artist.

36. Heinrich Simon, *Max Beckmann* (Berlin and Leipzig, Germany: Klinkhardt und Biermann, 1930).

37. The art historian Benno Reifenberg remembered seeing Beckmann dressed in a similar costume at a masked ball in Frankfurt. See Reifenberg, "Wandlung und Entscheidung, der Maler Max Beckmann und Frankfurt am Main," *Frankfurt Lebendige Stadt* 1, no. 1 (1956): 10.

38. Stephan Lackner, *Max Beckmann* (New York: Harry N. Abrams, 1977), p. 98.

39. Max Beckmann, "The Artist and the State" (1927); in Hans Belting, *Max Beckmann* (New York: Timken Publishers, 1989), p. 113. According to J. B. Neumann (in "Sorrow and Champagne," his unpublished essay on Beckmann), the artist, after attending a state dinner at which Paul von Hindenburg was present, said that he himself would not be adverse to being elected president of the German Republic.

40. Beckmann, "On My Painting," p. 133.

41. Marielouise Motesiczky, "Max Beckmann als Lehrer," lecture given to the Max Beckmann Society, Murnau, Germany, 1963; in *Max Beckmann Bildnisse aus den Jahren 1905–1950* (Munich: Günther Franke, 1964), unpaginated.

42. Theodore Garve, interview with author, Hamburg, Germany, November 7, 1963.

43. Günther Franke, Beckmann's Munich dealer, reported Picasso as saying, "Il est très fort" (he is very strong) when viewing Beckmann's show; see Max Beckmann, *Sammlung Günther Franke* (Munich: Günther Franke, n.d.).

44. Henry McBride, "The Pittsburgh International," *Creative Art* 5 (November 1929): XIII.

45. Beckmann, "On My Painting," p. 133.

46. According to Beckmann's carefully kept records, the central and right panels were completed in November 1933, and the left panel in December 1933. (Earlier it was believed that Beckmann had worked on *Departure* until 1935.)

47. Bernard S. Myers, *The German Expressionists* (New York: Frederick A. Praeger, 1957), p. 304.

48. This comment appeared on the label for the triptych during its special installation in 1951.

49. In an early pen-and-ink sketch, formerly in the collection of Frederick Zimmermann, New York, the weapon was still a spear.

50. It is partly because of this still life and partly because of the executioner's being dressed like an artist in a casual polo shirt that some thoughtful critics of the triptych have suggested that the murderer is simultaneously an allegory of the artist. See Clifford Amyx, "Max Beckmann: The Iconography of the Triptychs," *Kenyon Review* 13 (autumn 1951): 613–14; and Charles Kessler, "Max Beckmann's *Departure*," *Journal of Aesthetics and Art Criticism* 14 (December 1955): 206–17.

51. Perry T. Rathbone, introduction to *Max Beckmann 1948* (Saint Louis: City Art Museum, 1948), p. 11.

52. For Joseph, see Charles S. Kessler, *Max Beckmann's Triptychs* (Cambridge: Harvard University Press, Belknap Press, 1970), p. 215. For Charon, see Günter Busch, *Max Beckmann* (Munich: R. Piper, 1960), p. 76. But how could Charon convey his passengers in such bright light? For self-portrait, see Buchheim, *Beckmann*, p. 159.

53. Buchheim, *Beckmann*, p. 159.

54. James Thrall Soby, *Contemporary Painters* (New York: Museum of Modern Art, 1949), pp. 90–91.

55. Meyer Schapiro, "Recent Abstract Painting," lecture delivered in 1957; in Schapiro, *Modern Art* (New York: George Braziller, 1978), p. 223.

56. Beckmann to Curt Valentin, February 11, 1938. Translation by Jane Sabarsky.

57. Erhard Göpel, *Max Beckmann in seinen späten Jahren Munich* (Munich: Albert Langen–Georg Müller, 1955), p. 19.

58. Adolf Hitler in "Der Führer erröffnet die 'Grosse deutsche Kunstausstellung 1937,'" *Die Kunst im dritten Reich* (Munich) 7–8 (July–August 1937): 60.

59. Adolf Ziegler, opening speech at the exhibition *Entartete Kunst* (Degenerate Art), Munich, 1937; in the exhibition catalog *Munich, Haus der Kunst, Entartete Kunst* (Munich: Haus der Kunst, 1962), pp. xxi–xxii.

60. Beckmann generally indicated the city in which a painting was completed by an initial preceding the date. Thus, there is *A*, for Amsterdam; *B*, for Berlin; *F*, for Frankfurt; *NY*, for New York; *P*, for Paris; and *St.L* or *SL*, for Saint Louis.

61. Friedhelm W. Fischer, *Max Beckmann: Symbol of Weltbild* (London: Phaidon, 1973), p. 133.

62. Beckmann, "On My Painting," p. 133.

63. Beckmann, *Tagebücher*, p. 243, entry for March 16, 1948.

64. Beckmann, "On My Painting," p. 136.

65. Frederick Zimmermann, "Beckmann in America," lecture, Max Beckmann Society, Murnau, Germany, July 15, 1962.

66. Lackner, *Beckmann*, p. 138.

67. Stephan Lackner, "Bildnis des Bildnismalers Max Beckmann," *Das Kunstwerk* 17 (October 1963): 25.

68. Stephan Lackner, "Max Beckmann—Memories of a Friendship," *Arts Yearbook* 4 (1961): 120.

69. Stephan Lackner, *Der Mensch ist kein Haustier* (Paris: Editions Cosmopolites, c. 1937).

70. Years later, when Beckmann arrived at Mills College to teach the summer session, he was welcomed by a surprise exhibition of about thirty of his paintings, all but one of which Alfred Neumeyer (director of the school's art gallery) had borrowed for the occasion from Lackner, who was then living at the foot of the mountains in Santa Barbara. Beckmann entered in his diary: "Later, viewing Beckmann pictures in the Museum (old Berlin ones—Paris 1932–39—sad reminiscences) my God, all the things one had to live through—and now to meet myself again in California. (Beckmann, *Tagebücher*, p. 394, entry for July 5, 1950.)

71. Beckmann to J. B. Neumann, March 3, 1939.

72. Beckmann to Neumann, May 1, 1939.

73. Beckmann, *Tagebücher*, p. 21, entry for May 4, 1940.

74. The question arises as to why Beckmann so carefully kept diaries that reveal so little. The answer is probably twofold: first, it was the custom for noted men of his generation to keep diaries; second, such a personal record of the mundane details of life quite possibly helped to counteract the extreme isolation of his personality.

75. Beckmann, *Tagebücher*, p. 52, entry for June 1, 1943.

76. For "pauvre Odysseus," see ibid., p. 277, entry for September 27, 1948. For "I am Jupiter," the source is Walter Barker, interview with author, October 9, 1963.

77. *The Acrobats*, 1938, Saint Louis Art Museum; *Perseus*, 1941, Museum Folkwang, Essen, Germany; *The Actors*, 1941–42, Fogg Art Museum, Harvard University, Cambridge; *Carnival*, 1942–43, University of Iowa Museum of Art, Iowa City; *Blindman's Buff*, 1944–45, Minneapolis Institute of Arts.

78. Beckmann, *Tagebücher*, p. 33, entry for April 21, 1942.

79. Erwin Piscator was an innovative theatrical director who founded the Proletarian Theatre in Berlin in 1920. His "epic theater" exerted great influence on his collaborator, Bertolt Brecht. After the Nazi assumption of power Piscator emigrated to the USSR and eventually to the United States.

80. Claudia Gandelman, "Max Beckmann's Triptychs and the Simultaneous Theatre of the 'Twenties," in *Max Beckmann: The Triptychs* (London: Whitechapel Art Gallery, 1981), p. 30.

81. Erhard Göpel, ed., *Max Beckmann: Die Argonauten, ein Triptychon* (Stuttgart, Germany: Reclam, 1957), p. 4.

82. Fischer, *Beckmann*, pp. 162–65.

83. Gert Schiff, "The Nine Finished Triptychs of Max Beckmann," in *Beckmann: The Triptychs*, p. 18.

84. Beckmann, "On My Painting," p. 135.

85. Beckmann, *Tagebücher*, p. 113, entry for July 1, 1945.

86. Göpel has identified this individual as Herbert Fiedler, rather than as the theater manager Ludwig Berger, as named by Gotthard Jedlicka in "Max Beckmann in seinen Selbstbildnissen," in *Blick auf Beckmann*, p. 129.

87. Beckmann, "Artist and the State," p. 113.

88. Beckmann, *Tagebücher*, p. 158, entry for July 15, 1946.

89. Ibid., p. 174, entry for December 31, 1946.

90. Ibid., p. 204, entry for August 29, 1947.

91. Ibid., p. 205, entry for September 3, 1947.

92. For Beckmann's life in Saint Louis see Perry T. Rathbone, "Max Beckmann in America: A Personal Reminiscence," in Peter Selz, *Max Beckmann* (New York: Museum of Modern Art, 1964), pp. 123–29.

93. Max Beckmann, speech given to his first class in the United States at Washington University, manuscript.

94. Ellsworth Kelly, interview with author, May 20, 1992.

95. Nathan Oliveira, afterword to Peter Selz, *Max Beckmann: The Self-Portraits* (New York: Rizzoli, 1992), p. 109.

96. Libby Tannenbaum, "Beckmann: St. Louis Adopts the International Expressionist," *Artnews* 47 (May 1948): 21.

97. A classic among the attacks on modern art is an editorial by Ernest W. Watson in *American Artist* 13 (March 1948): 19, which reads in part: "As revolting an exposition of graphic vulgarity as is likely to be offered the American public in the name of Art. . . . All this ought to be pretty exciting news for Midwest parents. After all, Pop, think of the opportunity for Mary and John to soak up the latest imported ideals! . . . There's altogether too much tolerance of vulgarity and downright obscenity in contemporary art."

98. Beckmann to Minna Beckmann-Tube, March 3, 1949; in Buchheim, *Beckmann*, p. 178.

99. Beckmann, *Tagebücher*, p. 343, entry for October 13, 1949. Beckmann is almost unique among modern artists in having experienced within his lifetime three distinct periods of fame, interrupted by lengthy periods of relative neglect. The peaks of renown in his life seem to have fallen approximately eighteen to twenty years apart: 1912–14, 1928–33, and 1947–50.

100. Mathilde Q. Beckmann, interview with author, April 19, 1964.

101. Jules Langsner, "Los Angeles Letter: Symbol and Allegory in Max Beckmann," *Art International* 5 (March 1961): 29. In this penetrating article Langsner drew interesting parallels between the sexual connotations in Beckmann's *Fisherwomen* (plate 79) and Franz Kafka's *The Castle*.

102. Beckmann, speech to the Friends and Philosophy Faculty of Washington University, June 6, 1950; in *Max Beckmann* (New York: Curt Valentin Gallery, 1954), unpaginated. Translation by Jane Sabarsky.

103. Stephan Lackner, *Max Beckmann, 1884–1950* (Berlin: Safari, 1962), p. 2.

104. Beckmann, *Tagebücher*, p. 252, entry for May 7, 1948.

105. Ibid., p. 352, entry for December 5, 1949.

106. Beckmann, "Letters to a Woman Painter," p. 40.

107. Beckmann, *Tagebücher*, p. 338, entry for September 17, 1949.

108. Friedhelm W. Fischer, *Der Maler Max Beckmann* (Cologne, Germany: M. DuMont Schauberg, 1972), p. 85.

109. Erhard Göpel maintains that the heroic theme of the Argonauts was suggested to Beckmann by Wolfgang Frommel in Amsterdam, which Frommel himself confirms (see Göpel, *Die Argonauten*, which includes Frommel's "Das Argonautengesprach"). Quappi Beckmann pointed out, however, that Beckmann intended to paint a picture related to the theme of the Argonauts prior to his discussion with Frommel. While working on this triptych Beckmann read Friedrich Hölderlin's *Der Tod des Empedokles* (1799) and the Oedipus trilogy by Sophocles.

110. Kessler, *Beckmann's Triptychs,* pp. 94–95.

111. Beckmann, *Tagebücher*, p. 336, entry for September 4, 1949. A black sun hangs in the sky of *Resurrection,* the unfinished canvas of 1916–18.

112. Max Beckmann to Peter Beckmann, December 17, 1950; in *In Memoriam Max Beckmann* (Frankfurt, Germany: privately printed, 1953), n.p.

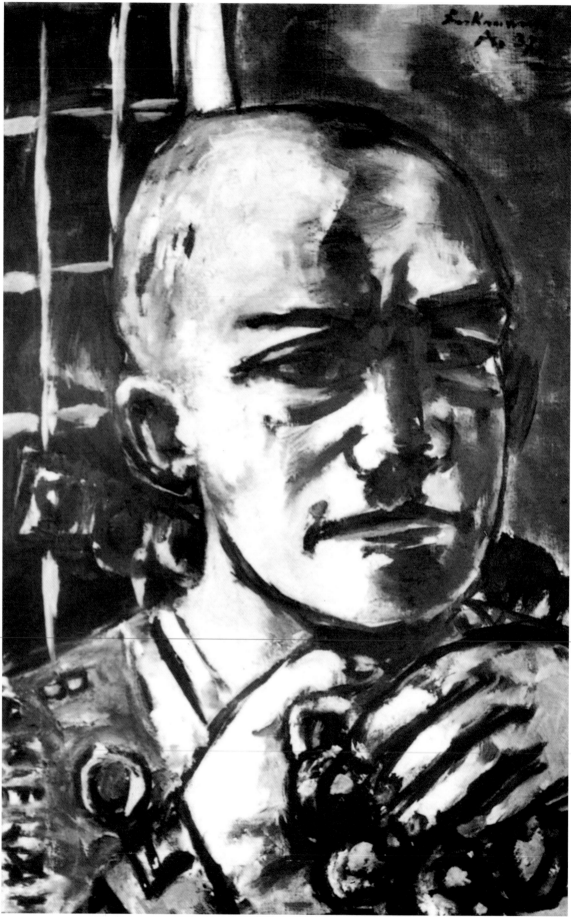

Artist's Statements

We must share all of the suffering that is coming. We must sacrifice our hearts and our nerves to poor, deceived humanity's horrible screams of pain. Especially now we must get as close to the people as possible. That is the only thing which can motivate our quite superficial and selfish existence. That we give to people an image of their fate, and that one can do only if one loves them.

> From Max Beckmann, "Creative Credo (1918)," in Kasimir Edschmid, ed., *Schöpferische Konfession: Tribüne der Kunst und Zeit* (Berlin: Erich Reiss, 1918). Translated in Carla Schulz-Hoffmann and Judith C. Weiss, eds., *Max Beckmann Retrospective* (Munich: Prestel; Saint Louis: Saint Louis Art Museum, 1984), p. 80.

Before I begin to give you an explanation, an explanation which it is nearly impossible to give, I would like to emphasize that I have never been politically active in any way. I have only tried to realize my conception of the world as intensely as possible.

Painting is a very difficult thing. It absorbs the whole man, body and soul—thus I have passed blindly many things which belong to real and political life.

I assume, though, that there are two worlds: the world of spiritual life and the world of political reality. Both are manifestations of life which may sometimes coincide but are very different in principle. I must leave it to you to decide which is the more important.

What I want to show in my work is the idea which hides itself behind so-called reality. I am seeking for the bridge which leads from the visible to the invisible, like the famous cabalist who once said: "If you wish to get hold of the invisible you must penetrate as deeply as possible into the visible."

My aim is always to get hold of the magic of reality and to transfer this reality into painting—to make the invisible visible through reality. It may sound paradoxical, but it is, in fact, reality which forms the mystery of our existence.

89. *The Liberated,* 1937
Oil on canvas, 23½ x 15¾ in. (60 x 40 cm)
Dr. Manfred Scholz, Augsburg, Germany

What helps me most in this task is the penetration of space. Height, width, and depth are the three phenomena which I must transfer into one plane to form the abstract surface of the picture, and thus to protect myself from the infinity of space. My figures come and go, suggested by fortune or misfortune. I try to fix them divested of their apparent accidental quality.

One of my problems is to find the Self, which has only one form and is immortal—to find it in animals and men, in the heaven and in the hell which together form the world in which we live.

Space, and space again, is the infinite deity which surrounds us and in which we are ourselves contained. . . .

When spiritual, metaphysical, material, or immaterial events come into my life, I can only fix them by way of painting. It is not the subject which matters but the translation of the subject into the abstraction of the surface by means of painting. Therefore I hardly need to abstract things, for each object is unreal enough already, so unreal that I can only make it real by means of painting. . . .

All these things come to me in black and white like virtue and crime. Yes, black and white are the two elements which concern me. It is my fortune, or misfortune, that I can see neither all in black nor all in white. One vision alone would be much simpler and clearer, but then it would not exist. It is the dream of many to see only the white and truly beautiful, or the black, ugly and destructive. But I cannot help realizing both, for only in the two, only in black and in white, can I see God as a unity creating again and again a great and eternally changing terrestrial drama. . . .

Self-realization is the urge of all objective spirits. It is the Self for which I am searching in my life and in my art. . . .

Everything intellectual and transcendent is joined together in painting by the uninterrupted labor of the eyes. Each shade of a flower, a face, a tree, a fruit, a sea, a mountain, is noted eagerly by the intensity of the senses to which is added, in a way of which I am not conscious, the work of my mind, and in the end the strength or weakness of *my soul*. It is this genuine, eternally unchanging center of strength which makes mind and sense capable of expressing personal things. It is the strength of the soul which forces the mind to constant exercise to widen its conception of space. . . .

If the canvas is only filled with a two-dimensional conception of space, we shall have applied art, or ornament. Certainly this may give us pleasure, though I myself find it boring as it does not give me enough visual sensation. To transform height, width, and depth into two dimensions is for me an experience full of magic in which I glimpse for a moment that fourth dimension which my whole being is seeking. . . .

The greatest danger which threatens mankind is collectivism. Everywhere attempts are being made to lower the happiness and

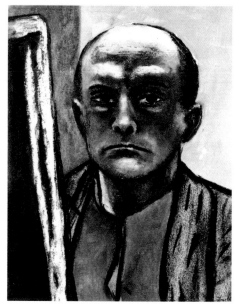

90

90. *Self-Portrait in Olive and Brown,* 1945
Oil on canvas, 23¾ x 19½ in. (60.3 x 49.9 cm)
The Detroit Institute of Arts; Gift of Robert H. Tannahill

91. *Young Men by the Sea,* 1943
Oil on canvas, 74⅝ x 39½ in. (189.5 x 100.5 cm)
The Saint Louis Art Museum

102

the way of living of mankind to the level of termites. I am against these attempts with all the strength of my being. . . .

I am immersed in the phenomenon of the Individual, the so-called whole Individual, and I try in every way to explain and present it. What are you? What am I? Those are the questions that constantly persecute and torment me and perhaps also play some part in my art.

From "On My Painting," lecture given at New Burlington Galleries, London, 1938. English translation published in Robert L. Herbert, *Modern Artists on Art* (Englewood Cliffs, N.J.: Prentice-Hall, 1964), pp. 131–37.

Art, love, and passion are very closely related because everything revolves more or less around knowledge and the enjoyment of beauty in one form or another. And intoxication is beautiful, is it not, my friend?

Have you not sometimes been with me in the deep hollow of the champagne glass where red lobsters crawl around and black waiters serve red rumbas which make the blood course through your veins as if to a wild dance? Where white dresses and black silk stockings nestle themselves close to the forms of young gods amidst orchid blossoms and the clatter of tambourines? Have you never thought that in the hellish heat of intoxication amongst princes, harlots, and gangsters, *there* is the glamour of life? Or have not the wide seas on hot nights let you dream that we were glowing sparks on flying fish far above the sea and the stars? Splendid was your mask of black fire in which your long hair was burning—and you believed, at last, at last, that you held the young god in your arms who would deliver you from poverty and ardent desire? . . .

Don't forget nature, through which Cézanne, as he said, wanted to achieve the classical. Take long walks and take them often, and try your utmost to avoid the stultifying motor car which robs you of your vision, just as the movies do, or the numerous motley newspapers. Learn the forms of nature by heart so you can use them like the musical notes of a composition. That's what these forms are for. Nature is a wonderful chaos to be put into order and completed. Let others wander about, entangled and color blind, in old geometry books or in problems of higher mathematics. We will enjoy ourselves with the forms that are given us: a human face, a hand, the breast of a woman or the body of a man, a glad or sorrowful expression, the infinite seas, the wild rocks, the melancholy language of the black trees in the snow, the wild strength of spring flowers and the heavy lethargy of a hot summer day when Pan, our old friend, sleeps and the ghosts of midday whisper. This alone is enough to make us forget the grief of the world, or to give it form. In any case, the will to form carries in itself one part of the salvation for which you are seeking. The way is hard and the goal is unattainable, but it is a way.

From "Letters to a Woman Painter," lecture given at Stephens College, Columbia, Missouri, 1948. English translation by Mathilde Q. Beckmann and Perry T. Rathbone, published in Peter Selz, *Max Beckmann* (New York: Museum of Modern Art, 1964), pp. 133–34.

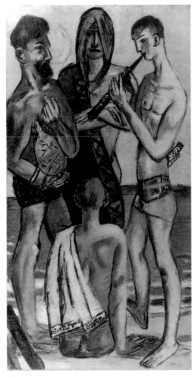

91

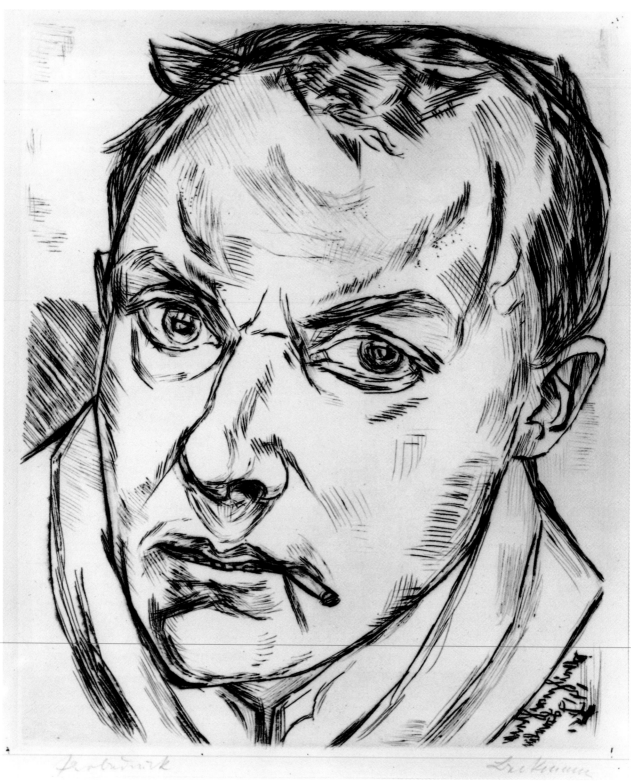

Probedruck Beckmann

Notes on Technique

Max Beckmann learned the skills of painting while studying at Weimar and during his long career as a painter. He made no revolutionary experiments in painting technique but simply developed ever greater virtuosity. It could be said that he employed an "old master" way of painting, laying different glazes on top of each other in order to achieve the luster he sought.

After applying the white ground to his canvas, Beckmann would make preparatory sketches directly on the canvas, in pencil, pen and ink, or charcoal. He would then use large brushes for underdrawing, and this might be followed by underpainting in color pigment, or, in his later work, in pastel or colored chalk. Sometimes he permitted the white ground to remain visible, integrating it as a constituent part of the final picture.

His wife, Quappi, recalls how he held his brush in his right hand, fingers stretched out, moving his hand from the shoulder, much as a violinist would hold a bow. He painted standing up in front of the stretched canvas on the easel, except when working from the model or painting a portrait, which he did sitting, facing the person. When working, he would dip the brush into a large container of turpentine before applying pigment to the brush and then fling off the excess fluid, creating what Quappi Beckmann remembered as "a color mosaic on the floor and the furniture in his studios."[1] He took great pains to have immaculate palettes and many clean brushes of different sizes, with every bristle bright and shiny. While painting he was always on the move, taking various positions in front of the easel, moving hands, body, and brushes. Then he would sit down for a few seconds to examine the picture before continuing his work. "When painting his body and spirit were completely in tune with each other—a total balance between tension and repose in his back, his arms, his legs. It was like the flight of a great bird on a high mountain summit, landing and soaring off."[2]

We know from Beckmann's diaries that he frequently worked on many canvases at a time, leaving them at varying states of completion. In order to examine the composition of each picture, he

92. *Large Self-Portrait,* 1919
Drypoint, 9⅜ x 7⅝ in. (23.7 x 19.7 cm)
The Brooklyn Museum

would often put it upside down or on its side to study and test the structure of the total design. In his early paintings, such as *Large Gray Waves,* he employed brushwork recalling that of Vincent van Gogh, whose work was well known in German art circles by this time, and he used light color values related to those favored by the German Impressionist painters Lovis Corinth and Max Liebermann. The influence of Edouard Manet and the French Impressionists is clearly visible in a work such as *Self-Portrait, Florence.* At the same time, during this period of youthful experimentation Beckmann also used a heavy, vigorous brushstroke in his paintings dealing with catastrophe and death.

In the prewar years Beckmann often used a spatula to apply pigment, whereas later the spatula served solely for cleansing his palette. His application of paint became much thinner and his colors much lighter during the postwar period, when he applied local color in the manner of Henri Rousseau, for whom he had great admiration. Around 1925, in pictures such as *Quappi in Blue,* a fundamental change took place: the colors became much stronger, taking on a luminosity of their own. These works have some of the strongest pigmentation in early-twentieth-century painting, as in the powerful contrast of green and red in *Carnival in Paris* or the brilliant penetrating blue presence in the central panel of *Departure.*

Black seems to dominate, as in *The Loge* and numerous other paintings. The black is often mixed with reds, dark blues, siennas, greens, and purples, and it was definitely a color—rather than its absence—for Beckmann. In fact, he referred to himself as a *Schwarzmaler* ("black painter") and continued a long and distinguished legacy of Diego Velázquez, Francisco Goya, and Manet in European painting.

In his mature work Beckmann was able to create a strong tension between adjacent colors, between pure and broken tones, and between underpainting and surface. A fusion of harmony and discord prevails in his most successful paintings. He would have agreed with G. I. Gurdjieff's teaching of self-revelation by means of opposing forces. And self-revelation was of utmost important in Beckmann's oeuvre. In his London lecture he spoke about the spiritual quality of color as "the strange and magnificent expression of the inscrutable spectrum of Eternity." But he also asserted that color should be "subordinated to light and, above all, to the treatment of form."[3] In fact, however, in many of his later paintings his bold juxtapositions of chroma actually create form, rhythm, and space.

Although Beckmann produced fewer graphic works than some of his German contemporaries (such as Ernst Ludwig Kirchner, Erich Heckel, and Max Pechstein) and certainly fewer than the prodigious number made by Pablo Picasso, he must be ranked among the major printmakers of his time. With their insight both into the social and political turbulence of the period and into his personal anguish, his prints, created in the years during and following World War I, are masterpieces of modern graphics.

Just as in painting he adhered largely to traditional techniques, Beckmann did not experiment much as a printmaker. He had no time and no patience for the cumbersome and artful technical manipulation with which twentieth-century printmaking is bur-

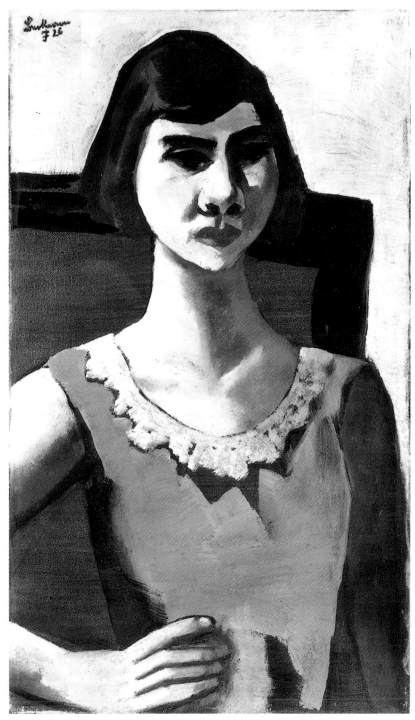

93

93. *Quappi in Blue,* 1926
Oil on canvas, 24 x 14 in. (60.5 x 35.5 cm)
Staatsgalerie Moderner Kunst, Munich

dened. But the great revival of the woodcut, especially among German artists, did during the early part of the century inspire Beckmann to master the expressive potential of the medium. The cutting and gouging of the wood ultimately proved too hampering a process, however, and he produced only a handful of woodcuts during his career. The great majority of his prints—347 out of 374—are lithographs and drypoints. A superb draftsman, Beckmann could draw directly on the stone for his lithography. In drypoint, the medium of his greatest achievement in printmaking, the image is incised directly into the metal plate. It was this immediacy that Beckmann wanted in his prints.

94

95

After a few tentative approaches to drypoint Beckmann began to turn seriously to printmaking when he was commissioned by Paul Cassirer in 1911 to illustrate a series of poems on the theme of Eurydice. Soon he produced a good number of lithographs, which, like his paintings of the prewar period, often dealt with Greek mythology and biblical subjects. Many of his lithos also commented on daily life, ranging from goings-on in upper-class cafés to dance halls, street scenes, and brothels. In style they relate to prints by the Secessionists Lovis Corinth, Max Liebermann, and Max Slevogt.

The experience of the Great War caused a fundamental and lasting change in Beckmann's work, a transformation that started in his prints and was only later transferred to his paintings. As early as 1914, in *Declaration of War* and *Weeping Woman*, his prints took on a very personal stamp. In the former, a Berlin crowd responds to the announcement that hostilities had begun, each person reacting in an individual way. In this pivotal print Beckmann began to communicate the dynamic quality of the drypoint process, the action of the sharp tool lacerating the copper surface of the plate. *Weeping Woman* depicts Beckmann's mother-in-law's response to news of her son's death at the front—a deeply moving delineation of sorrow.

Even while serving as a medical orderly on the western front, Beckmann still managed to work on his prints. He discarded the easy calligraphy and flowing line of his prewar period in favor of

17, 18

94. *Medic Carrying the Wounded*, 1914
Drypoint, first state, 6¼ x 4¾ in. (15.5 x 12 cm)
The Art Institute of Chicago; on loan from Allan Frumkin, Chicago

95. *Medic Carrying the Wounded*, 1914
Drypoint, second state, 6¼ x 4¾ in. (15.5 x 12 cm)
The Art Institute of Chicago; on loan from Allan Frumkin, Chicago

96. *Morgue*, 1915
Drypoint, third state, plate: 10⅛ x 14⅛ in. (25.7 x 35.7 cm)
The Museum of Modern Art, New York; Purchase

108

96

a more direct and powerful style. A drypoint like *Medic Carrying the Wounded* exists in several states.

In the first state the head of the wounded soldier recalls a conventional head of Christ, the bandages and hair suggesting a crown of thorns. The drypoint could, in fact, be taken as a representation of the Good Samaritan. In the final state, however, Beckmann relinquished the vestiges of a traditional interpretation in favor of an unfictitious and simpler approach. In the face of the carnage of war the former sentimentality apparently became useless to the artist. 94 95

In *Morgue* Beckmann fused his familiarity with the art of the past—in this case, Andrea Mantegna's *Dead Christ* in the Pinacoteca di Brera, Milan—with his immediate experience of anonymous death in war. 96

Printmaking was well suited to express the shattering wartime experiences of the artist, and it was to assume a dominant position within his oeuvre for several years. Prints could be executed rapidly and disseminated in the copious new political journals or printed independently and distributed in portfolios. Also, in the early 1920s, Germany's raging inflation generated a demand for prints as an inexpensive but secure investment.

Beckmann's work, like that by many of his predecessors in German art as well as by his Expressionist contemporaries, was principally determined by line. This stress on linear structure also appeared in his painting during the postwar years. It was at that time that he was most attentive to Germany's Gothic masters and

the angularity of their form.

The print cycles that Beckmann completed during this harrowing period show a chaotic and fragmented world, in which cities and their inhabitants are torn apart by disaster. Each year a new suite came off the press: *Faces* (drypoint), 1918; *Hell* (lithographs), 1919; *City Night* (lithographs), 1920; *Annual Fair* (drypoint), 1921; and *Berlin Journey* (lithographs), 1922. Beckmann's own image appears in many of these prints. In the earliest (which the artist originally called *World Theatre* until the eminent critic Julius Meier-Graefe renamed it *Faces*), the lines are cut into the plate with nervous agitation. In this suite, even more than in the following ones, Beckmann dealt with the murders and all the other atrocities during the postwar years; the suite includes *The Night,* which
26 was based on the painting of the same title and is his quintessential image of the violence of the time. He himself is seen several times,
97 as in *Evening (Self-Portrait with the Battenbergs),* in which he is seen in a crowded scene, jammed together with the close friends who gave him shelter in Frankfurt after his breakdown in the war. The tension among the three individuals—to say nothing of the big-eyed cat—is expressed by the sharpness of the drypoint lines as well as by the intensity of the composition.

92 In 1919 Beckmann created *Large Self-Portrait* in drypoint. The artist, with the ever-present cigarette dangling from his mouth, directs his large piercing eyes at the viewer with a probing and quizzical expression. His powerful head fills the entire sheet, giv-

97

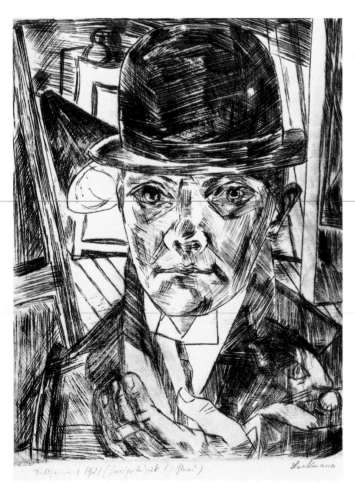

98

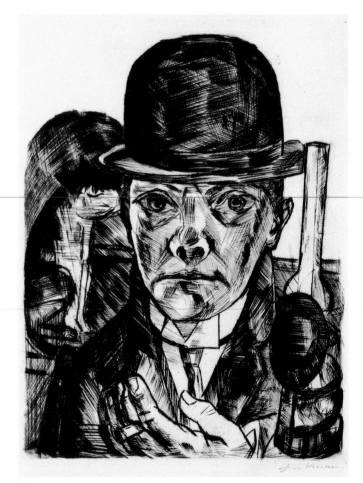

99

ing the print a sense of monumentality. This work and the masterful *Self-Portrait in Bowler Hat* of 1921 have a vital presence, partly due to the heavy burrs of the drypoint. Although the artist in the 1921 print is posed as a gentleman with a proper jacket, stiff collar, and even stiffer bowler hat, he still appears disturbed as he stares at the viewer in severe frontality. As in several of his drypoints, Beckmann made significant alterations in successive states. A bright conical lamp on the left side of the first state of the print 98 was replaced by a large cat, which had been sitting on the artist's 99 arm in the earlier state. A beer mug and a tall, narrow vase have been added on the right, but all the canvases that were stacked on the wall of the crowded space have been removed. Indeed, there is a great deal more white in the later state, both in the background and in the artist's face, creating a stronger contrast to the deep black in hat, eyes, and coat.

After the mid-1920s, with the resurgence of Germany's economy and the increasing recognition for Beckmann's paintings, his print production tapered off sharply, not to be revived until the 1940s. During his exile to the Netherlands he was commissioned by Georg Hartmann of Frankfurt to create a series of twenty-seven hand-colored lithographs illustrating the biblical Book of Revelation—visionary drawings related to the work of William Blake, an artist Beckmann mentioned often and with reverence in his diaries. Then, in 1946, he was commissioned by Curt Valentin to produce what was to become his final suite of graphics, *Day and Dream* (originally called *Time-Motion)*. Coming close to Surrealist imagery, it deals with a variety of motifs, including (in the artist's words), "mythological, biblical, and theatrical subjects, or relating to circus or café life. It could be an all-in-one thing."[4] Again, a number of the lithographs were hand-colored by the artist. Harold Joachim, who was a great connoisseur of Beckmann's graphics, concluded an essay on his prints by observing: "Here, as in many of his late drawings, Beckmann employed the thin ascetic line of the pen, purest and most exacting of drawing media. Nostalgic and gentle memories alternate with visions of death. Explanations are impossible; only those familiar with the artist's total work can hope to find the key."[5]

NOTES

1. Mathilde Q. Beckmann, *Mein Leben mit Max Beckmann* (Munich and Zurich: Piper, 1985), p. 146.

2. Ibid., p. 148.

3. Max Beckmann, "On My Painting," in Robert Herbert, *Modern Artists on Art* (Englewood Cliffs, N.J.: Prentice-Hall, 1964), pp. 135–36.

4. Beckmann to Curt Valentin, March 1, 1946, archives of the Museum of Modern Art, New York.

5. Harold Joachim, "Beckmann's Prints," in Peter Selz, *Max Beckmann* (New York: Museum of Modern Art, 1964), p. 119.

97. *Evening (Self-Portrait with the Battenbergs),* from the portfolio *Faces,* 1916
Drypoint, plate: 9⁷⁄₁₆ x 7 in. (23.9 x 17.8 cm)
The Museum of Modern Art, New York: Abby Aldrich Rockefeller Fund

98. *Self-Portrait in Bowler Hat,* 1921
Drypoint, trial proof, first state, plate: 12⁵⁄₁₆ x 9⅝ in. (31.3 x 24.5 cm)
The Museum of Modern Art, New York; Gift of Edward M. W. Warburg

99. *Self-Portrait in Bowler Hat,* 1921
Drypoint, printed in black, plate: 12¾ x 9¾ in. (32.3 x 24.8 cm)
The Museum of Modern Art, New York; Gift of Edward M. W. Warburg

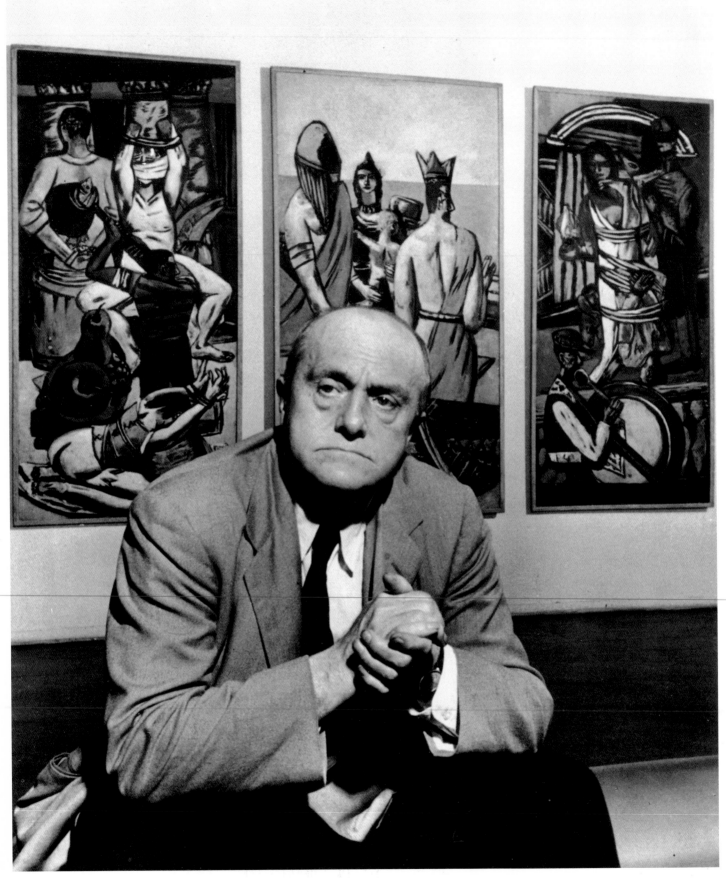

Chronology

101

100. Max Beckmann in front of *Departure* at the Museum of Modern Art, New York, 1947

101. *Portrait of the Artist's Mother,* 1906
Oil on canvas, 30½ x 27½ in. (77.5 x 70 cm)
Kunsthalle Mannheim, Mannheim, Germany;
Collection Mayen Beckmann

1884 February 12—Max Beckmann is born in Leipzig, Germany, to Carl Heinrich Christian Beckmann and Antoinette Henrietta Bertha Beckmann, the youngest of three children. His father is the proprietor of a grain mill and a grain merchant.

1894 After his father dies, the family returns to Braunschweig, Germany, where both parents had grown up.

1894–99 Max attends public school in Braunschweig and boarding school in Gandersheim, Germany.

1899 Fails entrance examination to the Dresden Academy, Dresden, Germany.

1900 Enters Grandducal Art School in Weimar, Germany.

1902 Meets Minna Tube, a fellow art student, at a Mardi Gras costume ball.

1903 Completes studies at Weimar; takes first trip to Paris and sets up a studio there.

1904 Leaves Paris; goes to Colmar, in Alsace, to see the Isenheim Altar, then moves to Berlin. He spends this and the next summer on the Baltic seacoast.

1906 First participates in Berlin Secession exhibition. Receives Villa Romana Prize for study in Florence for his painting *Young Men by the Sea* (plate 8), which is purchased by the Grossherzogliches Museum für Kunst und Kunstgewerbe in Weimar. Marries Minna Tube; they honeymoon in Paris and then move to Florence. Summer—his mother dies of cancer.

1907 Returns to Berlin and builds a house in the Berlin suburb of Hermsdorf.

1908 His son, Peter, is born (dies 1990). Beckmann takes his third trip to Paris.

1909 Meets Emil Nolde and the critic Julius Meier-Graefe. Participates in first group exhibition abroad, at the Salon d'Autumne, Paris. Makes his first lithographs.

1910 Elected to the executive board of the Berlin Secession; resigns the following year to have more time for painting.

1911 Begins his association with the dealer Israel Ber Neumann (later J. B. Neumann) in Berlin.

1912 His first solo shows are held in Magdeburg, Germany, and in Weimar.

1913 January—retrospective of forty-seven paintings opens at Paul Cassirer in Berlin, accompanied by the first monograph on Beckmann, by Hans Kaiser. January—participates in his first group exhibition in the United States, *Contemporary German Art,* at the Art Institute of Chicago.

1914 Joins the Berlin Free Secession and becomes a member of the Munich Secession. Volunteers for the German army's medical corps; September—is sent to the Russian front.

1915 Becomes a medical orderly in Flanders. Paints a mural (later destroyed) for a field hospital. Meets the artist Erich Heckel, who is also a nurse in Flanders. Summer—suffers a mental collapse and is sent to a hospital in Strasbourg, in Alsace, to recover. Discharged from the military and goes to Frankfurt to live with his old friends the Battenbergs.

1918 Publishes "Schöpferische Konfession" (Creative Credo) in *Tribüne der Kunst und Zeit.*

1921 Meets art historian Wilhelm Hausenstein, art dealer Günther Franke, and actor Heinrich George.

1922 First participates in Venice Biennale.

1923 Neumann moves to New York and plans to introduce Beckmann's work in the United States.

1924 Major monograph on Beckmann—with contributions by Curt Glaser, Wilhelm Fraenger, Hausenstein, and Meier-Graefe—is published by R. Piper Verlag, Munich. Has a solo show at Paul Cassirer in Berlin and signs a contract with the gallery. Travels to Italy; in Vienna, meets Mathilde von Kaulbach (known as Quappi).

1925 Work is featured in the *Neue Sachlichkeit* exhibition at Kunsthalle, Mannheim, Germany. Is divorced from Minna Beckmann-Tube and engaged to Mathilde von Kaulbach; they marry in Munich and honeymoon in Italy. Appointed to teach at Städelsches Kunstinstitut in Frankfurt.

1926 First solo exhibition abroad is held at J. B. Neumann's New Art Circle, New York.

1927 Writes his article "The Artist and the State." Takes a trip to the Adriatic.

1928 February—large retrospective opens at Kunsthalle, Mannheim. Receives Honorary Award of the German Reich for German Art and the Gold Medal of the City of Düsseldorf. Travels to the Netherlands, Paris, and Switzerland.

1929 Appointed professor at the Städelsches Kunstinstitut. Receives Honorary Prize of the City of Frankfurt; *The Loge* (plate 42) receives honorable mention at the Carnegie International in Pittsburgh. Detroit Institute of Arts buys *Still Life with Fallen Candles* (plate 44), Beckmann's first painting to enter an American collection. He establishes a studio on the avenue des Marronniers in Paris.

1930 A permanent room to display Beckmann's work is established at Städtische Galerie at the Städelsches Kunstinstitut.

1931 Spring—his first solo show in Paris is held at Galerie de la Renaissance.

1932 Permanent Beckmann gallery opens at the Nationalgalerie, Berlin. May—begins work on *Departure* (plate 50) in his Frankfurt studio.

1933 Gives up his Paris studio and rents an apartment on Graf Spee Strasse in Berlin. Hitler seizes power. Beckmann is dismissed from his professorship in Frankfurt and moves to Berlin; the Beckmann gallery at the Nationalgalerie is closed. First exhibition defaming modern art travels to various German cities.

Beckmann's work is removed from German museums; his solo shows in Hamburg and Erfurt are shut down. Stephan Lackner, a well-to-do writer and art collector, sees Beckmann's work and purchases several paintings. Beckmann begins to use the triptych format; December—he completes *Departure*.

1935 Meets Karl Buchholz and Curt Valentin, his future dealers in Berlin and New York, respectively.

1936 Joseph Goebbels bans art criticism in Germany. A solo show in Hamburg is Beckmann's last in Germany until 1946. He travels to Paris (accompanied by Lackner) and to the Netherlands.

1937 By now, a total of 590 works by Beckmann have been confiscated from German museums. July 19—the *Degenerate Art* exhibition opens in Munich; the next day the Beckmanns leave Germany and move to Amsterdam. The art historian Dr. Hans Jaffé finds an apartment and studio for Beckmann in an old tobacco warehouse on the Rokin. Beckmann takes a trip to Paris.

1938 The New Burlington Galleries, London, opens *Exhibition of Twentieth-Century German Art,* to protest the defamation of modern art by the Nazis. Sir Herbert Read is chairman of the exhibition committee, which includes Le Corbusier, Sir Roland Penrose, Pablo Picasso, H. G. Wells, and others. Beckmann, who is represented by six paintings, goes to the opening (with Lackner) and delivers his important lecture "On My Painting." Lackner contracts

to pay him a monthly stipend in return for two paintings a month. Beckmann rents an apartment at 17, rue Massenet, Paris.

1939 Continues living in Paris but decides to move back to Amsterdam. July—receives first prize of one thousand dollars for *Temptation* (plate 55) at the *International Exhibition of Contemporary Art* at the Golden Gate World's Fair in San Francisco.

1940 After German troops invade the Netherlands, Beckmann's work is endangered. His son, a medical officer in the German Luftwaffe, frequently visits his father in Amsterdam, and he is able to ship his paintings to safety in Germany. Life in Amsterdam becomes very difficult for the Beckmanns, although Erhard Göpel, a German officer in charge of protecting art in the Netherlands, gives them some protection. The Art Institute of Chicago offers Beckmann a teaching position, but his visa is denied by the American consul in Amsterdam because he is a German citizen.

1941 Georg Hartmann (owner of a foundry in Frankfurt) commissions him to illustrate a deluxe edition of the biblical Book of Revelation (published in 1943).

1942 Receives mobilization orders from the German army but is found unfit for military service. Museum of Modern Art, New York, buys *Departure*.

1943 Works on 143 pen-and-ink illustrations for Johann Wolfgang von Goethe's *Faust II,* also commissioned by Hartmann.

1944 Becomes ill with inflammation of the lungs and heart condition. Food becomes even scarcer in Amsterdam after the Allied troops land in Normandy. The Beckmanns have to leave their small house and studio on the Rokin and move in with their friends the art dealer Helmuth Lütjens and his wife. Again Beckmann is examined for military duty but not called up.

1945 January—has a small solo exhibition at the Stedelijk Museum in Amsterdam. The war ends but deprivations continue. Beckmann is put under surveillance as a German citizen.

1946 Declines offers of teaching positions in Munich and Darmstadt, Germany. Exhibits widely in Germany and the United States.

1947 Spends three weeks in Paris and then visits the south of France. Refuses appointment to teach at the Berlin Art Academy; accepts an invitation to teach at Washington University, Saint Louis—a position temporarily vacated by Philip Guston. August 29—sets sail on the SS *Westerdam;* meets Thomas Mann on board. In New York is greeted by his old friend Ludwig Mies van der Rohe. September 8–17—visits New York. September 18—arrives in Saint Louis, where his lectures and critiques are translated by his wife.

1948 February 3—his lecture "Letters to a Woman Painter" is delivered at Stephens College, in Columbia, Missouri, and subsequently repeated in Boston; Saint Louis; Boulder, Colorado; and Oakland, California. Refuses teaching job in Hamburg. May 10—major Beckmann retrospective opens at City Art Museum, Saint Louis. Summer—travels to the Netherlands and closes the Rokin apartment. Fall—applies for U.S. citizenship in New York. December—visits New York again; Artists Equity holds a big party in his honor at the Plaza Hotel.

1949 Meets Morton D. May, who becomes his most important collector. January—accepts a tenured position to teach advanced painting at Brooklyn Museum Art School. Leaves Saint Louis. Summer—teaches at University of Colorado, Boulder. Visits Chicago. Fall—moves into a studio apartment at 234 East Nineteenth Street, in Manhattan. October—receives first prize ($1,500) at Carnegie International in Pittsburgh for his painting *Fisherwomen* (plate 79).

1950 Receives Conte-Volpi Prize at Venice Biennale. April—moves to a new apartment at 38 West Sixty-ninth Street, near Central Park. Receives honorary doctorate at Washington University. Summer—vacations in Carmel, California, and teaches at Mills College, Oakland. December 26—completes his last triptych, *The Argonauts* (plate 87). December 27—falls dead of a heart attack while walking near Central Park.

103

102. The Beckmanns in Baden-Baden, 1929

103. Max and Quappi Beckmann in Saint Louis, c. 1947–49

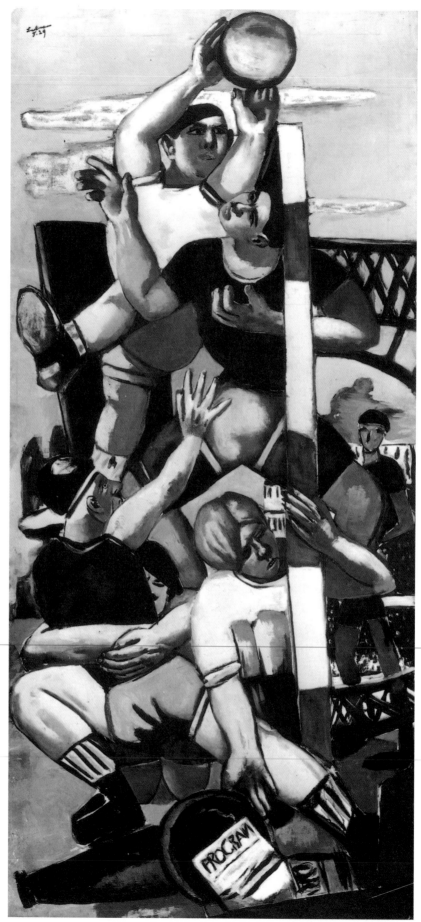

Selected Exhibitions

104. *Soccer Players,* 1929
Oil on canvas, 83⅞ x 39⅜ in. (213 x 100 cm)
Wilhelm Lehmbruck Museum, Duisburg, Germany

Selected Solo Exhibitions

1912
Max Beckmann, Kunstverein, Magdeburg, German, April.
 Gemälde von Max Beckmann, Grossherzogliches Museum für Kunst und Kunstgewerbe, Weimar, Germany, August.

1913
Max Beckmann Retrospective, Paul Cassirer, Berlin, January–February.

1917
Max Beckmann, Kunstverein, Frankfurt, May 23–June 15.
 Max Beckmann: Graphik und Zeichnungen, I. B. Neumann, Berlin, November.

1919
Max Beckmann: Ausstellung seiner neuesten Werke, Buchhandlung Tiedemann und Uzielli, Frankfurt, June.

1921
Max Beckmann Ausstellung, I. B. Neumann, Berlin.
 Max Beckmann, Kunstverein, Frankfurt, April 10–May 5.

1922
Max Beckmann: Neue Arbeiten, Zinglers Kabinett, Frankfurt, April.

1923
Max Beckmann: Zeichnungen und Graphik, Modern Galerie Thannhauser, Munich, November–December.

1924
Max Beckmann: Gemälde der Jahren 1917–23, Paul Cassirer, Berlin, January–February.

 Ausstellung Max Beckmann, Kunstverein, Frankfurt, October 19–November 11.

1925
Max Beckmann: Gemälde der Jahren 1920–24, Galerie Alfred Flechtheim, Düsseldorf, March.

1926
Max Beckmann, Kunstverein, Leipzig, Germany.
 Max Beckmann, New Art Circle, New York, April–May. Also in 1927, 1929, 1931, 1934, and 1937.

1927
Max Beckmann: Druckgraphik aus den Jahren 1911–1924, Graphisches Kabinett Günther Franke, Munich, February–March.
 Max Beckmann, Galerie Neue Kunst Fides, Dresden, Germany, summer.

1928
Max Beckmann: Gemälde aus den Jahren 1920–1928, Graphisches Kabinett Günther Franke, Munich.
 Max Beckmann: Das gesammelte Werk, Kunsthalle, Mannheim, Germany, February 19–April 1.
 Max Beckmann, Galerie Alfred Flechtheim, Berlin, April 22–end of May.

1929
Max Beckmann: Neue Gemälde, Galerie Alfred Flechtheim, Berlin, January 12–31.
 Max Beckmann, New Art Circle, J. B. Neumann, New York, July–August, and tour to Graphisches Kabinett Günther Franke, Munich.

1930
Max Beckmann: 100 Gemälde, Kunsthalle, Basel, Switzerland, August 3–21, and tour to

Kunsthaus, Zurich, and Galerie Neue Kunst Fides, Dresden, Germany.

1931
Max Beckmann: Gemälde und Graphik, Kestner Gesellschaft, Hanover, Germany, January 15–February 8.

Max Beckmann, Galerie de la Renaissance, Paris, March 16–April 30.

Max Beckmann, Galerie Le Centaure, Brussels, May 16–28.

1932
Max Beckmann, Galerie Bing, Paris.

Max Beckmann, Galerie Alfred Flechtheim, Berlin, March 5–24.

Max Beckmann, permanent installation, Nationalgalerie, Berlin, November–August 1933.

1933
Max Beckmann: Gemälde, Museum, Erfurt, Germany, spring.

Max Beckmann: Gemälde, Kunstverein, Hamburg, Germany, February 5–March 5.

1936
Max Beckmann: Gemälde Aquarelle, Kunstkabinett Dr. Hildebrand Gurlitt. This was Beckmann's last exhibition in Germany until 1946.

1938
Max Beckmann: Gemälde und Graphik, Galerie Aktuaryus, Zurich, and tour to Galerie Bettie Thommen, Basel, Switzerland; Kunsthalle, Bern; and Kunstverein, Winterthur, Switzerland.

Exhibition of Recent Paintings by Max Beckmann, Buchholz Gallery, New York, January 11–February 8, and tour to Nelson-Atkins Museum of Art, Kansas City, Missouri; Los Angeles County Museum; San Francisco Museum of Art; City Art Museum, Saint Louis; Portland Art Museum, Portland, Oregon; and Seattle Art Museum.

Tentoonstelling van nieuwe werken door Max Beckmann, Kunstzaal van Lier, Amsterdam, June 4–23.

1939
Max Beckmann, Buchholz Gallery, New York, February 12–March 18. Also in 1940, 1941, 1946, 1947, 1948, 1950, 1951, and 1954.

Max Beckmann, Galerie Alfred Poyet, Paris, April 28–May 15.

Max Beckmann, Graphisches Kabinett Günther Franke, Munich, September. Also in 1946, 1947, 1948, 1950, 1952, 1953, 1963, and 1975.

1942
Max Beckmann Exhibition, Arts Club of Chicago, January 2–27.

1944
Paintings from the Collection Lackner and Morgenroth, Santa Barbara Museum of Art, Santa Barbara, California, June–July.

1945
Max Beckmann, Stedelijk Museum, Amsterdam, September–October.

1946
Beckmann: His Recent Work, San Francisco Museum of Art, June–July, and tour to Boston Museum School.

Max Beckmann: Graphik, Württembergische Staatsgalerie, Stuttgart, Germany, September 14–28.

1947
Max Beckmann: Paintings from 1940 to 1946, Albright Art Gallery, Buffalo, March 31–April 30.

Max Beckmann: Gemälde, Kunstverein, Hamburg, Germany, May–June.

1948
Max Beckmann 1948 Retrospective Exhibition, City Art Museum, Saint Louis, May 10–June 21, and tour to Detroit Institute of Arts; Los Angeles County Museum; San Francisco Museum of Art; Busch-Reisinger Museum, Harvard University, Cambridge; Art Institute of Chicago; and Minneapolis Institute of Arts.

1949
Max Beckmann, Kestner Gesellschaft, Hanover, Germany, February–March.

1950
Max Beckmann, Kunsthalle, Düsseldorf, February 26–April 21.

Max Beckmann, Mills College Art Gallery, Oakland, California, June 21–August 13.

1951
Max Beckmann Memorial Exhibition, Santa Barbara Museum of Art, Santa Barbara, California, January 20–February 18.

Max Beckmann Gedächtnis Ausstellung, Städelsches Kunstinstitut, Frankfurt, January 21–March 4.

Max Beckmann zum Gedächtnis 1884–1950, Haus der Kunst, Munich, June 8–July, and tour to Schloss Charlottenburg, Berlin, and Stedelijk Museum, Amsterdam.

1952
Gemälde aus der Sammlung Günther Franke: Max Beckmann, Kunstverein, Freiburg, Germany, June 15–July 20.

1953
Max Beckmann Gedächtnisausstellung, Kunstverein, Städtisches Museum, Braunschweig, Germany, October 25–November 22, and tour to Bremen, Germany.

1955
Max Beckmann, Santa Barbara Museum of Art, Santa Barbara, California, May–June, and tour to San Francisco Museum of Art and Pasadena Art Institute, Pasadena, California.

Max Beckmann, 1884–1950, Kunsthaus, Zurich, November 22–January 8, 1956, and tour to Kunsthalle, Basel, Switzerland, and Gemeentemuseum, The Hague.

1957
Max Beckmann, Catherine Viviano Gallery, New York, October 1–November 2. Also in

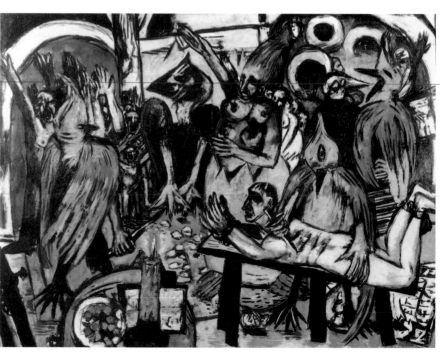

105

1959, 1960, 1962, 1966, 1968, 1969, and 1970.

1959

Max Beckmann: Sammlung Günther Franke, Wallraf-Richartz-Museum, Cologne, Germany, March 21–May 3, and tour to Munich and Lübeck, Germany.

1960

Max Beckmann: Lackner Collection, Santa Barbara Museum of Art, Santa Barbara, California, December 1–January 1, 1961.

1961

Max Beckmann: Die Druckgraphik, Badischer Kunstverein, Karlsruhe, Germany, August 27–November 4. First exhibition of Beckmann's complete graphic work.

1963

Max Beckmann: Das Portrait, Badischer Kunstverein, Karlsruhe, Germany, August 26–November 17.

1964

Max Beckmann: Bildnisse aus den Jahren 1905–1950, Galerie Günther Franke, Munich, February 12–April 15.

Max Beckmann, Museum of Fine Arts, Boston, October 1–November 15; and tour to Museum of Modern Art, New York; Art Institute of Chicago; Kunstverein, Frankfurt; Kunstverein, Hamburg, Germany; and Tate Gallery, London.

1966

Max Beckmann: Die Sammlung Stephan Lackner, Kunsthalle, Bremen, Germany, September 4–October 30, and tour to Akademie der Künste, Berlin; Badischer Kunstverein, Karlsruhe, Germany; Wiener Secession, Vienna; Neue Galerie der Stadt Linz, Linz, Austria; and Kunstverein, Lucerne, Switzerland.

1967

Max Beckmann, Allan Frumkin Gallery, Chicago, November–December.

1968

Max Beckmann, Musée National d'Art Moderne, Paris, September 25–October 28, and tour to Haus der Kunst, Munich; Palais des Beaux-Arts, Brussels; and Kunsthalle, Bremen, Germany.

105. *Birds' Hell,* 1938
Oil on canvas, 47¼ x 63 in. (120 x 160 cm)
Private collection; Courtesy Richard L. Feigen, New York

106. *The Women (Glass Door),* 1940
Oil on canvas, 31½ x 23¾ in. (80 x 60.5 cm)
Museum Ludwig, Cologne, Germany; Rheinisches Bildarchiv

1971

Max Beckmann, Serge Sabarsky Gallery, New York, October 26–November 20.

The Complete Drawings by Max Beckmann for Goethe's "Faust II," Sotheby and Co., London, October 26–30, and tour to Sotheby's in Houston, New York, Munich, and London.

1974

Max Beckmann in der Sammlung Piper, Kunsthalle, Bremen, Germany, October 27–December 1.

Max Beckmann: A Small Loan Retrospective of Paintings Centered around His Visit to London in 1938, Marlborough Gallery, London, November, and tour to Marlborough Gallery, New York.

1975

Max Beckmann, Kunsthalle, Bielefeld, Germany, November 2–December 14.

1977

Max Beckmann: Aquarelle und Zeichnungen, Kunsthalle, Bielefeld, Germany, October 16–December 11.

1980

Max Beckmann: The Triptychs, Whitechapel Gallery, London, November 13–January 11, 1981, and tour to Städelsches Kunstinstitut, Frankfurt, and Stedelijk Museum, Amsterdam.

1981

Max Beckmann: Painting and Sculpture, Grace Borgenicht Gallery, New York, October 17–November 19. Also in 1982, 1983, 1984, 1985, 1989, and 1992.

1982

Max Beckmann: Die frühen Bilder, Kunstmuseum, Bielefeld, Germany, September 26–November 21, and tour to Städelsches Kunstinstitut, Frankfurt.

1983

Max Beckmann: Die Hölle, Kupferstichkabinett, Staatliche Museen, Preussischer Kulturbesitz, Berlin, October 21–December 18.

Max Beckmann: Frankfurt, 1919–1983, Städelsches Kunstinstitut, Frankfurt, November 18–February 12, 1984.

1984

Max Beckmann Graphik, Leipzig, Germany, Museum der Bildenden Künste, February 21–April 22.

Max Beckmann Retrospective, Haus der Kunst, Munich, February 25–April 23, and tour to Nationalgalerie, Berlin; Saint Louis Museum of Art; and Los Angeles County Museum of Art.

Max Beckmann, Josef-Haubrich-Kunsthalle, Cologne, Germany, April 19–June 24.

Max Beckmann: Seine Themen, seine Zeit, Kunsthalle, Bremen, Germany, May 6–July 1.

106

1987

Max Beckmann: Work on Paper, Montgomery Museum of Fine Arts, Montgomery, Alabama, April 27–June 8, and tour to Denison University Gallery, Granville, Ohio; Kalamazoo Institute of Arts, Kalamazoo, Michigan; Bowdoin College Museum of Art, Brunswick, Maine; Milwaukee Art Museum; Winnipeg Art Gallery, Winnipeg, Canada; University of Iowa Museum of Art, Iowa City.

1990

Max Beckmann, Städelsches Kunstinstitut, Frankfurt, July 21–September 23, and tour to Museum der Bildenden Künste, Leipzig, Germany.

1992

Max Beckmann: Prints from the Museum of Modern Art, Modern Art Museum of Fort Worth, May 17–July 5, and tour to Center for the Arts, Miami; Toledo Museum of Art, Toledo, Ohio; San Francisco Museum of Modern Art; Glenbow Museum, Calgary, Canada; Williams College of Art, Williamstown, Massachusetts; Oklahoma City Art Museum; and Museum of Modern Art, New York.

Max Beckmann: The Self-Portraits, Gagosian Gallery, New York, September 15–October 31.

Max Beckmann: Gemälde Aquarelle, Kunsthandlung Wolfgang Witrock, Düsseldorf, October 21–November 23.

1993

Max Beckmann: Selbstbildnisse, Kunsthalle, Hamburg, Germany, March 19–May 23, and tour to Staatsgalerie Moderner Kunst, Munich.

1994

Max Beckmann, Michael Werner, New York, March 1–May 14.

Max Beckmann: Meisterwerke aus St. Louis, Staatsgalerie Stuttgart, Germany, September 21–January 8, 1995.

1906

Eleventh Exhibition of the Berlin Secession, Berlin. Beckmann exhibited regularly with the Berlin Secession until 1913.

1908

Fifth Exhibition, Paul Cassirer, Berlin.

1909

Tenth Annual Exhibition, Glaspalast, Munich.
Salon d'Automne, Paris, October 1–November 23.

1913

Contemporary German Art, Art Institute of Chicago, January 2–19.

1914

Freie Secession, Berlin, Ausstellungshaus am Kurfürstendamm, Berlin. Beckmann exhibited with the Freie Secession until 1921.

1922

XIII Biennale Internazionale d'Arte, Venice. Also in 1926, 1928, 1930, and 1950.

1925

Exhibition of Younger Artists from Germany, England, and the U.S., Nationalgalerie, Berlin.
International Society of Sculptors, Painters, and Gravers, Royal Academy of Arts, London.
Neue Sachlichkeit, Kunsthalle, Mannheim, Germany, June 12–September 13, and tour.

1929

International Exhibition of Paintings, Carnegie Institute, Pittsburgh, October 17–December 8. Also in 1930, 1934, 1935, 1938, 1939, 1948, 1949, and 1950.

1931

German Painting and Sculpture, Museum of Modern Art, New York, March 13–April 26.

1933

A Century of Progress, World's Fair, Chicago, June 1–November 1.
Spiegelbilder des Verfalls der Kunst, Neues Rathaus, Dresden, Germany, September. This, the precursor to the large *Degenerate Art* show in Munich, was reconstituted in many cities throughout Germany.

1937

Entartete Kunst (Degenerate Art), Altes Galeriegebäude, Munich, July–November, and tour.

1938

Exhibition of Twentieth-Century German Art, New Burlington Galleries, London, July 7–August.

1939

International Exhibition of Contemporary Art, Golden Gate World's Fair, San Francisco. Won First Prize for *Temptation.*
Art in Our Time, Museum of Modern Art, New York, summer.

1948

1948 Annual Exhibition, Whitney Museum of American Art, New York, November 13–January 2, 1949.

1955

Documenta I, Kassel, Germany, July 15–September 18. Also in 1964.

1957

German Art of the Twentieth Century, Museum of Modern Art, New York, October 1–December 8.

1962

Entartete Kunst: Bildersturm for 25 Jahren, Haus der Kunst, Munich, February 11–April 17.

1977

Die dreissiger Jahre, Haus der Kunst, Munich, February 11–April 17.

1978

Berlin-Paris, Centre National d'Art et de Culture Georges Pompidou, Paris, July 12–November 6.

1981

Westkunst, Museen der Stadt Köln, Cologne, Germany, May 3–August 6.

1986

Expressionisten: Die Avantgarde in Deutschland, 1905–1920, Nationalgalerie, Berlin, September 3–November 18.

1991

"Degenerate Art," Los Angeles County Museum of Art, February 17–May 12, and tour.

Public Collections

Aachen, Germany, Suermondt-Ludwig-
 Museum
Amsterdam, The Netherlands, Stedelijk
 Museum
Ann Arbor, Michigan, University of Michigan
 Museum of Art
Baltimore, Maryland, Baltimore Museum of Art
Basel, Switzerland, Kunstmuseum Basel
Berkeley, California, University of California
 at Berkeley, University Art Museum
Berlin, Germany, Berlinische Galerie
Berlin, Germany, Kupferstichkabinett
Berlin, Germany, Nationalgalerie
Berlin, Germany, Staatliche Museen,
 Preussischer Kulturbesitz
Beverly Hills, California, Robert Gore Rifkind
 Foundation
Bielefeld, Germany, Kunsthalle Bielefeld
Bloomington, Indiana, Indiana University Art
 Museum
Bonn, Germany, Städtisches Kunstmuseum
 Bonn
Boston, Museum of Fine Arts
Bremen, Germany, Kunsthalle, Bremen
Brooklyn, New York, Brooklyn Museum
Buffalo, Albright-Knox Art Gallery
Cambridge, Massachusetts, Busch-Reisinger
 Museum, Harvard University Art Museums
Cambridge, Massachusetts, Fogg Art
 Museum, Harvard University Art Museums
Champaign, Illinois, University of Illinois,
 Krannert Art Museum
Chicago, Illinois, Art Institute of Chicago
Cleveland, Ohio, Cleveland Museum of Art
Cologne, Germany, Museum Ludwig
Cologne, Germany, Westdeutscher Rundfunk
Columbia, Missouri, Stephens College
Columbus, Ohio, Columbus Museum of Art
Darmstadt, Germany, Hessisches
 Landesmuseum
Denver, Colorado, Denver Art Museum
Detroit, Michigan, Detroit Institute of Arts
Dortmund, Germany, Museum am Ostwall

Dresden, Germany, Gemäldegalerie Neue
 Meister, Staatliche Kunstsammlungen
Dresden, Germany, Sächsische
 Landesbibliothek
Duisburg, Germany, Wilhelm Lehmbruck
 Museum
Düren, Germany, Leopold-Hoesch-Museum
 der Stadt Düren
Düsseldorf, Germany, Kunstmuseum der
 Stadt Düsseldorf
Düsseldorf, Germany, Kunstsammlung
 Nordrhein-Westfalen
Eindhoven, The Netherlands, Stedelijk van
 Abbemuseum
Essen, Germany, Museum Folkwang
Esslingen, Germany, Graphische Sammlung
 der Stadt Esslingen
Fort Worth, Texas, Modern Art Museum of
 Fort Worth
Frankfurt, Germany, Städtische Galerie im
 Städelsches Kunstinstitut
Frankfurt, Germany, Stadtgeschichliches
 Museum, Deutsche Bank, A.G.
Hagen, Germany, Karl-Ernst-Osthaus-Museum
Halle, Germany, Staatliche Galerie
 Moritzburg
Hamburg, Germany, Hamburger Kunsthalle
Hanover, Germany, Niedersächsische Landes-
 galerie, Niedersächsisches, Landesmuseum
Hanover, Germany, Sprengel Museum
Heidelberg, Germany, Kurpfälzisches Museum
Houston, Texas, Sarah Campbell Blaffer
 Gallery, University of Houston
Iowa City, Iowa, University of Iowa Museum
 of Art
Kaiserslautern, Germany, Pfalzgalerie des
 Bezirksverbandes
Kansas City, Missouri, Nelson-Atkins
 Museum of Art
Karlsruhe, Germany, Staatliche Kunsthalle
Kiel, Germany, Kunsthalle zu Kiel
Leipzig, Germany, Museum der Bildenden
 Künste

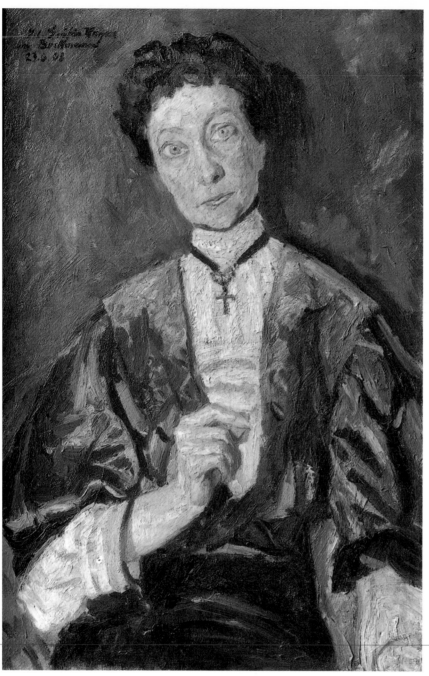

107

107. *Portrait of Augusta Countess von Hagen,* 1908
Oil on canvas, 31 x 20 in. (78.5 x 52 cm)
Sächsische Landesbibliothek, Dresden, Germany

Selected Bibliography

Interviews and Writings

Beckmann, Max. *Briefe,* vol. 1, *1899–1925.* Munich and Zurich: R. Piper, 1993.

———. *Frühe Tagebücher, 1903–1904.* Edited by Doris Schmidt. Munich and Zurich: R. Piper, 1985.

Im Kampf um die Kunst: Die Antwort auf den Protest deutscher Künstler. Munich: R. Piper, 1911.

———. "Gedanken über zeitgemässige und unzeitgemässige Kunst." *Pan* 2 (April 1912): 499–502.

———. "Uber den Wert der Kritik." *Der Ararat* 2 (1912): 132.

———. "Das neue Program." *Kunst und Künstler* 12 (March 1914): 301.

———. *Briefe im Kriege.* Compiled by Minna Tube. Berlin: Bruno Cassirer, 1916.

———. "Creative Credo" (1918). English translation in Carla Schulz-Hoffmann and Judith C. Weiss, eds. *Max Beckmann Retrospective,* p. 80. Munich: Prestel; Saint Louis: Saint Louis Art Museum, 1984. First published in German in *Schöpferische Konfession: Tribüne der Kunst und Zeit,* edited by Kasimir Edschmid. Berlin: Erich Reiss, 1918.

———. "Das Hotel." A drama in four acts. Typescript, c. 1920.

———. *Ebbi.* A comedy. Vienna: Johannes Presse, 1924.

———. "Der Künstler im Staat." *Europäische Revue* 3 (1927): 287ff.

———. *Briefe,* vol. 2, *1925–37.* Munich and Zurich: R. Piper, 1994.

———. "On My Painting." English translation of "Meine Theorie in der Malerei," lecture given at New Burlington Galleries, London, 1938. In Robert L. Herbert, ed., *Modern Artists on Art,* pp. 131–37. Englewood Cliffs, N.J.: Prentice-Hall, 1964.

———. *Tagebücher, 1940–1950.* Edited by Mathilde Q. Beckmann. Munich: Albert Georg Langen-Müller, 1955.

———. Lecture to his first class in the United States, Washington University, Saint Louis, 1947. In Mathilde Q. Beckmann, *Mein Leben mit Max Beckmann.* Munich and Zurich: R. Piper, 1985.

———. "Letters to a Woman Painter." English translation by Mathilde Q. Beckmann and Perry T. Rathbone of "Drei Briefe an eine Malerin," lecture at Stephens College, Columbia, Missouri, 1948. In Peter Selz, *Max Beckmann,* pp. 132–34. New York: Museum of Modern Art, 1964. First published in *Art Journal* 9 (autumn 1949): 39–43.

———. English translation by Jane Sabarsky of speech to the Friends and Philosophy Faculty of Washington University, Saint Louis, June 6, 1950. In *Max Beckmann.* New York: Curt Valentin Gallery, 1954.

———. "Briefe an Reinhard Piper." In Klaus Gallwitz, ed. *Max Beckmann.* Frankfurt: Städelsches Kunstinstitut, 1984.

Pilled, Rudolf. *Die Realität der Träume in den Bildern, Schriften und Gespräche 1911 bis 1950.* Munich and Zurich: R. Piper, 1990.

Schmidt, Doris. *Briefe an Günther Franke: Portrait eines deutschen Kunsthändlers.* Cologne, Germany: Dumont, 1970. Includes twenty letters by Beckmann from 1926–50.

Portfolios and Illustrated Books

Guthmann, Johannes. *Euridikes Wiederkehr.* Nine lithographs by Beckmann. Berlin: Bruno Cassirer, 1909. Limited edition of 60 copies.

Beckmann, Max. *Sechs Lithographien zum*

neuen Testament. Berlin: Tieffenbach, 1911.

Dostojewski, F. M. *Aus Totenhaus: Das Bad det Sträflinge.* Nine lithographs by Beckmann. Berlin: Bruno Cassirer, 1913.

Edschmid, Kasimir. *Die Fürstin.* Six etchings by Beckmann. Weimar, Germany: Kiepenheuer, 1918. Limited edition of 500 copies.

Beckmann, Max. *Gesichter: Original Radierungen.* Introduction by Julius Meier-Graefe. Munich: Verlag der Marées-Gesellschaft; R. Piper, 1919. Limited edition of 100 copies. Introduction reprinted in *Blick auf Beckmann: Dokumente und Vorträge,* edited by Hans Martin Freiherr von Erffa and Erhard Göpel, pp. 50–56. Munich: R. Piper, 1962.

Beckmann, Max. *Die Hölle.* Ten lithographs. Berlin: Graphisches Kabinett, J. B. Neumann, 1919. Limited edition of 75 copies; also published in a facsimile edition of 1,000 copies.

Braunbehrens, Lili von. *Stadtnacht.* Seven lithographs by Beckmann. Munich: R. Piper, 1921. Limited edition of 500 copies; also published in a portfolio in a deluxe edition of 100 copies.

Beckmann, Max. *Der Jahrmarkt.* Ten etchings. Munich: Verlag der Marées-Gesellschaft; R. Piper, 1922. Limited edition of 200 copies.

Beckmann, Max. *Berliner Reise.* Ten lithographs. Berlin: J. B. Neumann, 1922. Limited edition of 100 copies.

Brentano, Clemens von. *Das Märchen von Fanferlieschen Schönefüsschen.* Eight etchings by Beckmann. Berlin: F. Gurlitt, 1924. Limited edition of 220 copies.

Beckmann, Max. *Ebbi.* Six etchings. Vienna: Johannes-Presse, 1924. Limited edition of 33 copies.

Lackner, Stephan. *Der Mensch ist kein Haustier.* Seven lithographs by Beckmann. Paris: Editions Cosmopolites, c. 1937. Also published in a limited edition of 120 numbered and signed copies.

Beckmann, Max. *Die Apokalypse.* Twenty-seven lithographs. Frankfurt: Bauersche Giesserei, 1943.

Beckmann, Max. *Day and Dream.* Fifteen lithographs. New York: Curt Valentin, 1946. Limited edition of 100 copies. Each lithograph is numbered and signed by the artist.

Goethe, Johann Wolfgang von. *Faust: der Tragödie zweiter Teil.* One hundred forty-three drawings by Beckmann. Frankfurt: Bauersche Giesserei, 1957. Edition of 850 copies printed for members of the Maximilian Gesellschaft in Hamburg. The drawings were made by Beckmann in 1943–44.

Monographs, Solo-Exhibition Catalogs, Catalogues Raisonnés, and Dissertations

Beckmann, Mathilde Q. *Mein Leben mit Max Beckmann.* Munich and Zurich: R. Piper, 1985.

Beckmann, Peter. *Max Beckmann.* Nuremberg, Germany: Glock und Lutz, 1955.

———. *Max Beckmann Sichtbares und Unsichtbares.* Introduction by Peter Selz. Stuttgart, Germany: Christian Belser, 1965.

———. *Max Beckmann: Leben und Werk.* Munich and Zurich: R. Piper, 1982.

Belting, Hans. *Max Beckmann: Tradition as a Problem in Modern Art.* Translated by Peter Wortsman with a preface by Peter Selz. New York: Timken Publishers, 1989.

Blick auf Beckmann: Dokumente und Vorträge. Edited by Hans Martin Freiherr von Erffa and Erhard Göpel. Munich: R. Piper, 1962.

Buchheim, Lothar-Günter. *Max Beckmann.* Feldafing, Germany: Buchheim, 1959.

Buenger, Barbara C. "Max Beckmann's Artistic Sources: The Artist's Relation to Older and Modern Tradition." Ph.D. diss., Columbia University, New York, 1979.

———. *Max Beckmann: Gemälde, Handzeichnungen, Druckgraphik.* Bremen, Germany: Kunsthalle, 1984.

Clark, Margot. "Max Beckmann's Sources of Imagery in the Hermetic Tradition." Ph.D. diss., George Washington University, Saint Louis, 1975.

Dube, Wold Dieter. *Max Beckmann: Das Triptychon Versuchung.* Munich: Hirmer, 1981.

———. *Max Beckmann: Leben im Werk.* Munich: Beck, 1985.

Fischer, Friedhelm Wilhelm. *Max Beckmann: Symbol und Weltbild,* Munich: Fink, 1972.

———. *Max Beckmann.* Translated by P. S. Falla. London: Phaidon, 1973.

Franzke, Andreas. *Max Beckmann Skulpturen.* Munich and Zurich: R. Piper, 1987.

Gallwitz, Klaus. *Max Beckmann: Die Druckgraphik. Radierungen, Lithographien, Holzschnitte.* Karlsruhe, Germany: Badischer Kunstverein, 1962.

———. *Max Beckmann in Frankfurt.* Frankfurt: Insel, 1989.

———. *Max Beckmann.* Stuttgart, Germany: Gerd Hatje, 1990.

———, ed. *Die Triptychen im Städel.* Frankfurt: Städelsches Kunstinstitut, 1981.

Gässler, Ewald. "Studien zum Frühwerk Max Beckmanns: Eine motivkundliche und ikonographische Untersuchung zur Kunst der Jahrhundertwende." Ph.D. diss., University of Göttingen, 1974.

Glaser, Curt; Julius Meier-Graefe; Wilhelm Fraenger; and Wilhelm Hausenstein. *Max Beckmann.* Munich: R. Piper, 1924.

Göpel, Erhard. *Max Beckmann in seinen späten Jahren.* Munich: Langen-Müller, 1955.

———. *Max Beckmann: Die Argonauten.* Stuttgart, Germany: Reclam, 1957.

———. *Max Beckmann: Berichte eines Augenzeugen.* Frankfurt: Fischer, 1984.

Göpel, Erhard, and Barbara Göpel. *Max Beckmann: Katalog der Gemälde.* 2 vols. Bern: Verlage Kornfeld, 1976.

Güse, Ernst-Gerhard. *Das Frühwerk Max Beckmanns.* Frankfurt and Bern: Peter and Herbert Lang, 1977.

Hartlaub, G. F. *Max Beckmann: Das gesammelte Werk.* Mannheim, Germany: Kunsthalle, 1928.

Hausenstein, Wilhelm. *Max Beckmann: Gemälde aus den Jahren 1920–1928.* Munich: Graphisches Kabinett Günther Franke, 1928.

Hofmaier, James. *Max Beckmann: Catalogue Raisonné of His Prints.* 2 vols. Bern: Gallery Kornfeld, 1990.

Huldigung an Max Beckmann: 30 zeitgenössige Maler und Bildhauer zum 100. Geburtstag. Berlin: POL Leditionen, 1984.

In Memoriam Max Beckmann 12.2.1884–27.12.1950. Includes tributes by Perry T. Rathbone, Erhard Göpel, Peter Beckmann, Benno Reifenberg, Georg Meistermann, Theo Garve, and excerpts from writings by the artist. Frankfurt: Lohse, 1953.

Jatho, Heinz. *Max Beckmann: Schauspieler Triptychon.* Frankfurt: Insel, 1989.

Kaiser, Hans. *Max Beckmann.* Berlin: Cassirer, 1913.

Kessler, Charles S. *Max Beckmann's Triptychs.* Cambridge, Mass.: Harvard University Press, Belknap Press, 1970.

Lackner, Stephan. *Ich erinnere mich gut an Max Beckmann.* Mainz, Germany: Kupferberg, 1967.

———. *Max Beckmann: Memories of a Friendship.* Coral Gables, Fla.: University of Miami Press, 1969.

———. *Max Beckmann.* New York: Harry N. Abrams, 1977.

Max Beckmann Colloquium. Verband Bildender Künstler der DDR. Leipzig, Germany: Museum der Bildenden Kunst, 1984.

Max Beckmann Symposium. Cologne, Germany: Joseph Haubrich Kunsthalle, 1984.

Neumann, J. B. *Max Beckmann.* Edited and published by J. B. Neumann and Günther Franke. New York and Munich: New Art Circle, 1931.

———. "Sorrow and Champagne." Typescript, 1958. Library, Museum of Modern Art, New York.

Piper, Reinhard. *Nachmittag: Erinnerungen eines Verlegers.* Munich: R. Piper, 1950.

Poeschke, Joachim. *Der frühe Beckmann.* Bielefeld, Germany: Kunsthalle, 1984.

Rathbone, Perry. *Max Beckmann 1948.* Saint Louis: City Art Museum, 1948.

Reifenberg, Benno, and Wilhelm Hausenstein. *Max Beckmann.* Munich: R. Piper, 1949.

Roh, Franz. *Max Beckmann als Maler.* Munich: Desch, 1946.

Schiff, Gert. "Max Beckmann: Die Ikonographie der Triptychen." In Tillman Buddensieg, ed. *Munuscula Discipulorum* (Berlin: Hessling, 1968), pp. 265–85.

Schnede, Uwe M., and Carla Schulz-Hoffmann. *Max Beckmann Selbstbildnisse.* Stuttgart, Germany: Gert Hatje, 1993.

Schulz-Hoffmann, Carla, and Judith C. Weiss, eds. *Max Beckmann Retrospective.* Munich: Prestel; Saint Louis: Saint Louis Art Museum, 1984.

Selz, Peter. *Max Beckmann.* New York: Museum of Modern Art, 1964.

———. *Max Beckmann: The Self-Portraits.* New York: Rizzoli, 1992.

Simon, Heinrich. *Max Beckmann.* Berlin and Leipzig, Germany: Klinkhardt und Biermann, 1930.

Wichmann, Hans. *Max Beckmann.* Berlin: Deutsche Buchgemeinschaft, 1961.

Wiese, Stephan von. *Max Beckmann—Das zeichnerische Werk 1903–1925.* Düsseldorf: Droste, 1978.

Zenser, Hildegard. "Studien zu den Selbstbildnissen Max Beckmann." Ph.D. diss., University of Munich, 1981.

———. *Max Beckmann Selbstbildnisse.* Munich: Schirmer/Mosel, 1984.

Zimmermann, Frederick. *Beckmann in America.* New York: Marchbanks Press, 1968. Address to the Beckmann Society, Murnau, Germany, 1962.

Periodicals

Amyx, Clifford. "Max Beckmann: The Iconography of the Triptychs." *Kenyon Review* 13 (1951): 610–23.

Arts Magazine (Special Max Beckmann Issue) 39 (December 1964). Includes articles by Alfred Werner, Hilton Kramer, Charles Kessler, and Perry Rathbone.

Baker, Kenneth. "Max Beckmann Is Still in Exile." *Artforum* 23 (December 1984): 45–51.

Barker, Walter. "Max Beckmann in America." *Arts Magazine* 44 (March 1970): 63.

Brach, Paul. "Beckmann on Beckmann." *Art in America* 91 (March 1993): 104–5.

Buenger, B. C. "Max Beckmann's Ideologues: Some Forgotten Faces." *Art Bulletin* 71 (summer 1989): 453–79.

Frommel, Wolfgang. "Die Argonauten." *Castrum Peregini* 33, no. 9 (1957–58): 16.

George, Waldemar. "Beckmann l'Européen." *Formes* 13 (March 1931): 50.

Glaser, Curt. "Max Beckmann." *Kunst und Künstler* 27 (March 1929): 223–26.

Göpel, Erhard. "Beckmann als Zeichner." *Die Weltkunst* 25, no. 9 (1955): 16.

Greenberg, Clement. "Max Beckmann." *Nation,* May 18, 1946, pp. 610–11.

Janson, H. W. "Max Beckmann in America." *Magazine of Art* 44 (March 1951): 89–92.

Joachim, Harold. "'Blindman's Buff': A Triptych by Max Beckmann." *Minneapolis Institute of Arts Bulletin* 47 (winter 1958): 1–13.

Kessler, Charles. "Max Beckmann's 'Departure': The Modern Artist as Heroic Prophet." *Journal of Aesthetics and Art Criticism* 14 (December 1955): 206–17.

Kimmelman, Michael. "The Artist as Conjurer, King and Christ." *New York Times,* October 11, 1992, pp. 35, 38.

Langsner, Jules. "Symbol and Allegory in Max Beckmann." *Art International* 5 (March 1, 1961): 27–29.

Marc, Franz. "Anti-Beckmann." *Pan* 2 (March 1912): 555–57.

Metgen, G. "Beckmann: Une Expérience de tragique." *Beaux-Arts Magazine* 11 (March 1984): 46–53.

Neumeyer, Fred. "Erinnerungen an Max Beckmann." *Der Monat* (April 1952): 70–71.

Reifenberg, Benno. "Max Beckmann." *Ganymed* 3 (1921): 37–49.

Roh, Franz. "Zum Tode Max Beckmanns." *Kunstchronik* 4 (February 1951): 25–26.

Scheffler, Karl. "Max Beckmann." *Kunst und Künstler* 2 (March 1913): 297–305.

Schmidt, Paul Ferdinand. "Beckmann Ausstellung in Magdeburg." *Deutsche Kunst und Dekoration* 30 (1912): 140.

Seckler, Dorothy. "Can Painting Be Taught? Beckmann's Answer." *Artnews* 50 (March 1951): 39–40.

Simon, Heinrich. "Max Beckmann." *Das Kunstblatt* 3 (1919): 257–64.

Soupault, Philippe. "Max Beckmann." *La Renaissance* 14 (March 1931): 96–100.

Tannenbaum, Libby. "St. Louis Adopts the International Expressionist." *Artnews* 47 (May 1948): 20–22.

Thwaites, John Anthony. "Beckmann—Notes for an Evaluation." *Art Quarterly* 14 (winter 1951): 274–82.

Index

Photography Credits

The photographers and the sources of photographic
material other than those indicated in the captions
are as follows (numerals refer to plates):

Copyright © Art Institute of Chicago: 19, 24, 49,
94, 95; Artothek, Peissenberg, Germany: 10, 27, 46,
58; Archive of Dr. Beckmann, Murnau, Germany: 7;
Richard Carafelli: 77; Fotowerkstatt, copyright ©
Elke Walford: 5; Copyright © Bernd Kirtz,
Duisburg, Germany: 104; Kunsthalle Mannheim,
Mannheim, Germany: 101; Copyright © Museum
Folkwang, Essen, Germany: 56; Courtesy Piper
Verlag, Munich: 100, 102; Private collection: 1;
Rheinisches Bildarchiv, Cologne, Germany: 52, 54,
106; Courtesy The Saint Louis Museum of Art: back
endpaper, left; Walter Schmidt, Beverly Hills,
California: 62; Courtesy Timken Publishers, New
York: 103; Copyright © VG Bildkunst, Bonn,
Germany: 26, 34, 36, 76, 81; Paul Weller, East
Hampton, New York: back endpaper, right.

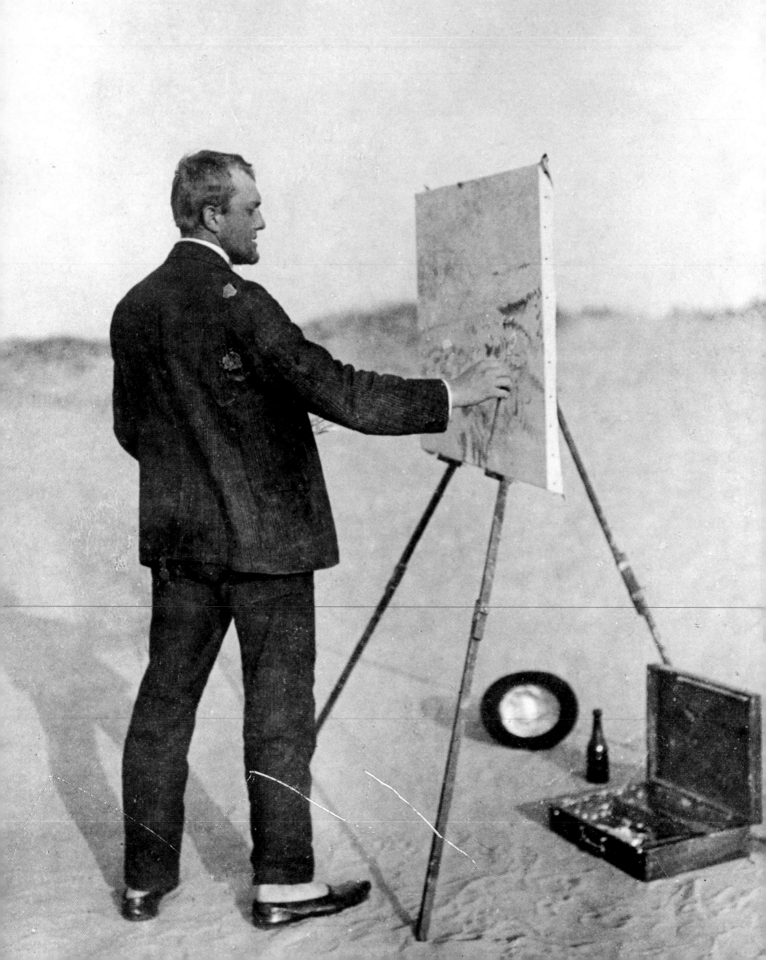